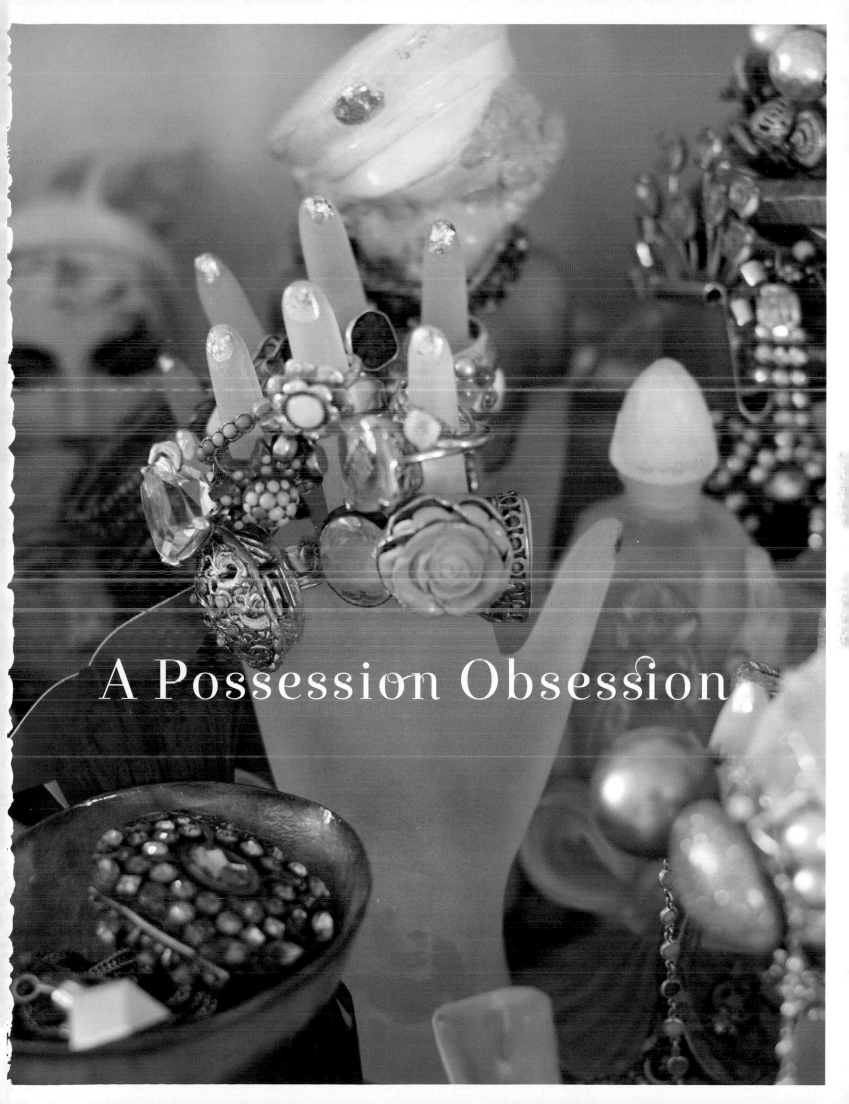

A Possession Obsession

*For my girls,*
*a constant inspiration.*

First published in 2016 by

New York Office:
630 Ninth Avenue, Suite 603
New York, New York 10036
Telephone: 212 362 9119

London Office:
1 Rona Road
London NW3 2HY
Tel/Fax +44 (0) 207 267 8339

www.GlitteratiIncorporated.com | media@GlitteratiIncorporated.com for inquiries

First edition, 2016

Library of Congress Cataloging-in-Publication data is available from the publisher.

Hardcover edition ISBN 13: 978-1-943876-32-7
Design: Laura Klynstra

Printed and bound in China

10 9 8 7 6 5 4 3 2 1

# A Possession Obsession

## WHAT WE CHERISH & WHY

### Monica Rich Kosann

*foreword by* LINDA FARGO

Glitterati
INCORPORATED

# contents

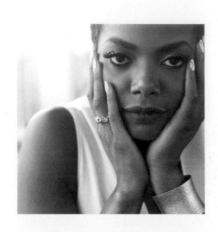

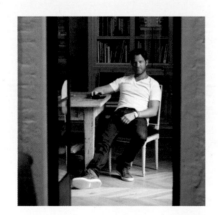

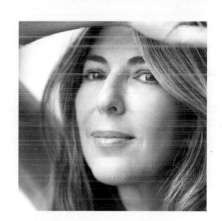

# foreword

Do we possess or are we in turn possessed? Did we choose or were we chosen? In an almost pre-destined manner, we gather and attract those things around ourselves which create a nest of familiarity, a web of connectivity, and become our own private evidence of our lives. These powerful "things" are touchstones which can connect us to our most meaningful relationships and memories, so although there's frequently very little superficial value, they are actually our most valuable touchstones. An object, while technically inanimate, is hardly so in reality. It can easily transport us to beloved connections and memories in the glance of an eye across a shelf. It tells stories even without speaking. The objects we hold on to most dearly, or which hold on to us, are most certainly highly personal conduits to milestone moments in another time and place. Sentimental little time machines. One doesn't set out to purposefully acquire these keepsakes, but rather they tend to come to us magnetically through the bumpy course of our lives, through our interactions and experiences, gifted, bequeathed, serendipitously discovered, and yes, even purchased. We don't purposefully imbue them with meaning, but like patina and history, the acquired meaning comes with layers of use and age. They are often the remaining symbols of a life well lived and shared, the talismans of our humanity and the connectedness we crave.

In my mental safe of valuables, of objects which have come to own me as much as I them, is a small book of haiku which my mother presciently gave me at a creatively formative age; her engagement ring, forged from her husband-to-be's only possession of value—his grandfather's tiepin, carried through dangerous and dire times; and my father's remaining bottle of Old Spice—basically all nothing of particular value, except invaluable to me.

*Linda Fargo*

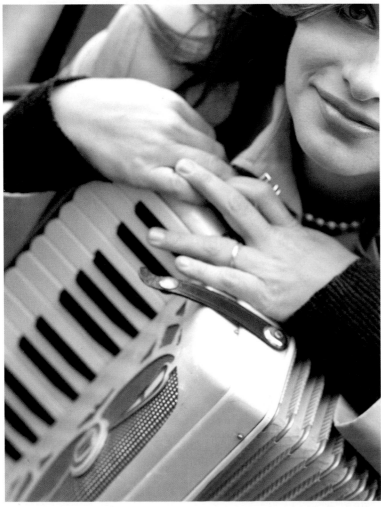

# introduction

In my professional life, I am both a photographer and jewelry designer. As my career evolved to include both pursuits, I sometimes wonder why I am so strongly attracted to such different forms of creative expression. Now the connection is clear to me. At heart, I am a storyteller, and whether the medium is photography or jewelry, the life stories associated with people and their possessions intrigue me.

To begin with my work as a photographer: I have never been the kind of "portrait photographer" who asks people to pose in front of a white backdrop. I have always wanted to portray people's lives as they really are—to catch them in moments that document their daily lives. Since I work in their natural environment (often their homes), I get caught up in those lives. As we edit the photos, my interaction with clients goes beyond the selection process. We talk about where the selected photographs seem to belong—in a certain room, on a wall, alongside other photographs, or displayed on a chosen desk or dressing table. Inevitably, as we go about the process of selection and placement, the people I have photographed speak about other significant possessions and heirlooms and tell me how those came to be in their homes. From those conversations, I learn their stories and the narrative of their family histories. Whether the items are pieces of jewelry, photographs passed down for generations, or some other cherished keepsakes, these possessions speak to them in a very personal and intimate way about who they are and where they come from.

I also encourage them to bring other cherished possessions out of hiding. If they have a decades-old photograph that means something to them, why not

hang it alongside new photos of their family? Do they have a wedding ring that a grandmother gave her granddaughter? Why not keep that memory alive by wearing the ring on a necklace or displaying it on a bedside table? I remind them that their connection with these objects reveals part of their personal stories.

After realizing the importance of these connections, I started a column on my website where I showed photographs of people with the objects that had special meaning for them and that brought up memories of a parent or grandparent, a sibling or a friend, or of some event—an adventure, a milestone, a celebration. Family is the common thread weaving through these much-valued possessions.

In my own life, my prized possession is a charm bracelet. The first charm, which was given to me by my mother, is a tiny ski with a boot. It evokes memories of early childhood. The times when my sister and I visited Austria with my mother to see her family, and where we first learned to ski. I have a continent charm of Asia, celebrating my first trip there, when I completely fell in love with the culture. I also have a continent charm of South America, because my beloved uncle, who used to bring charms to my mother, lived in Brazil. And then there is the charm I prize the most—a locket with portraits of my two daughters. Point to any of these charms, and I can tell you the story of why it is on the bracelet and what it means to me.

My interest in jewelry design grew directly from my fascination with the connection that people have with family history and the possessions they treasure. When I was flea-marketing and antiquing (a hobby of mine), I became interested in the beautifully designed silver lockets in which people used to keep pictures of their loved ones. I was intrigued. Whose picture was originally in that locket? Who carried that portrait for years, or decades, opening the locket to remind them of someone special? Each locket held a secret that could only be revealed at the discretion of the bearer.

Before long, I was not only collecting vintage lockets, but also elegant antique cigarette cases and powder compacts. Almost on a whim, I inserted pictures in the keepsakes and offered them as gifts to clients. They, in turn, showed these to their children and relatives, and before long they asked for more. Inspired by their interest, I designed original lockets, charms, and unique jewelry for a single purpose—to create

something of lasting value to the person who owns it. My philosophy is to create a piece that a woman will want to pass on to her daughter or granddaughter, who will hold on to it forever.

What I have learned is that we are all collectors, and the objects we collect make us all storytellers. Whether I am photographing a family, designing jewelry that will be passed to future generations, or encouraging people to live with what they love, I am helping to tell those stories. The objects we cherish bridge the generations and join us together with the past and future.

For this book, I asked the same questions to each of the people you will meet on the pages ahead: How did you come to own your possession? How do you live with it? What was the most memorable gift you've ever given or received? What was your last purchase that you believe will mean something to you ten years from now?

An onrush of personal associations and memories accompanied each answer. When asked to choose their most precious possession, many of the women I photographed for this book selected a piece of jewelry, valued not for its monetary worth but because it reminded them of who gave it to them and on what occasion. Others showed me significant heirlooms, vividly recalling the moment when a parent or grandparent said, "I want you to have this." While some things had been recently purchased for a memorable event or occasion, others had been in their family for many years. But whether the possession is old or new, something of permanent value has become part of each person's life story.

xox
M

# CHRISTENE
# Barberich

**How did you come to own your possession?**

My Italian grandmother didn't have a lot of money growing up in Brooklyn, and as an older, more established woman, she never allowed herself any indulgences—except jewelry. She *loved* jewelry—the bigger and gaudier, the better. When she passed away many years ago—I was probably in my early twenties—she left all her jewelry to my sister and me. My sister took all the classic stuff, and I took everything else. This ring, which my sister hilariously thinks is hideous, is just one of my favorite pieces ever. It not only reminds me of her—and how she would often wear four gigantic rings at a time on one hand—but it was also a sort of premonition of what my style would eventually become—a mix of vintage and modern, uninhibited, a little gaudy sometimes, too, just like her.

**How do you live with your heirloom?**

I honestly get a little nervous I'll lose it, so I only wear it for evenings out to dinner or on special occasions. Although, it's just as fabulous for an ordinary day at the office.

**Who in your life has most influenced your personal style and taste?**

My grandmother for sure. . . . She taught me how to wear red lipstick, too. The many powerful women and characters in film and television in the seventies when I was growing up . . . everyone from *Charlie's Angels* to Jessica Lange. And, of course, you can't go wrong with advice or imagery from Elsa Schiaparelli or Diana Vreeland; they are the queens.

**Fill in the blank: Whenever I look at _____ I can't help but smile.**

My cat, Phoebe.

**What's the best part of your day?**

Early morning, when the house is quiet, the sun is just beginning to break through the clouds—everything feels new and full of possibilities. I get my best work done in the morning, always.

**What is your favorite place to shop for antique/vintage pieces? Can be anywhere in the world.**

eBay, for sure. I'll never say no to a good Salvation Army, and I will always research the closest flea markets in any new city I'm traveling to.

**What was the most memorable gift you've ever given or received?**

Many years ago, my friend Hadis gave me a beautiful polished stone cocktail ring and a vintage fashion book for my birthday. Both gifts were perfect, and I was just so touched that she *really* got it right. Annie, one of my editors, gave me a tiny book of quotes about encouragement that I bring with me everywhere. . . . That one is special, too. And, of course, my Cartier Trinity ring that my husband gave me when we got engaged. I never take it off.

**What was your last purchase that you believe will mean something to you ten years from now?**

A long and very wild Prada coat that I missed out on in stores, but managed to find on eBay. At first, I blew the final hour of bidding and didn't get it. I was crushed! But strangely, a few months later, the coat was relisted and I received an alert. I didn't mess around and just paid the Buy It Now price. And, you know, it's one of the most perfect things in my closet. I hope I can wear it forever!

*This ring, which my sister hilariously thinks is hideous, is just one of my favorite pieces ever.*

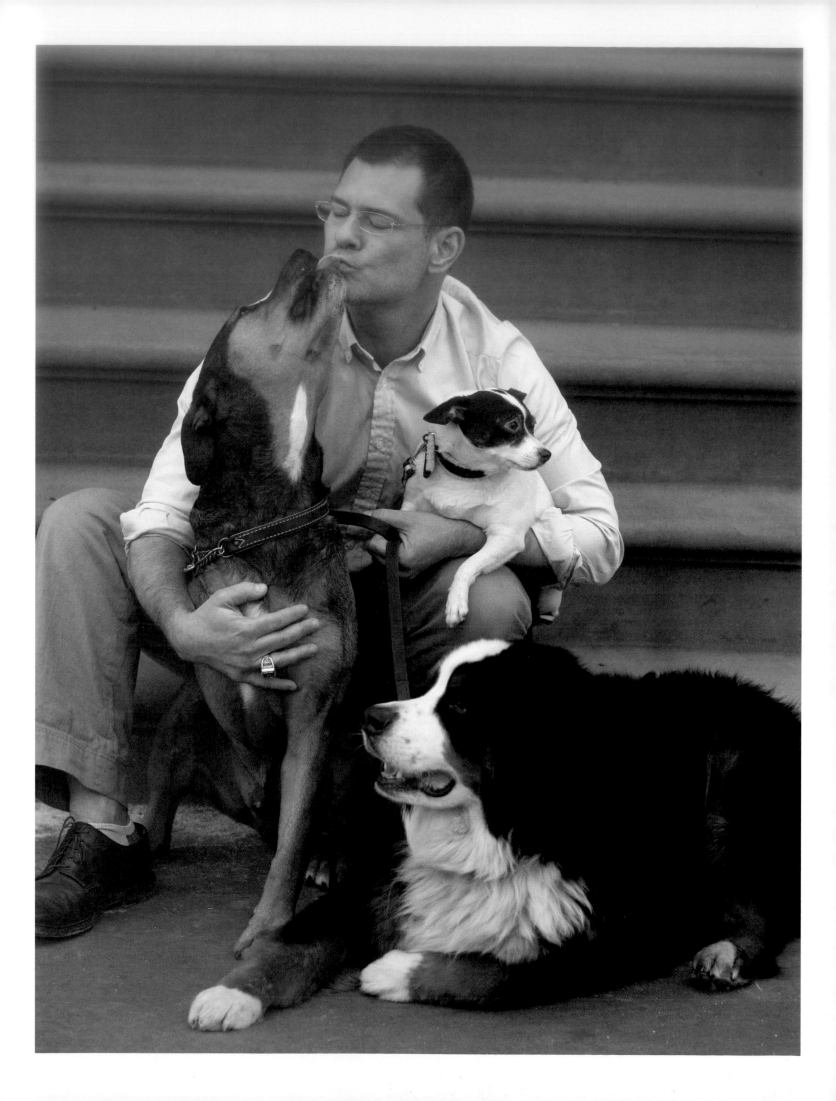

# JOHN Bartlett

**How did you come to own your possession?**

My heirloom is my beloved father's 1975 Cincinnati Reds World Series ring. When he passed away a year and a half ago, my mother told me that he wanted his three children to have his three favorite possessions: his two World Series rings and a pennant ring. He had received them while working at the local television station that carried the Reds' games. They meant everything to him. He loved to show them off and was so proud to be the man who had negotiated the contracts for the station with the team.

**How do you live with your heirloom?**

I keep my heirloom in a little box in my drawer next to my bed. I tried to wear it, but it wasn't my style and was forever falling off my finger. I will go weeks without thinking about this ring, but every now and then, when I pull it out, memories of my father and our family outings to ball games come flooding back.

When I was seven, my dad took us down to the dugout and I met Johnny Bench and Pete Rose. We had our photo taken with the whole team, which was amazing. I wasn't an especially big baseball fan, but my dad was so proud of his association with the team (the television station had a "room" at the stadium where he would go most nights to entertain clients) and loved to wear the rings of the championship team.

**Who in your life has most influenced your personal style and taste?**

My grandmother definitely was my first style inspiration. I remember when she arrived at my first communion in a banana yellow minidress and white patent go-go boots. I was in heaven. She came from very humble beginnings but knew how to create a splash and express herself through clothing and inspired me to do the same.

**Fill in the blank: Whenever I look at _____ I can't help but smile.**

My three dogs. They are pure love and will forever be my children. They are uncomplicated and love me for who I am. I can sit and watch them play tug-of-war and run around the house for hours. It is magic.

**What's the best part of your day?**

The best part(s) of my day are the beginning and the end. If I have the time in the morning, I love to lie in bed with my three dogs—a three-legged Rottie-Shepherd, a Chihuahua-Jack Russell Terrier (both are rescues), and a Bernese Mountain Dog—and read *The New York Times* while my lovely partner, John, brings me up a cup of coffee. The dogs will fall back asleep and sometimes we'll all doze together.

My other favorite part of the day is late at night when I'm up working and my creative juices are flowing. The house is silent and my tripod dog, Tiny Tim, is lying at my feet while I work.

**What was the most memorable gift you've ever given or received?**

The most memorable gift I have ever received is my education. Both of my parents came from very humble backgrounds in small Ohio towns. It was their mission to send their three children to good schools and to provide them with the education they never were able to afford for themselves. Going to Harvard was a dream come true for me and for my parents. The fact that they could send me there was the greatest gift ever.

**What was your last purchase that you believe will mean something to you ten years from now?**

John and I bought each other wedding bands from Ted Muehling. They are both gold made with an organic design that is thick and thin. These wedding bands represent a lifetime of commitment that I hope will always be there "through thick and thin."

*They meant everything to him.*

# MARIA
# Bartiromo

**How did you come to own your possession?**

My mom bought me an accordion when I was seven years old. We all grew up with instruments. My sister played one, my brother played the guitar, and my mom played the organ. We used to play together. I don't know why she chose the accordion for me, but I had to take lessons after school a couple times a week. I didn't appreciate it then at all.

A few years ago, my mother said to me, "Look, do you want your accordion?" And I said, "Absolutely!" It's so amazing to me that I spent so many years playing it as a child. I don't think anyone would believe me unless they could see it. So she brought it over and inside the case I found my old song book. It was sweet to see my little-kid handwriting in it.

A couple days ago, Monica came over to take my picture with the accordion. After she left, I started playing it again for the first time since 1978. I must have been eleven when I stopped playing. It was so wonderful. It just warmed my heart to sit in my living room with my accordion thirty-two years later. It's still in great shape. I love it so much.

**How do you live with your heirloom?**

It's sitting in its brown leather case on a shelf in the corner of my living room. I look at it lovingly, pick it up, and play with it from time to time. It's something that I want to keep beautiful forever, so I don't live with it every day. Though it's on display, it's in a safe spot in my home.

**Who in your life has most influenced your personal style and taste?**

My mom has always had great wisdom. As a child, she was very smart in terms of money. She would force me to save money so

I could buy an ice cream cone or something that I wanted. She really set the tone for me in terms of responsible savings. It's no surprise that I eventually got involved in business news. She really did have a quiet but real impact on me.

**Fill in the blank: Whenever I look at _____ I can't help but smile.**

My accordion.

**What's the best part of your day?**

Well, there are different times—not just one time every day. I love it when I do yoga in the morning. It's so refreshing and strengthening. I feel like I get a clear head from it. I also love coming home and playing with my Maltese.

**What was the most memorable gift you've ever given or received?**

My mom gave me the beautiful gold bracelet that my dad had given her when they were first married. He also got her beautiful charms for each of their children (she had three). I don't wear it, because I want to safeguard it in my jewelry box. It is very special to me.

**What was your last purchase that you believe will mean something to you ten years from now?**

I bought a small sculpture in London of a woman kneeling with her head down. It is a beautiful piece of work from an artist named Jonathan Wylder located on Motcomb Street. I love the very calming and intricate way she is posing. It's gorgeous.

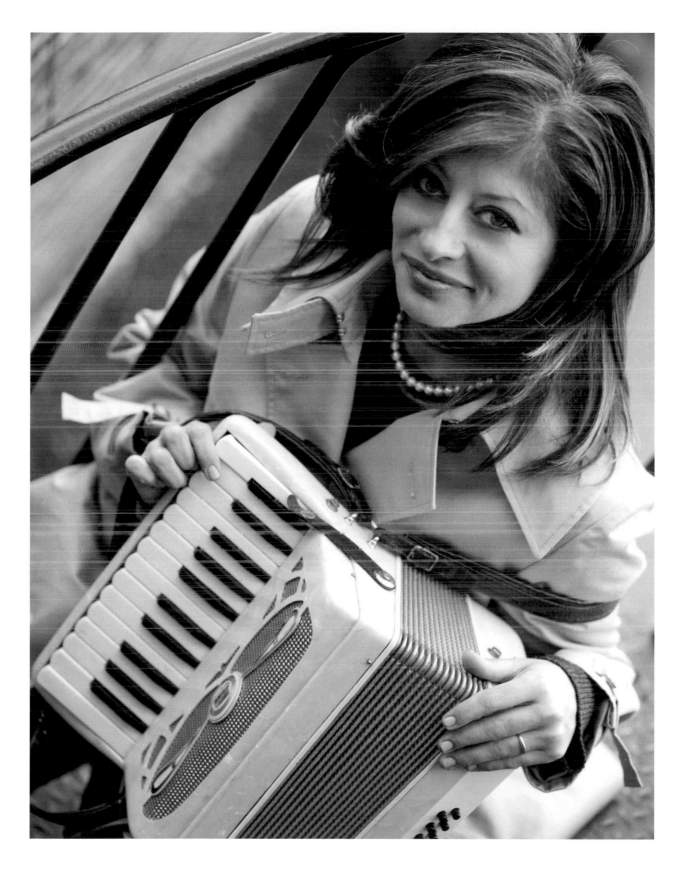

Inside the case I found my old song book. It was sweet to see my little-kid handwriting in it.

# TAI
# Beauchamp

**How did you come to own your possession?**

The ring was something my grandmother purchased in the seventies. She gave it to my mother as a gift in the nineties, and I remember loving it and admiring it so much when I was in high school. My mother finally gifted it to me, with my grandmother's permission, around 2002 after she misplaced it and then found it. I was so happy to have it.

**How do you live with it?**

It really is a treasure to me. As a lover of style and a granddaughter who is obsessed with her grandmother, the ring has sentimental value and makes a style statement. I wear it every chance I get, with both the most casual and formal looks. I also wear it as a pendant on a necklace. When I do wear it, it's usually the last piece of jewelry I take off so it often rests on my nightstand rather than in one of my jewelry boxes.

**Who in your life has most influenced your personal style and taste?**

My grandmother, Mary, by far has influenced my style the most. Second to her, I'd say Diana Ross.

**Fill in the blank: Whenever I look at _____ I can't help but smile.**

Children, especially my godchildren.

**What's the best part of your day?**

The mornings when I wake up! Knowing that I have the opportunity to make the most of the day and then deciding to do the most with it—that is a gift.

**Describe your ideal day.**

My ideal day would be sleeping until at least seven thirty or eight in the morning. (I'm typically up by six thirty most mornings.) I'd meditate for at least twenty minutes, sit down for a cup of coffee and apple, work out for an hour and a half. Take a slow shower, have a casual breakfast on the beach (or if I'm home in New York City, on the rooftop), read the newspaper, work for an hour or two, get a massage, visit my family—including my grandmom—go on a gorgeous dinner date with a beau (husband—I'm speaking this one into existence) or girlfriends. You may notice that I didn't mention anything about talking on the phone or sleeping. I really like to be active.

**What is your favorite place to shop for antique/vintage pieces? Can be anywhere in the world.**

I recently discovered 25 Janvier in Paris. It is the sweetest and most delicate boutique, yet so highly curated. And Decades in Los Angeles is always exciting to visit.

**What was the most memorable gift you've ever given or received?**

My first car is probably the most memorable gift I've ever received. The fact that my family purchased it for me at seventeen years old symbolized freedom, maturity, and trust. I remember being so excited to pick up the car after waiting three weeks for it to come in.

**What was your last purchase that you believe will mean something to you ten years from now?**

Paul Andrew marabou sandals—although they are so fashion forward, there's also something so classic about them. They are undeniably very special. My grandmother passed down several fur coats and stoles to me, so perhaps my daughter or granddaughter will also have very large feet and I'll be able to pass these beauties down to her. I imagine I'll only wear them once a year, if that. They are a work of art.

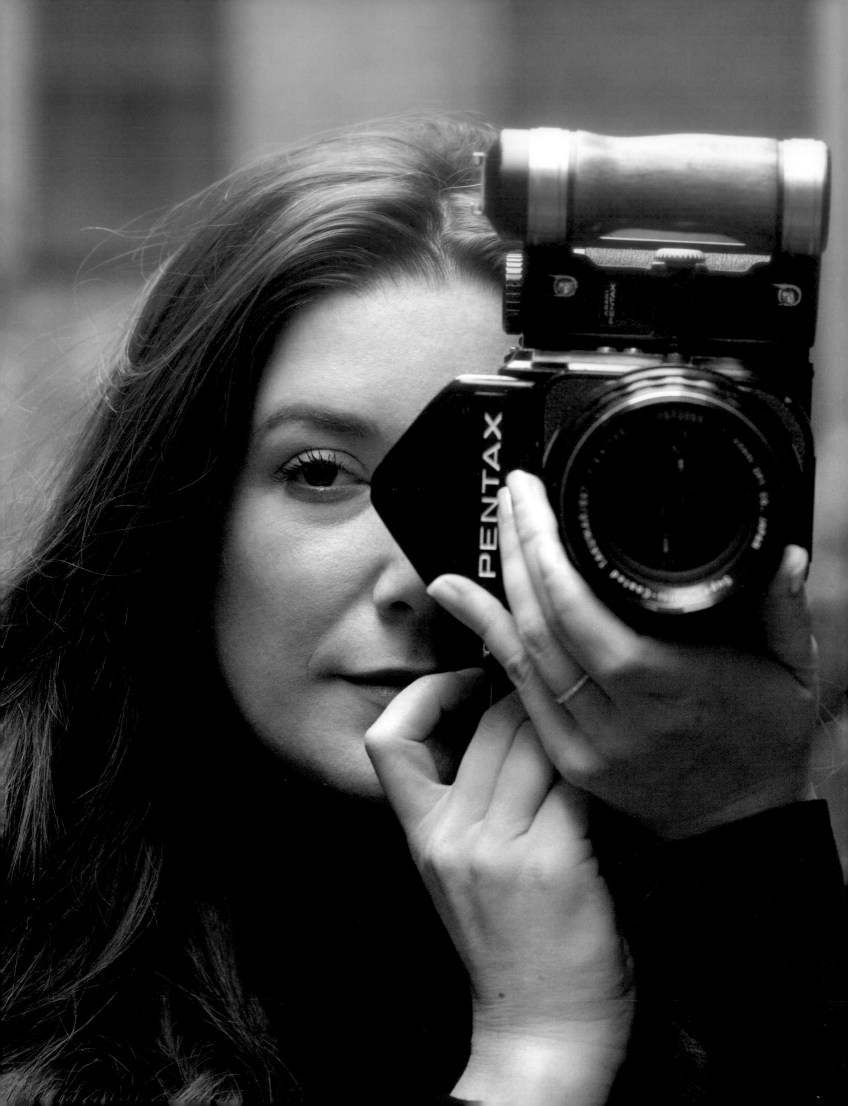

# JAMIE
# Beck

**How did you come to own your possession?**

I have always dreamed about owning the Pentax 67 since I first fell in love with photography. This particular camera, used famously by fashion photographers of the 1990s, is the medium format version of the 35mm Pentax camera I first began shooting on (and still to this day shoot with from time to time). After some financial success, I was able to buy one of my own. When the man at the photo store brought out the body, it was like, for me, having a child. I loved it instantly, and when I first held it, it felt like we had always been together.

**How do you live with your heirloom?**

I use this camera on more intimate and thoughtful shoots, where I'm looking for a deeper connection with the subject. Older film cameras themselves are such beautifully designed pieces of machinery that when I'm not working with it, I keep it on a shelf in my library displayed next to books by my favorite photographers to constantly keep me visually connected to both my work and my ideas.

**Who in your life has most influenced your personal style and taste?**

My grandmother was a huge influence on me because I admired her so much. I think in a lot of ways her approach to dressing influenced my ideals of style. There is a respect for yourself and for the people around you that is expressed by how you present yourself, and I learned these ideals from her at a very young age. Taste, on the other hand, comes from a different place than influence. Taste is something you are born with that manifests itself outwardly in many different ways. The most obvious for me is through my photographs. You can see my taste in any of my shots.

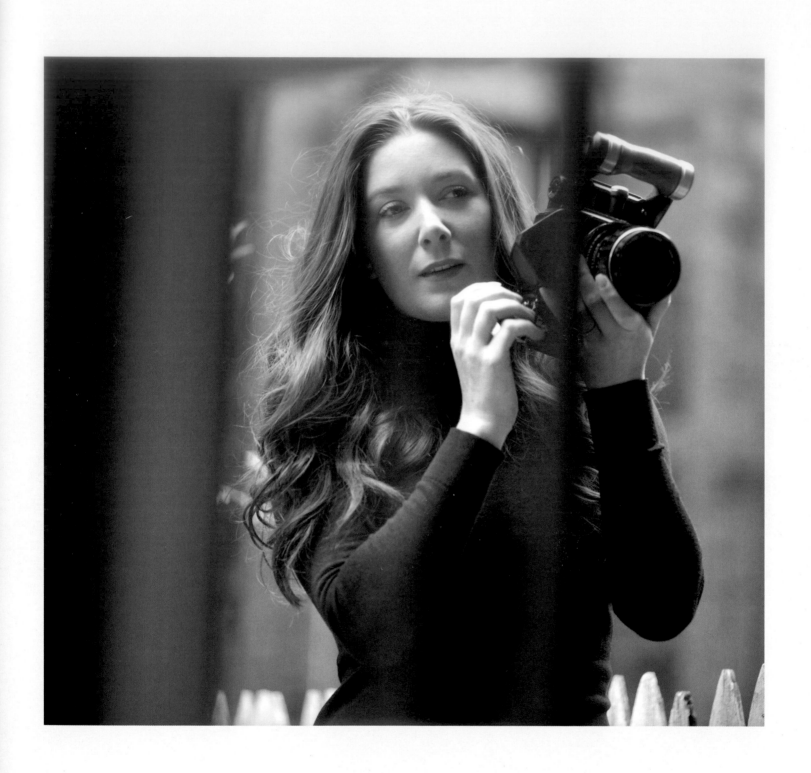

I loved it instantly, and when I first held it,
it felt like we had always been together.

**Fill in the blank: Whenever I look at _____ I can't help but smile.**

The ocean.

**What's the best part of your day?**

Early in the morning, before everyone wakes up and the light is soft and dewy, I go for a walk in Riverside Park by the community garden, which is always exploding with love and has a view that overlooks the sailboats bobbing up and down in the Hudson River.

**Describe your ideal day.**

On an empty beach in the south, riding bikes with my husband, an old film camera strapped around my neck and being present for inspiration and discovery. No day is ever complete without great food, drinks, and laughter.

**What is your favorite place to shop for antique/ vintage pieces? It can be anywhere in the world.**

I was recently up in Providence, Rhode Island, and loved antiquing there. I've found that you can really see the cultural depth of a place in the antique stores, from who lived there to what the overall interest of a region is. In Providence, all of the old whaling and sailing memorabilia is really beautiful and so representative to the people of the coast we met. I really find a spirit in antiques, and my advice to anyone who is looking for old treasures is to go to the city or region you're naturally drawn to, that you love, and search there. You'll find the soul of why you're drawn to that culture or people to live in the objects waiting for you to discover. This is very true for my Possession Obsession; my vintage Pentax 67, which I purchased in New York, has a soul I'm connected to far greater than just an object.

**What was the most memorable gift you've ever given or received?**

The most memorable gift I've ever been given was a wedding gift from my parents, a set of dining dishes in handmade pottery by an artist in the East Village. Each organic piece is a perfect balance of uniqueness and simplicity, and the sentiment of remembering receiving them at our wedding reminds us daily of that moment in our lives where everything was so magical.

The most memorable gift I've ever given was an anniversary gift to my husband. I commissioned a friend who happens to be an incredible artist to paint a still life from our wedding table of the beautiful arrangements and china. The painting now hangs in our dining room, bright and cheerful and full of sweet memories.

I find the best gifts of all are the ones handmade with love and loaded with thoughtfulness.

**What was your last purchase that you believe will mean something to you ten years from now?**

We recently purchased a bronze sculpture at the Chelsea Flea Market while my mother was in town visiting us. The piece, created in 1963, was love at first sight, and now, in our home, it evokes the emotion of joy each time we gaze upon it. What makes it everlasting is the memory tied to my mom on that great Sunday, together in New York, where we discovered this special piece that ultimately found its way in a cab traveling to, at the time, my husband's and my new home.

# LAURA
# Benanti

**How did you come to own your possession?**

After my divorce, my mom, dad, and sister gave me one ring from each of them to symbolize the unity of our family.

**How do you live with your heirloom?**

I wear it every day.

**Who in your life has most influenced your personal style and taste?**

My girlfriends: Celia, Kelly, and Sarah.

**Fill in the blank: Whenever I look at _____ I can't help but smile.**

A baby.

**What's the best part of your day?**

My meditation.

**Describe your ideal day.**

Wake up in the country next to my fiancé, Patrick, make a delicious cup of tea, and sit outside in a rocking chair while I sip it. Go for a walk, come back and make brunch. Go to a lake or stream, swim, read, and take a nap. Come back and make a fresh local dinner, share it with my friends and family and then play games until my stomach hurts from laughing and I collapse into my comfortable bed happily exhausted.

**What is your favorite place to shop for antique/ vintage pieces? It can be anywhere in the world.**

I am a horrible shopper. My mom *loves* to do that. The thought of antiquing makes me break out in hives.

**What was the most memorable gift you've ever given or received?**

I'm not sure of the most memorable gift I have given. I would hate to name something and have the recipient read this and think "yeah . . . not so much." I have been lucky enough to receive many thoughtful gifts throughout the course of my life—the rings from my family being among them. My grandmother wrote out the story of her life and gave it to me. I find that incredibly memorable.

**What was your last purchase that you believe will mean something to you ten years from now?**

Our apartment.

*The thought of antiquing makes me break out in hives.*

# NATE Berkus

**How did you come to own your possession?**

A bowl I purchased years ago from Pavilion Antiques, one of my favorite stores in Chicago. The Native American carved stone fetish I keep in it was a gift.

**How do you live with your heirloom?**

It sits on a beautiful cantilevered brass box, made by Jason Pickens of Brooklyn, in the entry of our apartment in New York.

**Who in your life has most influenced your personal style and taste?**

My late partner, Fernando Bengoechea. And my husband, Jeremiah Brent.

**Fill in the blank: Whenever I look at _____ I can't help but smile.**

Poppy Brent-Berkus

**What's the best part of your day?**

When my daughter wakes up!

**Describe your ideal day.**

Being at home with my husband and daughter. Or scouring markets or antique malls looking for unique, one-of-a-kind objects.

**What is your favorite place to shop for antique/vintage pieces? It can be anywhere in the world.**

I shop everywhere from rural Minnesota to the Parisian auction houses.

**What was the most memorable gift you've ever given or received?**

A framed manifesto about raising children that my husband, Jeremiah, gave me when we got married.

**What was your last purchase that you believe will mean something to you ten years from now?**

This is my rule of thumb for buying everything except clothing: I don't allow anything in my home that I don't absolutely love.

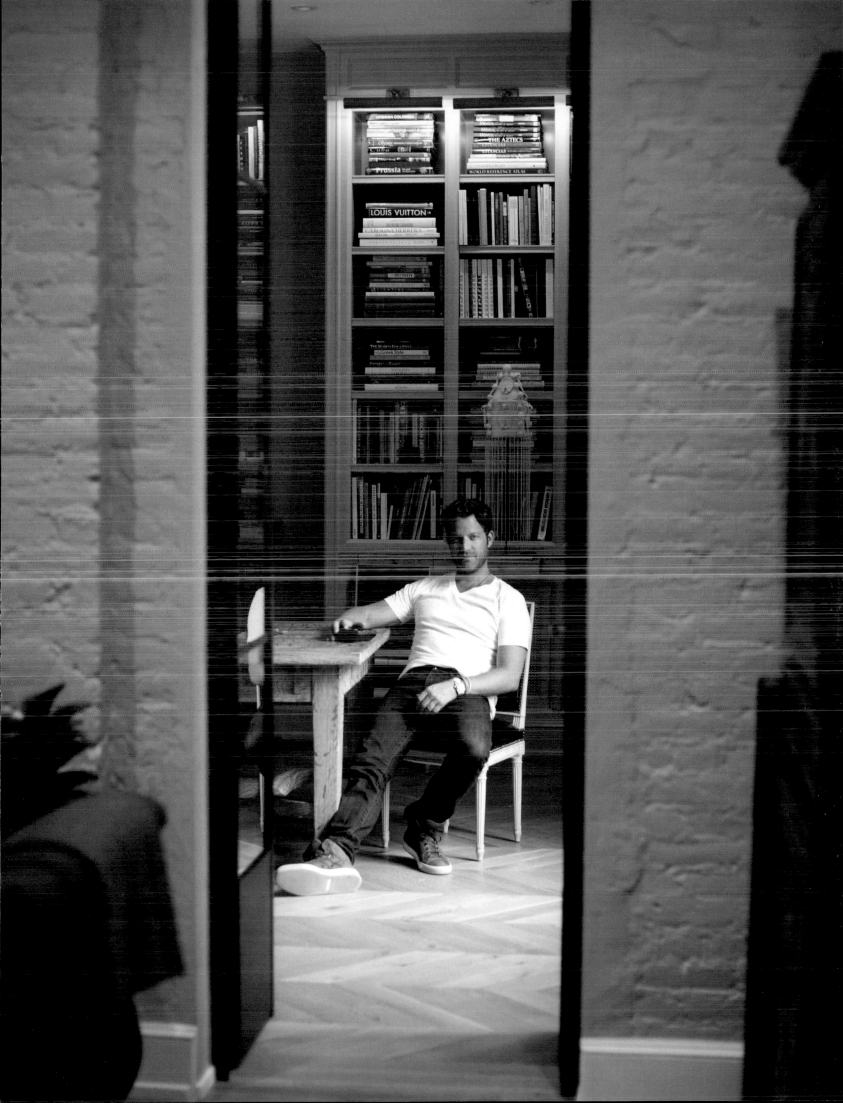

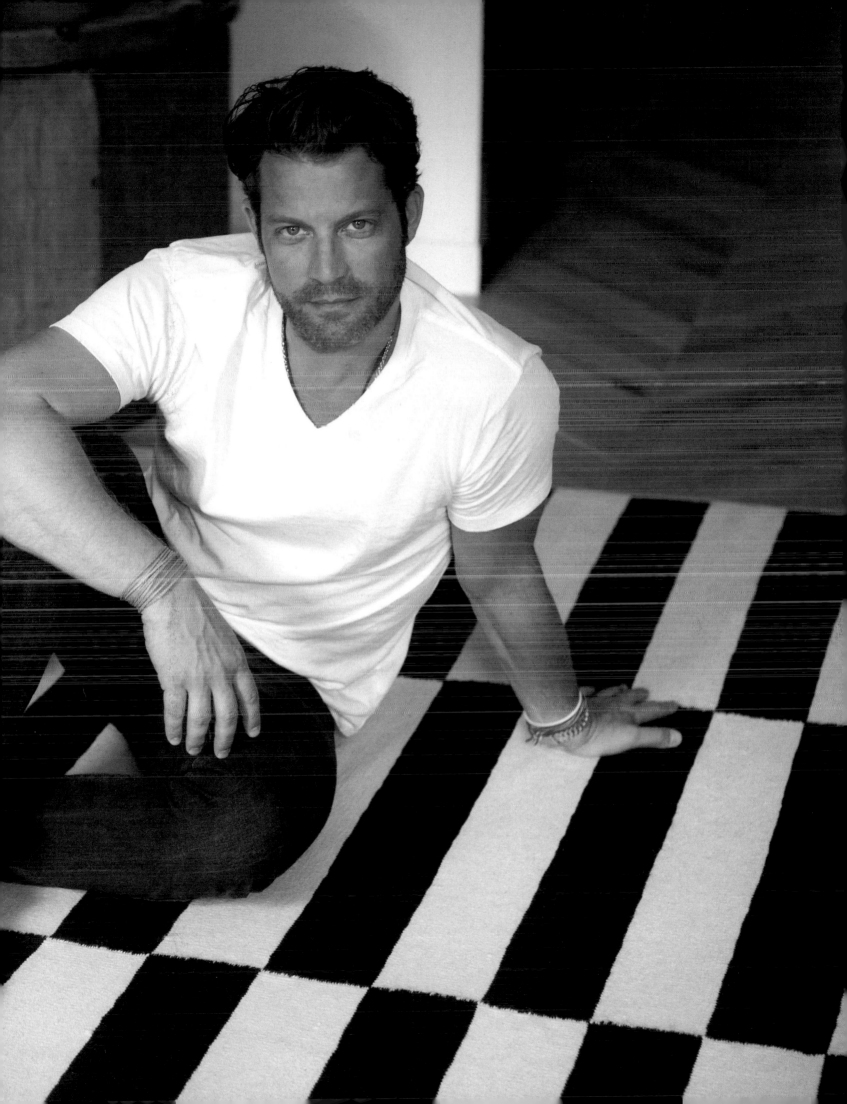

# KATE
# Betts

**How did you come to own your possession?**

My father gave me this necklace when I was eighteen. I love the totemic nature of jewelry, particularly the jewelry of designers like Elsa Peretti.

**How do you live with your heirloom?**

I've worn it every day for the past twenty-nine years. Sometimes I think maybe I should change it up, maybe it's too young for me now. But then I miss it when I take it off. It's become a part of me!

**Who in your life has most influenced your personal style and taste?**

My mother. She had great taste and a curiosity about people and places that shaped her taste. I think endless curiosity is a great gift—not to mention a sign of intelligence.

**Fill in the blank: Whenever I look at _____ I can't help but smile.**

Whenever I look at my kids I can't help but smile. I'm incredibly proud of them.

**What's the best part of your day?**

I love the early morning in my house, before anyone else is up. That's about the only time of day I can really think straight! Before the chaos begins.

**What's the most memorable gift you've ever given or received?**

Two gifts: one from my mother, one from my father. Neither gift was material, both were pieces of advice given to me at critical moments in my life. Both pieces of advice changed my path in life in very distinct ways. But in both cases, my parents were quite subtle about the way they guided me. They weren't forcing me to do something, just advising me. That is the greatest gift you can give anyone, especially a child.

**What was your last purchase that you believe will mean something to you ten years from now?**

A toaster. I am not kidding. We just got a new one, and it took five days to get here. You would be surprised how reliant you can become on a toaster! We had our last one for twelve years. Hopefully this one will last that long, too.

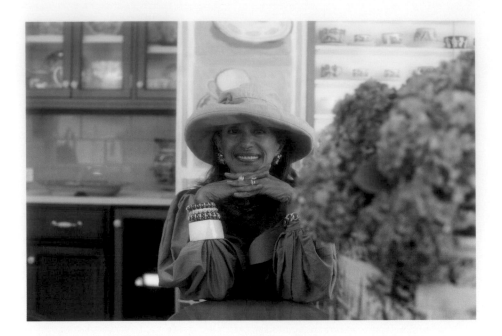

# ROSE MARIE Bravo

### How did you come to own your possession?

My heirloom is my blue and white pottery collection consisting of everything from teacups to pots, bowls to pitchers, and plates to serving pieces.

I came to own this collection from a few treasured pieces left to me by my mother-in-law, Mary Jackey. One in particular—a pitcher with a pastoral scene—gave me much pleasure, and the desire to begin collecting. Our almost nine years living in England and visiting Scotland, home of my husband's ancestors, greatly facilitated this search.

From visiting Bermondsey Market in London, to trips to the Cotswolds and weekends in Dornoch, Scotland, I have vivid memories of each of "the finds." I also treasure some of the fine pieces that were given to me by my husband, Bill, and the few friends and family who knew of my passion.

### How do you live with your heirloom?

My collection primarily resides in a newly renovated kitchen that is—you guessed it—blue and white. I take tea often using one of the several pots and heirloom teacups, especially with my four granddaughters: Grace, Jade, Lily, and Faith. (This ceremony is another relic from merry old England.)

### Who in your life has most influenced your personal style and taste?

I have had many people who influenced my particular style and taste, but in the career development years, I have never forgotten the taste and style exhibited by Mrs. Estée Lauder. I was always amazed at how every detail of her personal presentation was exquisite and by the graciousness she exhibited to one and all. The discipline and attention to detail that went into every public occasion was extraordinary. And I loved her Blue and White Collection exhibited in the reception hall of her office!

**Fill in the blank: Whenever I look at _____ I can't help but smile.**

Whenever I look at the teacups I smile. I think of the memories of "my girls" learning how to "pour tea."

**What's the best part of your day?**

The best part of the day for me is watching the sun go down. It makes me think of my dad and how much he loved watching sunsets in his beloved Naples, Florida.

**What was the most memorable gift you've ever given or received?**

The most memorable gift I ever received was a diamond engagement ring that Bill gave me long after we were married, after years of me telling him I didn't want one. Especially since he discovered the stone in an antique man's gold ring and had it specially mounted. Now it is never off my finger.

**What was your last purchase that you believe will mean something to you ten years from now?**

The most recent purchase that will hopefully mean something in ten years is the new rose bushes recently added to the garden. As they grow, they will serve as a reminder to "take time to smell the roses."

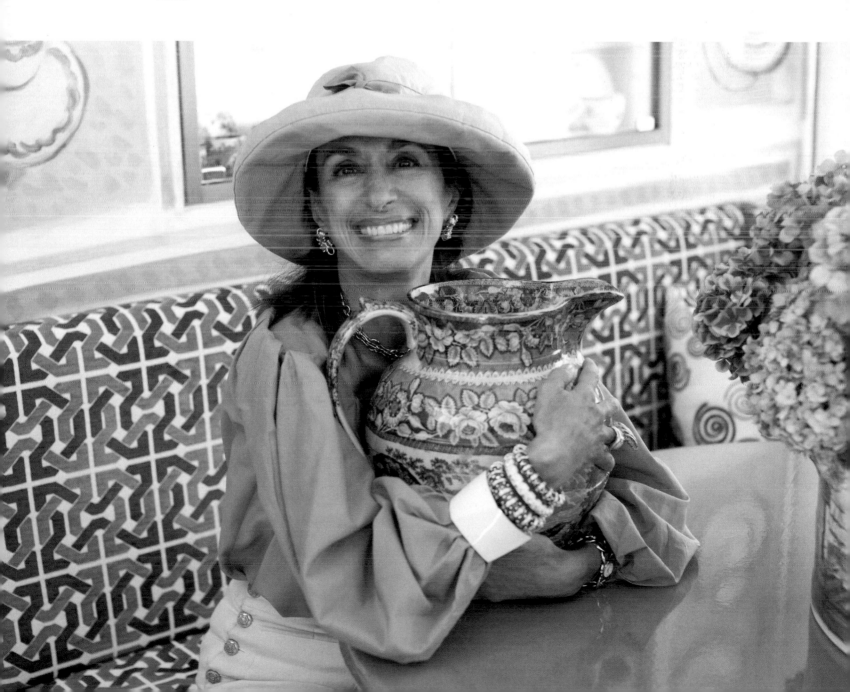

# KEEP CALM

# WEAR LIPSTICK

# BOBBI
# Brown

### How did you come to own your possession?

My husband, Steven, surprised me with this necklace.

### How do you live with your heirloom?

I wear it every day and rarely take it off. I feel like my boys are with me and keep them close to my heart.

### Who in your life has most influenced your personal style and taste?

All of the stylists and photographers I have worked with over the years influenced my style. I also learned over time that keeping it simple felt most like me.

### Fill in the blank: Whenever I look at _____ I can't help but smile.

My kids.

### What's the best part of your day?

Depends on the day. I love meeting new women and hearing their stories. I love creating and naming products. And most of all, I love when the work day is over and I get to go home and spend time with my family.

### Describe your ideal day.

Sleeping a bit later, exercising, and then relaxing on the beach while hanging out with my family. Perhaps with tequila in hand.

**What is your favorite place to shop for antique/vintage pieces? It can be anywhere in the world.**

Doyle & Doyle in New York City and Parcel in Montclair, New Jersey, which is where my necklace is from.

**What was the most memorable gift you've ever given or received?**

Given: I once published an old manuscript of children's stories into a book for my dad. I surprised him with it for his birthday and displayed it in the window of a bookstore in Telluride. When he saw it, it inspired and encouraged him to continue writing. He now has eight published children's books!

Received: My silhouette charm necklace and my first pair of Ted Muehlings from my husband.

**What was your last purchase that you believe will mean something to you ten years from now?**

I bought a YSL navy classic blazer with small lapels. I believe it will be in style forever.

*I love when the work day is over and I get to go home and spend time with my family.*

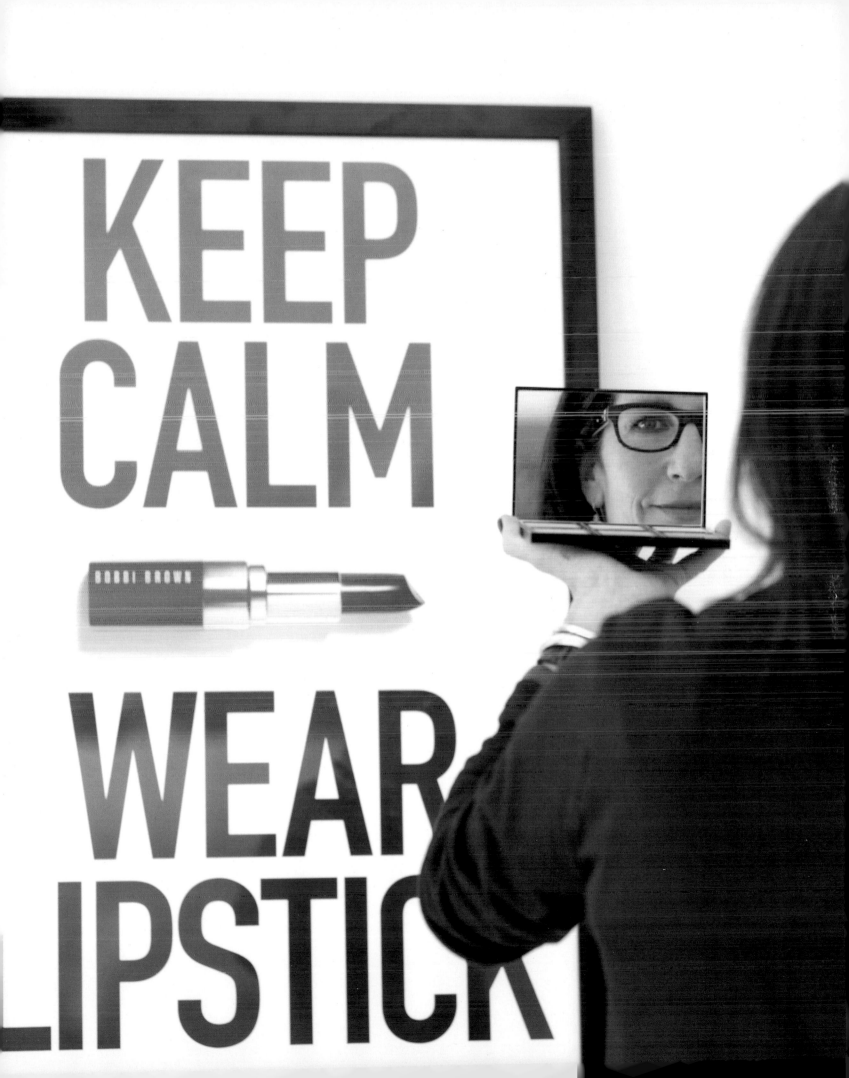

# LAURA
# Brown

**How did you come to own your possession?**

It was a picture my dad had mixed in with a lot of old pho-tographs in a box. When he was dying of cancer in 2010, I was going through his stuff. This picture just says every-thing about him—he would talk to anyone. It makes total sense that this dairy farmer, in his homemade Brown's Cows T-shirt, would befriend two random, mustachioed acrobats who are shot out of cannons. He just looks delighted.

**How do you live with your heirloom?**

It sits on the mantelpiece in my living room. When I moved apartments two months ago, it was the first thing I brought to the place. It's like he's right there.

**Who in your life has most influenced your personal style and taste?**

Oh gee, probably the profession I've chosen, rather than anyone specific. I am exposed to so many things—you try out different things, but you end up refining what makes you . . . you. I guess they call it editing!

**Fill in the blank: Whenever I look at _____ I can't help but smile.**

Quokka. Australian marsupial. Its face is permanently smil-ing, so the least one can do is reciprocate.

**What's the best part of your day?**

When someone incredible I've asked to collaborate with me for the magazine says yes. A spaghetti dinner. Oh, and that wondrous three-point-five seconds between turning off the light and closing your eyes.

**Describe your ideal day.**

In New York, I assume? Waking up early but actually feeling refreshed. Going to SoulCycle and getting all the choreog-raphy right. Bouncing to my local diner to get breakfast. Heading home, having time to read the piles of *New Yorker*s by my bed. Going to a *loooong* lunch with friends—drinking more wine than should be appropriate at that time of day. Nap. Night spent watching a backlog of Stephen Colbert and Bill Maher that I have missed on my travels. Bed.

**What is your favorite place to shop for antique/ vintage pieces? It can be anywhere in the world.**

Okay, two. In Paris, the Portes de Vanves flea market. It's not as pricey as Clignancourt—I've found incredible blue opaline pieces there for like ten euros. And for clothes, I adore Wonderama in Palm Springs. They have more Hawai-ian print shirts and dresses than you can poke a stick it. That store just makes me happy.

**What was the most memorable gift you've ever given or received?**

An iPhone for my mum, who had been off email for a year after she retired. Now she uses it to comment on my tweets and Instagrams. Call it self-flagellation.

**What was your last purchase that you believe will mean something to you ten years from now?**

A picture I bought almost ten years ago! It's a large photo-graph of Faye Dunaway taken by Terry O'Neill, whom she subsequently married, after she won her Oscar for *Network*. I love everything about it—the glamour, the ennui, the shoes.

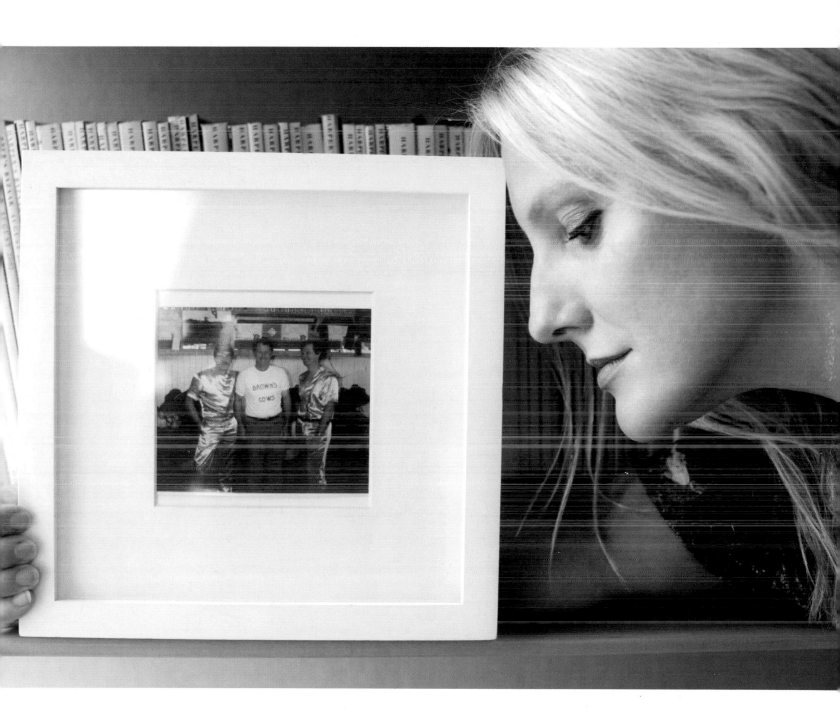

It makes total sense that this dairy farmer, in his homemade Brown's Cows T-shirt, would befriend two random, mustachioed acrobats who are shot out of cannons.

# JANIE
# Bryant

**How do you live with your heirloom?**

I wear my great-aunt's diamond and platinum ring every day on my right ring finger.

**Who in your life has most influenced your personal style and taste?**

My maternal grandmother, Etoile Lillard Chesnutt, or Gran Gran.

**Fill in the blank: Whenever I look at _____ I can't help but smile.**

Standard poodle, Lucie.

**What's the best part of your day?**

Having coffee in the morning at my home in Los Angeles and enjoying nature in my own backyard.

**What's the most memorable gift you've ever given or received?**

My mother sent me beautiful diamond earrings in the mail. I'll never forget it and always think of the gleeful, shocking surprise when I wear them.

**What was your last purchase that you believe will mean something to you ten years from now?**

My Judith Leiber monogram bag.

# FARRAH
# Burns

**How did you come to own your possession?**

Writing music is my possession. I dance in its presence and it captivates my imagination. Together we become one and wish to unite humanity through world music.

**How do you live with your heirloom?**

The same way I live with myself. Music lives within me. It is my muse.

**Who in your life has most influenced your personal style and taste?**

My mother, Sade. There are others. They use their divine feminine and masculine energy to restore balance. Underneath that is an unshakable fearlessness that one must acquire to fulfill their life purpose. They're all different but one of the same.

**Fill in the blank: Whenever I look at _____ I can't help but smile.**

Babies.

**What's the best part of your day?**

The morning. Reminiscing about yesterday's ventures. Laying there in the arms of love. Feeling fortified, renewed, and honored knowing the sun and I both rose together.

**Describe your ideal day.**

My ideal day would be waking up in Venice. Walking along the cobblestone streets and visiting local markets. Bathing in the Mediterranean sun while sampling some of the country's best meats, cheeses, and wines. Reading poetry to the love of my life in a gondola, kissing under bridges. Sharing my inner peace with this beautiful city submerged in water. Curating visual and musical masterpieces at all the main Venetian opera houses. Living in my dreams.

**What is your favorite place to shop for antique/vintage pieces? It can be anywhere in the world.**

Carré Rive Gauche, Village Saint-Paul. However, some of the best antique shops are hidden in street markets all over the world.

**What was the most memorable gift you've ever given or received?**

The best gift I've ever given was heart.

**What was your last purchase that you believe will mean something to you ten years from now?**

I purchased freedom from my thoughts with my blood, sweat, and tears.

*I dance in its presence and it captivates my imagination.*

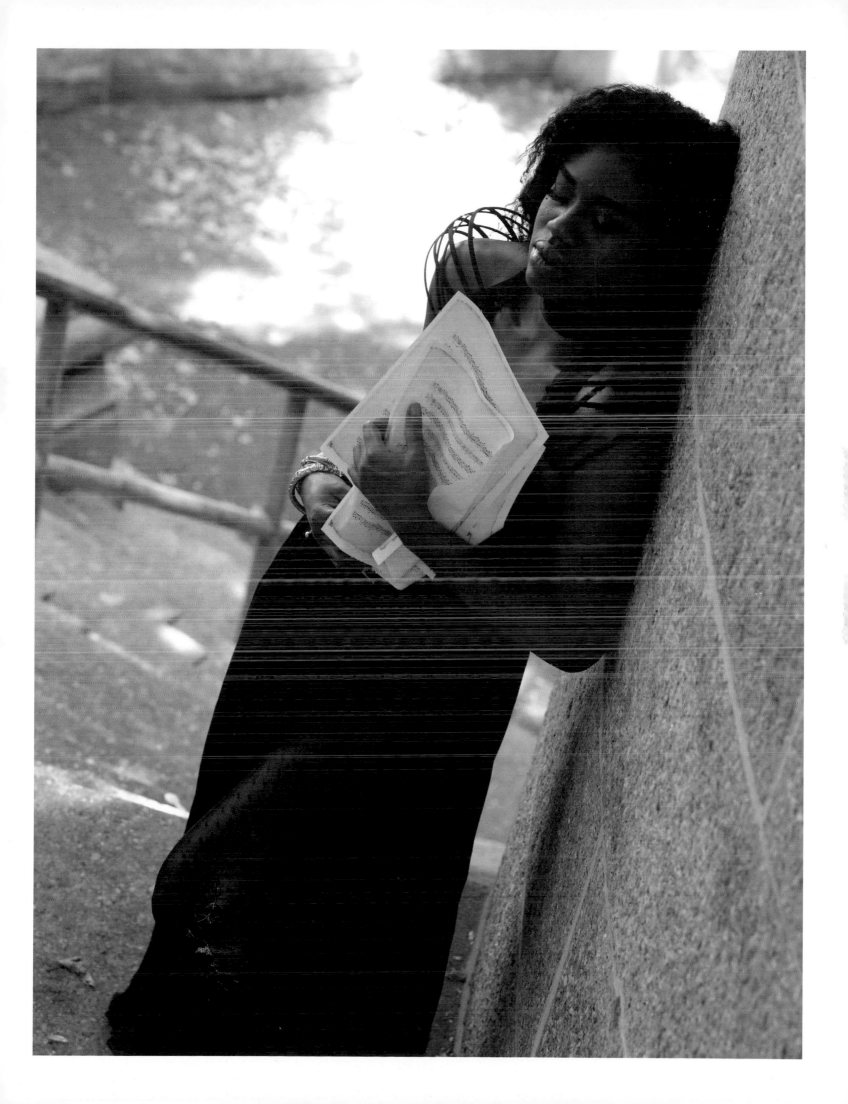

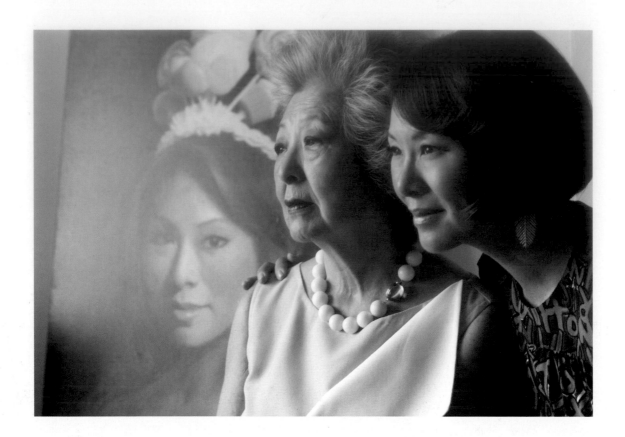

# ALINA *Cho*

**How did you come to own your possession?**

It was a gift from my parents.

**How do you live with your heirloom?**

It hangs in my bedroom so only those closest to me can see it.

**Who in your life has most influenced your personal style and taste?**

My mother.

**Fill in the blank: Whenever I look at _____ I can't help but smile.**

Handsome man.

**What's the best part of your day?**

I'm a night owl, so after midnight.

**Describe your ideal day.**

Any day spent with someone I love.

**What is your favorite place to shop for antique/vintage pieces? Can be anywhere in the world.**

What Comes Around Goes Around in East Hampton, New York, and Marché Serpette just outside Paris.

**What was your last purchase that you believe will mean something to you ten years from now?**

My Marilyn Minter photograph, called *Blue Shower*, which my father loved. I bought it just after he died, and I think of him every time I look at it.

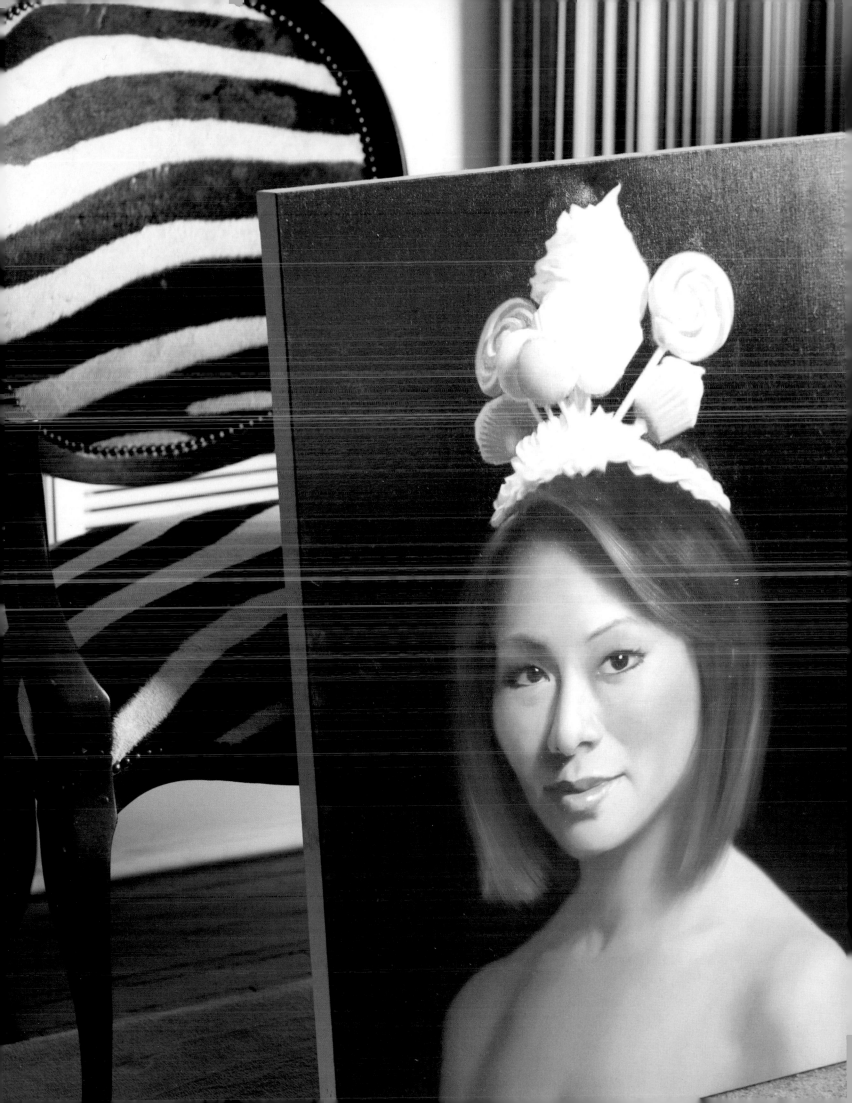

# MICHAEL Clinton

**How did you come to own your possession?**
A gift for my fiftieth birthday.

**How do you live with your heirloom?**
Sits proudly in my house where I can always look at it.

**Who in your life has most influenced your personal style and taste?**
My fantasy is to be James Bond.

**Fill in the blank: Whenever I look at _____ I can't help but smile.**
An airplane in the sky.

**What's the best part of your day?**
A run in Central Park.

**Describe your ideal day.**
Leaving for an exotic destination.

**What is your favorite place to shop for antique/vintage pieces? It can be anywhere in the world.**
The souks of Morocco and Turkey.

**What was the most memorable gift you've ever given or received?**
Giving my parents their first trip to Europe.

**What was your last purchase that you believe will mean something to you ten years from now?**
A college education for my nephews.

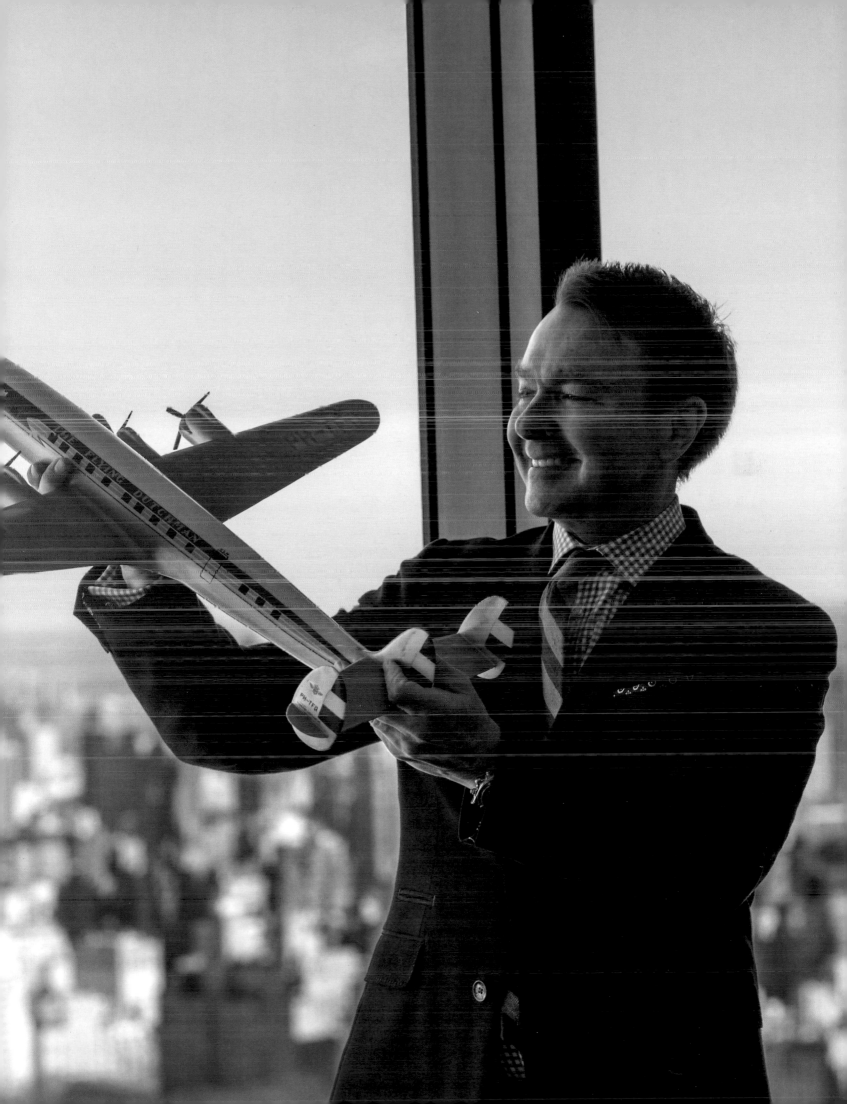

# AMY FINE *Collins*

**How did you come to own your possession?**

M. Azzedine Alaïa chose the dress for me in Paris a few years ago.

**How do you live with your heirloom?**

The dress and cardigan hang in my closet beside a small group of other Alaïa pieces.

**Who in your life has most influenced your personal style and taste?**

In age order, my grandmother, Geoffrey Beene, my mother, and my daughter have most influenced how I look and dress. I would then add to that list Gene Meyer, for his color sense, Yves Durif, for the way he has cut my hair for twenty-five years, and Helena Rubinstein.

**Fill in the blank: Whenever I look at _____ I can't help but smile.**

Baby picture of my daughter.

**What's the best part of your day?**

The best part of my day is coming home.

**Describe your ideal day.**

My ideal day would involve waking up after a very good night's sleep, finishing a long and complicated assignment, and seeing or hearing from the people I love most.

**What is your favorite place to shop for antique/vintage pieces? It can be anywhere in the world.**

I used to buy wonderful things at the Paris flea market and at thrift shops in Manhattan. I've found many beautiful objects at auction houses. At this point, my favorite vintage clothes can be found in my own closet. My sister recently opened a small antiques business in Boston, so that, of course, is now an exciting source for small treasures.

**What was the most memorable gift you've ever given or received?**

For decades, I have loved my engagement ring, and it's always a pleasure to find just the right book for my daughter.

**What was your last purchase that you believe will mean something to you ten years from now?**

I recently acquired a collaged chessboard by Dustin Yellin. It will be in my life for far more than ten years.

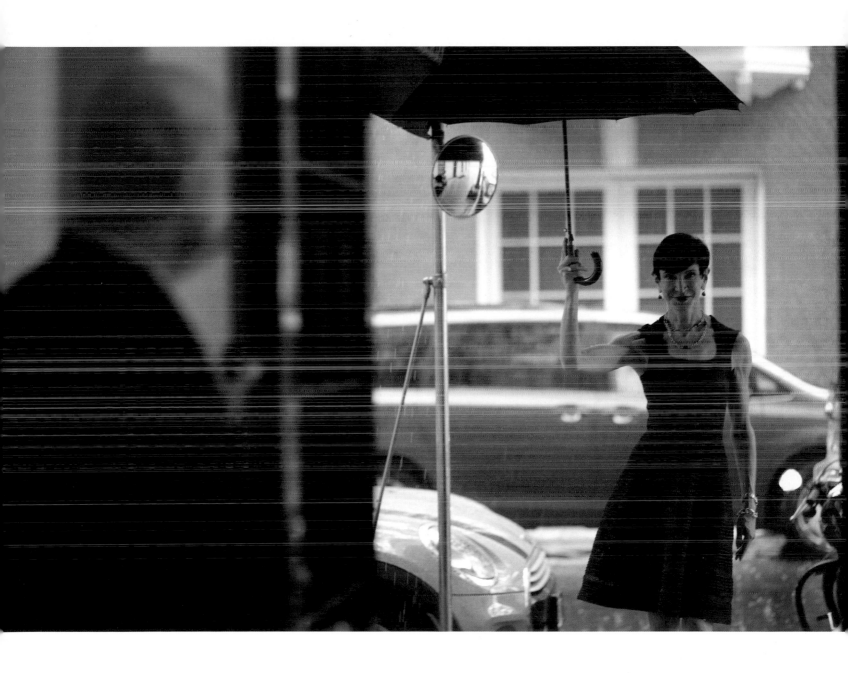

# JOHN
# Dempsey

**How did you come to own your possession?**

This is a vintage mirror that belonged to my great-grandmother Misha in Russia. It has been handed down from generation to generation.

**How do you live with your heirloom?**

In full reflection in my office.

**Who in your life has most influenced your personal style and taste?**

Renee Dempsey, my mother.

**Fill in the blank: Whenever I look at _____ I can't help but smile.**

Monkey.

**What's the best part of your day?**

Going to sleep with my cats: Olivia, Dora, and Mr. Pink.

**Describe your ideal day.**

Food, family, and cheeseburgers.

**What is your favorite place to shop for antique/vintage pieces? Can be anywhere in the world.**

1stdibs and Wright.

**What was the most memorable gift you've ever given or received?**

The gift of my beautiful daughter, Marie Helene.

**What was your last purchase that you believe will mean something to you ten years from now?**

A Chinese red fiberglass dinosaur sculpture by Sui Jianguo.

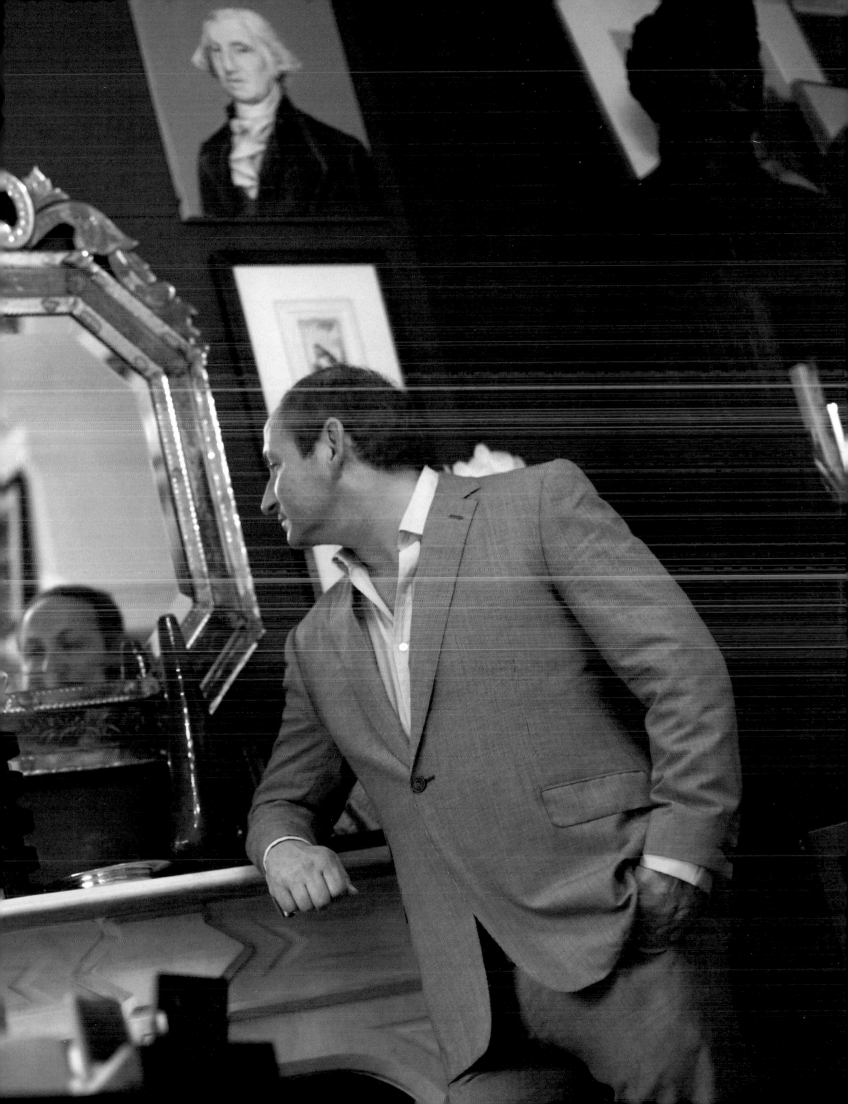

# SIMON
# Doonan

**How did you come to own your possession?**

I started designing the windows at Barneys in the mid-eighties. Gene Pressman, the owner at the time, was my boss. He told me that he wanted me to create crazy, talked-about windows. I realized that the way to do this was via celebrity caricatures. A great artist named Martha King created the life-sized effigies for these windows. Throughout the years, we did Madonna windows, Warhol windows, Cher windows. You name it. We even did Margaret Thatcher windows. I hung onto the Prince head. It reminds me of my crazy youth. And who doesn't love Prince? The most creative guy on the planet.

**How do you live with your heirloom?**

My Prince head moves around quite a bit. He is currently in the bookshelf. Before that, he lay on our Ping-Pong table.

**Who in your life has most influenced your personal style and taste?**

I love glamour and theatricality. Performers like Elvis, Bowie, Marc Bolan, Mick Jagger, and Dolly Parton influenced my style. Rihanna and Miley are pretty groovy, too.

**Fill in the blank: Whenever I look at _____ I can't help but smile.**

Dog pooping in public.

**What's the best part of your day?**

When my husband (Jonathan Adler) and I get home from work, we update each other with all the latest mishegoss from our respective worlds and have a good chuckle.

**Describe your ideal day.**

I love to spend time In Shelter Island with JA. We get up early and go paddle-boarding.

We have a bunch of pals over for lunch and tease each other for hours, then jump in the pool. If there is a British soccer game on television, I always tune in. Chelsea is my team. Then a nap. Jonny cooks dinner. We watch *Lockup* on MSNBC and then hit the hay.

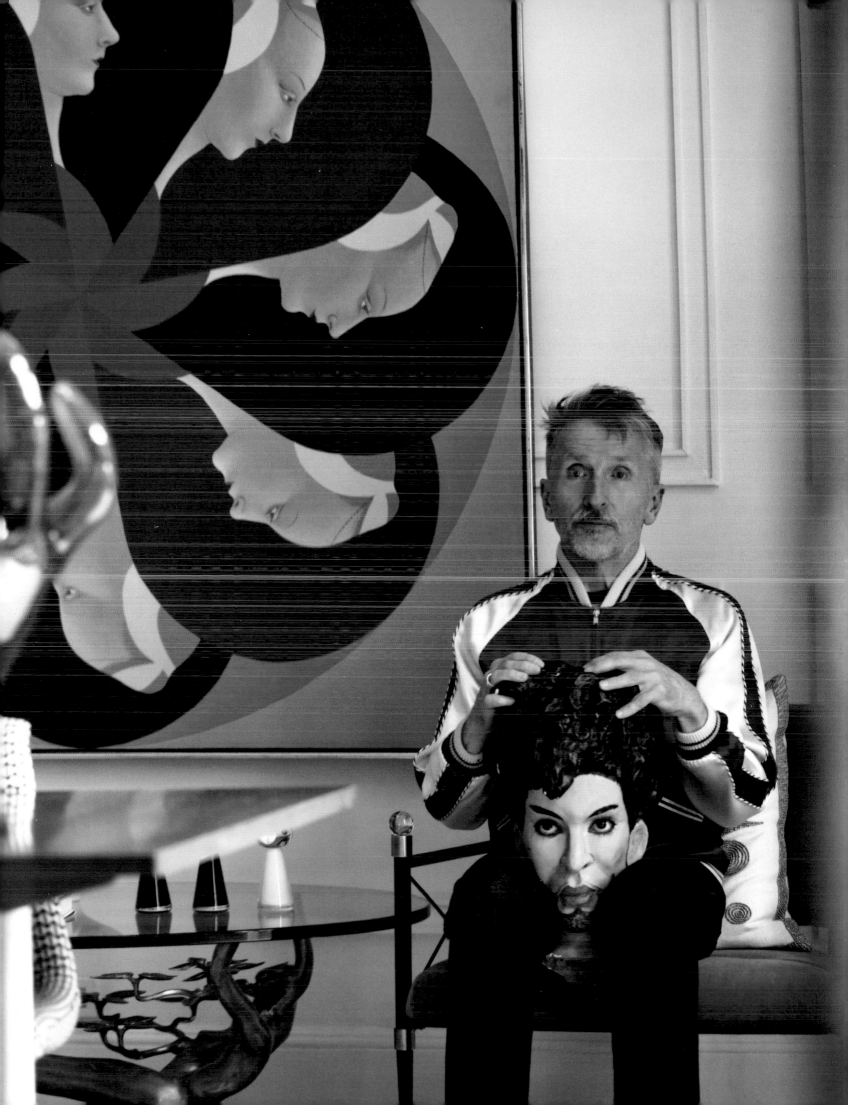

**What is your favorite place to shop for antique/vintage pieces? Can be anywhere in the world**

There is a great store in Greenport, Long Island, called Biel and Belle that always has surprising and nifty items.

**What was the most memorable gift you've ever given or received?**

When Jonny and I first met—over twenty years ago!—he made me a special custom-pot with a heart on one side and the word *truffles* on the other. For some reason, his nickname for me back then was Truffles.

**What was your last purchase that you believe will mean something to you ten years from now?**

I just bought a black satin Saint Laurent blouson with gold piping. It was expensive, so I am hoping it means something in ten years' time. I will be seventy-three.

It reminds me of my crazy youth.

And who doesn't love Prince?

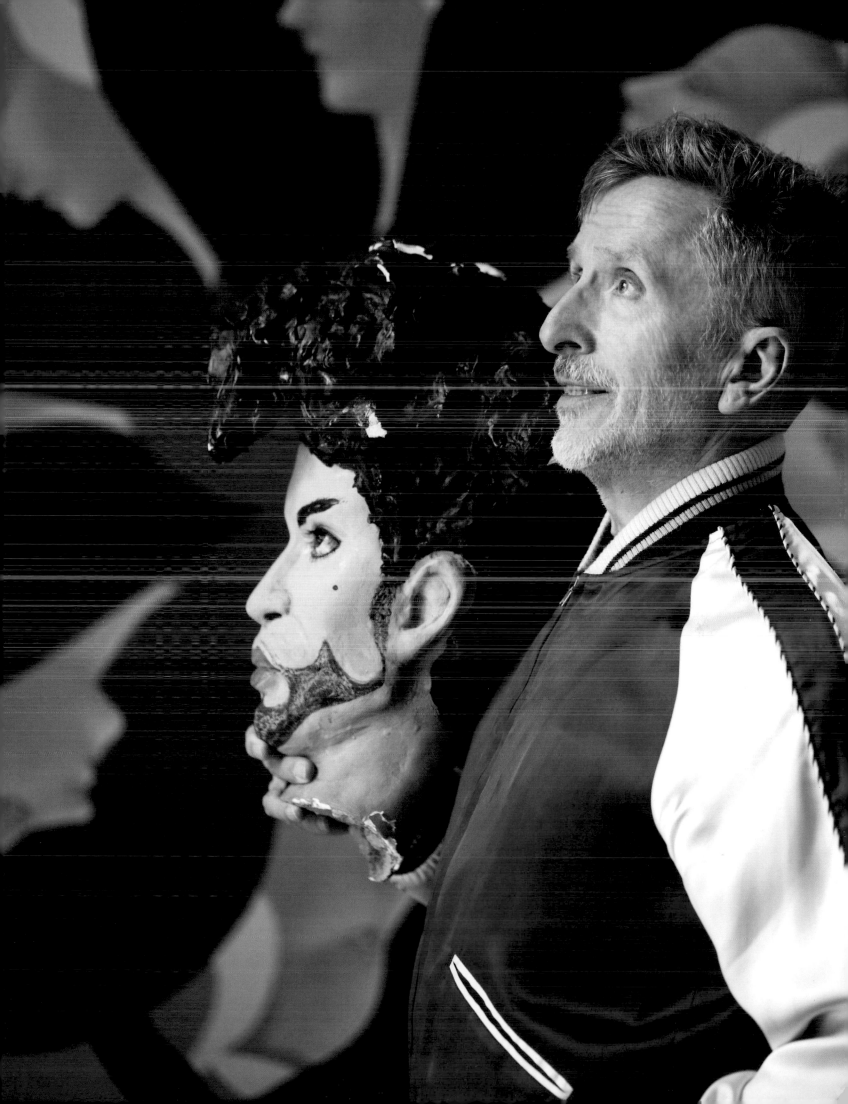

# Coco & Breezy
## DOTSON

**How did you come to own your possession?**

**Coco:** I became obsessed with collecting sunglasses when I was in middle school. Kids at school bullied me growing up because I dressed differently and wasn't afraid to be an artist. They used to make mean comments, point and stare. I used sunglasses as a shield of protection. We then started designing our own sunglasses and now own an eyewear company. Now we get to create and produce and share our obsession with the world.

**How do you live with your heirloom?**

**Coco:** I wear my sunglasses in the daytime and night! I am also the one designing and creating my possession.

**Who in your life has most influenced your personal style and taste?**

**Breezy:** My parents have most influenced my style and taste. As a child, they never held me back from being myself. They always supported and motivated me to create my own style, be unique, and always stay true to myself.

**Fill in the blank: Whenever I look at _____ I can't help but smile.**

**Coco:** A set of twins.

**What's the best part of your day?**

**Breezy:** Waking up every morning is the best part of my day. Not only am I thankful to wake up, I'm excited for life. . . . I get to create and continue to build my dream.

**Describe your ideal day.**

**Breezy:** My ideal day is running my business and being very passionate and excited! I absolutely love what I get to do every day! It can be anything from business meetings to working on the creative side.

**What is your favorite place to shop for antique/vintage pieces? Can be anywhere in the world.**

**Coco:** China. When I travel there we always find the coolest items.

**What was the most memorable gift you've ever given or received?**

**Coco:** Getting invited by Prince to hang out with him and dance on stage in New Orleans.

**What was your last purchase that you believe will mean something to you ten years from now?**

**Breezy:** Eyewear history books! Very classic!

# JAMIE Drake

**Tell us how you came to own this precious object.**

I inherited this chair when my father's mother died twenty years ago. I had always admired its elegant lines and delicate proportion. It will always remind me of her and my grandfather's lovely home. Though I've had it reupholstered three times and the frame refinished in a fumed metallic silver, it's still my Nana's chair!

**How do you live with your heirloom?**

Since the chair arrived in my life, it has moved with me three times. It currently resides in the living room of my temporary apartment. Before that, it was in a bedroom and earlier in a living room. The chair has not enjoyed residence in the kitchen or bath—yet!

**Who in your life has most influenced your personal style and taste?**

Certainly my mother. I grew up in a house that was beautifully decorated. She entertained often, serving what was considered at the time extremely sophisticated cuisine, which she cooked herself. For many years, she had a floral business that was ninety-five percent plastic or dried, which was popular during the sixties and early seventies. I was especially taken with her creations that combined feathers and dried pods. She dressed with flair and had an enormous wardrobe (still does!). She encouraged my artistic style and zest for fine dining and living well.

**Fill in the blank: Whenever I look at _____ I can't help but smile.**

The New York skyline.

**What's the best part of your day?**

I love the cocktail hour with friends. When the first drink arrives, the catching up and stories begin.

**What was the most memorable gift you've ever given or received?**

My first trip to Paris when I was twenty years old was the best gift ever. To arrive in the City of Light and explore and revel in all its beauty was a fantastic expression of affection.

**What was your last purchase that you believe will mean something to you ten years from now?**

My new apartment in far west Chelsea. I have yet to move in, but I know it will be fantastic when I'm finally able to.

*She encouraged my artistic style and zest for fine dining and living well.*

# MICAELA
# Erlanger

**How did you come to own your possession?**

I found it on eBay. I was looking for brass 1940s decorative objects and loved the idea of this unusual piece. It is so beautiful, and no one would know its purpose just by looking at it!

**How do you live with your heirloom?**

It sits on my bedside table, which is mirrored. I love the contrast in materials.

**Who in your life has most influenced your personal style and taste?**

I am so inspired by the women in my life. My family, my friends, my clients—they are all my muses!

**Fill in the blank: Whenever I look at _____ I can't help but smile.**

Flowers.

**What's the best part of your day?**

Mornings. This is the time that I take to myself—I meditate and gather my thoughts and gear up for taking on the day ahead.

**Describe your ideal day.**

Sleep, exercise, eat well, be creative.

**What is your favorite place to shop for antique/vintage pieces? Can be anywhere in the world.**

For furniture and decorative pieces, I go to eBay. I can find so many unique, hard-to-find items online. For clothing, one of my all-time favorite stores is New York Vintage. They have the most extraordinary things!

**What was the most memorable gift you've ever given or received?**

My grandmother's vintage gold watch; it is so beautiful and still works.

**What was your last purchase that you believe will mean something to you ten years from now?**

My Saint Laurent leather jacket. It is only going to get better with age!

# LINDA Fairstein

**How did you come to own your possession?**

I'm close to a hoarder when it comes to family photographs, especially those that take my most beloved relatives back to childhood. I can stare at them for hours, imagining what their lives were like when the pictures were taken. As far as physical objects go, I have a real obsession for writing instruments—especially Montblanc fountain pens—which I have collected on all my favorite travels.

**How do you live with your heirloom?**

I have photographs on tabletops and dressers and desks wherever I happen to be. Some are favorites and ever-present, and occasionally I open a drawer or get a letter from a friend and unearth a new treasure that becomes part of the rotation.

**Who in your life has most influenced your personal style and taste?**

My mother had an enormous influence on my style and taste, from the earliest points in my life until her death at the age of eighty-eight. She was a beautiful woman—quite practical—and always managed to look chic in the most casual manner. Although her style evolved over the decades, the clean lines she favored are evident in very early photographs.

**Fill in the blank: Whenever I look at _____ I can't help but smile.**

A photograph of my parents together.

**What's the best part of your day?**

For me, waking up (to sunshine, preferably) and knowing that no two days are going to be alike is practically magical. I had a very challenging job for thirty years, as a prosecutor, where my time was pretty well prescribed for me—from early morning appointments to hours in court and long nights at my desk. Now, the freedom of my literary life makes planning each day a delight.

**Describe your ideal day.**

My ideal day is waking up beside the man I love. It starts everything with a smile. I enjoy morning coffee and planning the hours that follow. If it's a writing day, then I get to the machine early—procrastinate with some email—and get as many good pages of writing done as I can. I love taking long walks, either to start the creative juices flowing in the morning or to re-energize me after a long day at the computer. The evenings are all for socializing with friends and family.

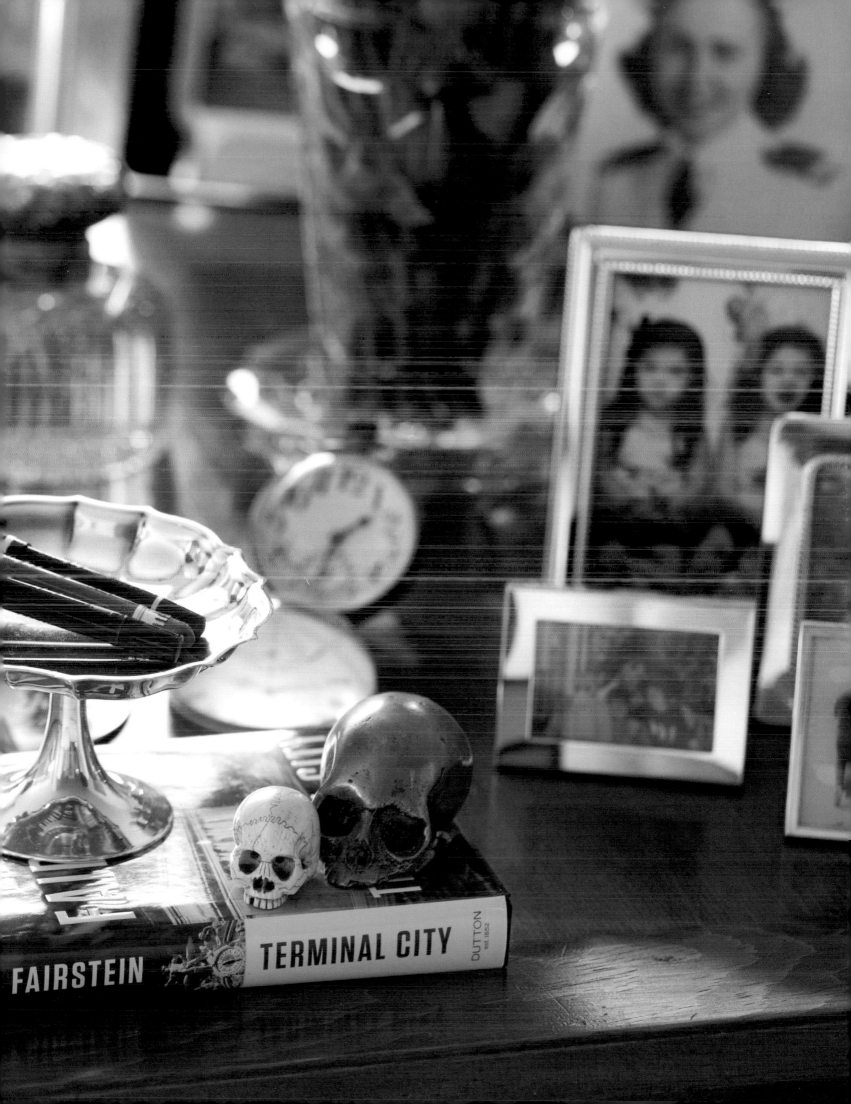

**What is your favorite place to shop for antique/vintage pieces? Can be anywhere in the world.**

My absolute favorite place to shop for old pieces is the Paris flea market at Clignancourt. There are a few shops I make a beeline for—for antique jewelry and writing instruments and crystal inkwells. I have a real obsession for Montblanc fountain pens. Their limited edition pens are stunning. Once a collection is sold out, I stalk the antique dealers and flea markets. I got my Agatha Christie on Portobello Road in London and my Edgar Allan Poe in Paris. In New York, I drop in frequently to Alice Kwartler's shop on Park Avenue for jewelry—old and new—and for unique antique pieces—pens and inkwells—for myself or gifts for friends and family.

**What was the most memorable gift you've ever given or received?**

I love beautiful objects and material things of all kinds—holding them, looking at them, enjoying them in my home. But the most memorable gifts I have given and received are not physical objects.

**What was your last purchase that you believe will mean something to you ten years from now?**

I was given a magnificent bracelet at Christmas (I had scouted for it at Alice Kwartler's before the holiday), and it has particular meaning to me—now and forever—because it was given to me the first Christmas after my remarriage to a man who has been my best friend for forty-six years.

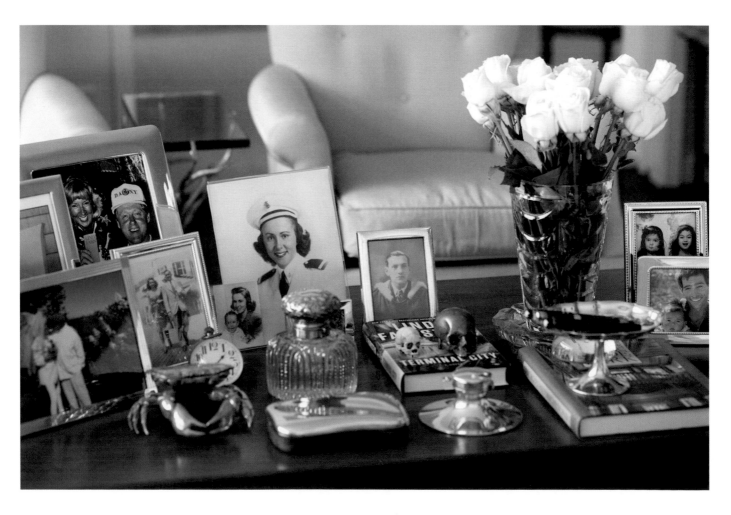

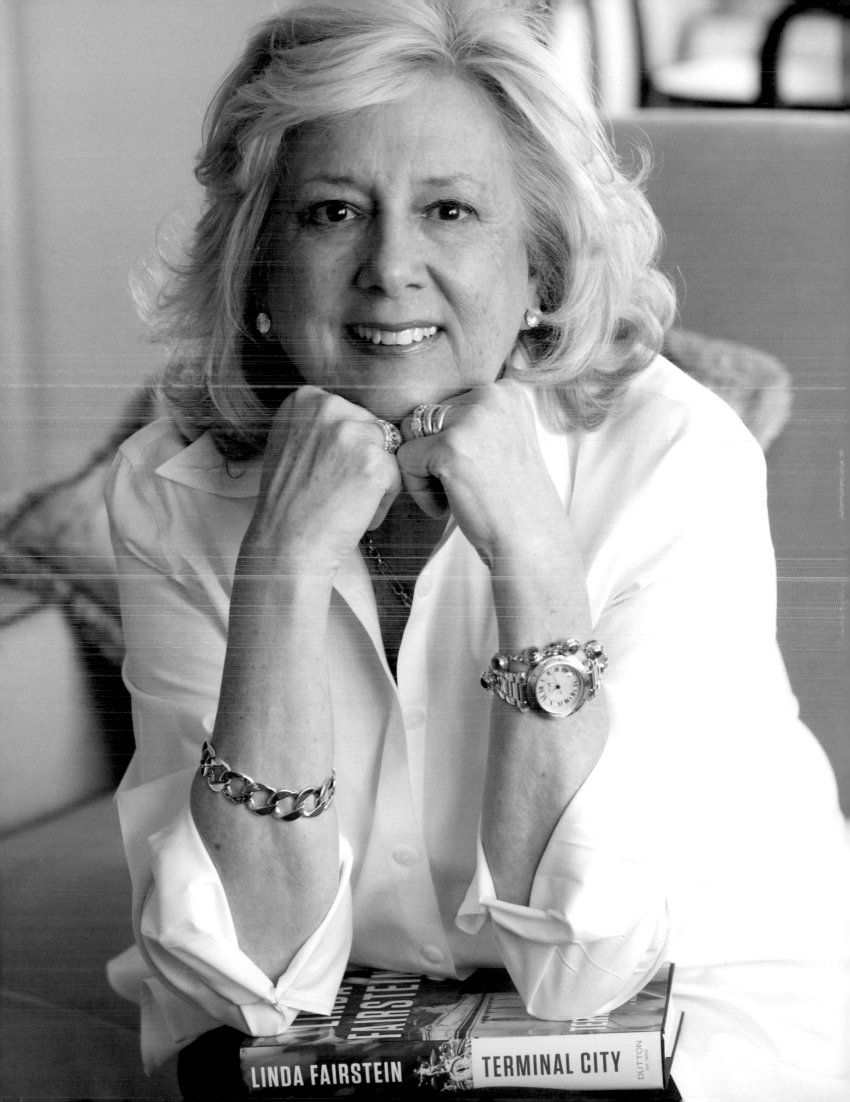

LINDA FAIRSTEIN     TERMINAL CITY    DUTTON est.1852

# PAMELA Fiori

**Tell us how you came to own this precious object.**

My precious heirloom is my grandmother's diamond ring. My grandfather gave it to her in the 1950s as a peacemaking gift; they were often at odds with each other and not on speaking terms for months at a time. The ring was a let's-kiss-and-make-up effort. It worked . . . for a while.

I thought it was beautiful and gazed at it longingly every time I was with her. One day, when I was visiting her (by this time, she was old and ailing), she asked my aunt to take it out of the jewelry box so she could give it to me. She died two weeks later. She knew the end was near and wanted me to have it.

**How do you live with your heirloom?**

I wear it most often whenever I take a flight. It's as if being high up in the air at 30,000 feet somehow brings me closer to her and puts me under her protective and angelic wing. When I forget to take it with me, I am uneasy during the entire flight.

**Who in your life has most influenced your personal style and taste?**

I was, and still am, an avid moviegoer. In the 1950s, during my formative years, I was heavily influenced by stylish Hollywood stars such as Ava Gardner, Audrey Hepburn, Grace Kelly and, later, Sophia Loren.

**Fill in the blank: Whenever I look at _____ I can't help but smile.**

My niece, Caitlin, and nephew, Zachary.

**What's the best part of your day?**

Late afternoon, particularly on a Saturday or Sunday, when I can take a nap listening to music. I cherish that time of day.

**What was the most memorable gift you've ever given or received?**

When my husband, Colt, and I were married for ten years, he created a video of our life together. It took him a hundred hours to do. We watch it every year on our anniversary. We've been married for twenty-seven years.

**What was your last purchase that you believe will mean something to you ten years from now?**

Nothing I have ever bought can compare to what has been given to me by my husband, family, and friends.

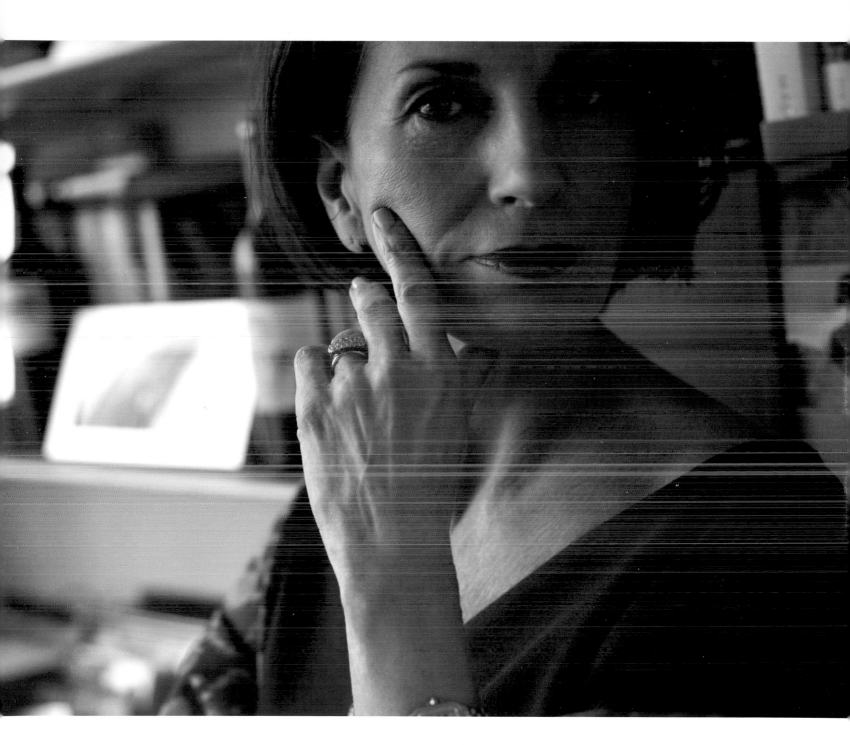

Nothing I have ever bought can compare to what has been given to me by my husband, family, and friends.

# JODIE Fox

**How did you come to own your possession?**

I have a shoe company called Shoes of Prey where women can design their very own shoes. We worked on a capsule collection with Australian fashion designer Carla Zampatti for her SS 2016 collection. The brief was eighties prom, and I absolutely adore the drama of this shoe. This is one of the first we produced, and I am so proud of it.

**How do you live with your heirloom?**

I love wearing these beautiful heels. However, they are also known to adorn shelves at home as a decoration.

**Who in your life has most influenced your personal style and taste?**

The first real fashion influence in my life was my cousin, Vanessa. She was a couple years older than me and was the big sister I never had while growing up. After that, it was Alison Veness, at that time the editor of Australia's *Harper's Bazaar.* It was my first real step into understanding fashion.

**Fill in the blank: Whenever I look at _____ I can't help but smile.**

Snowflake. As an Australian woman, snow is still an incredibly rare, special, romantic thing.

**What's the best part of your day?**

The very best part of my day is when I wake up and I have a few minutes to open my mind wide and think about absolutely anything at all in my little haven of pillows and feather quilt with my little British shorthair cat, Hunter.

**Describe your ideal day.**

Waking up to the summer sun rising rather than the beeping of an alarm clock in darkness. Not having to get out of bed immediately, but having time to roll around and indulge in the warm, soft, lovely feeling of being curled up in bed.

Meditate for twenty minutes before heading into a day that has not one single plan in place. I'd exercise, see friends over coffee, go to the farmers' market to breathe in the smell of fresh

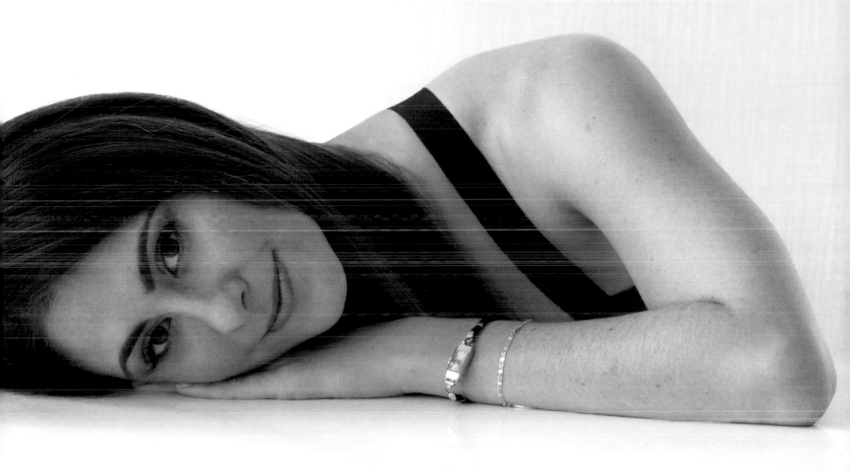

produce and cook something wonderful for dinner. I'd cook with a glass of wine in hand, beautiful company at my side, and cheesy tunes on in the background.

Not a single email would come in all day.

**What is your favorite place to shop for antique/vintage pieces? Can be anywhere in the world.**

While there are some truly beautiful famous markets like Portobello Road in London, I love going to really small towns like my hometown, Lismore (Australia, not Ireland), where there are great little pieces that have just been held on to for such a long time. I also love the Mitchell Road auction house in Sydney. It's such an eclectic mix of wonderful finds.

**What was the most memorable gift you've ever given or received?**

There are two: one was a surprise holiday away to an island for a week—a beautiful, delicious, and incredibly thoughtful experience in relaxation and nature.

The other is a pair of earrings from my nonna. She used to wear them all the time, and I feel like I have a little bit of her love with me every time they are in my ears. I wear them whenever I am doing something really important. She is my strength. It dawns on me as I write this—I should tell her that I do this so she knows just how important she is to me.

**What was your last purchase that you believe will mean something to you ten years from now?**

I bought a Saint Laurent Betty handbag. It's an absolute workhorse that I use almost daily. I bought it in celebration of a moment of freedom and independence. That memory and this bag will always be in style.

# KELLY
# Framel

**How did you come to own your possession?**

It was a gift from Monica herself!

**How do you live with your heirloom?**

I literally never take it off. Inside it, I keep a lock of my lover's hair, and thus it has become a powerful romantic talisman to me.

**Who in your life has most influenced your personal style and taste?**

Travel has been the biggest influence on my life. It's been said that the mind, once expanded, can never return to its original dimensions. The more I see of the world, the more my taste evolves and matures.

**Fill in the blank: Whenever I look at _____ I can't help but smile.**

The future.

**What's the best part of your day?**

Work! I love that my job as a creative director allows me new opportunities to flex my imagination every day. The journey just keeps getting better, and the next project always surpasses the last.

**Describe your ideal day.**

Room service breakfast at La Mamounia in Morocco; mid-morning shopping at Dover Street Market in London; lunch at Matt's El Rancho in Austin, Texas; an afternoon photo shoot on the beach in Bali; a long, wine-filled dinner on the Seine; and then cuddling up to sleep in my own bed.

**What is your favorite place to shop for antique/vintage pieces? Can be anywhere in the world.**

It's hard to beat the souk in Marrakech, although Le Marché aux Puces de Saint-Ouen in Paris comes close. And when I need a fix that's closer to home, Camilla Dietz Bergeron in the Upper East Side of Manhattan is fun to pick through. Their selection of vintage estate jewelry is incredibly special.

**What was the most memorable gift you've ever given or received?**

Edie Sedgwick was one of my original fashion icons. For my thirtieth birthday, my boyfriend bought me a signed, handmade photograph of her by Gerard Malanga. It is one of the greatest treasures of my life.

**What was the last purchase that you believe will mean something to you ten years from now?**

It's a toss-up between a magical necklace made of tanzanite beads and a crystal lariat necklace from the 1880s. Clearly, jewelry is my favorite investment!

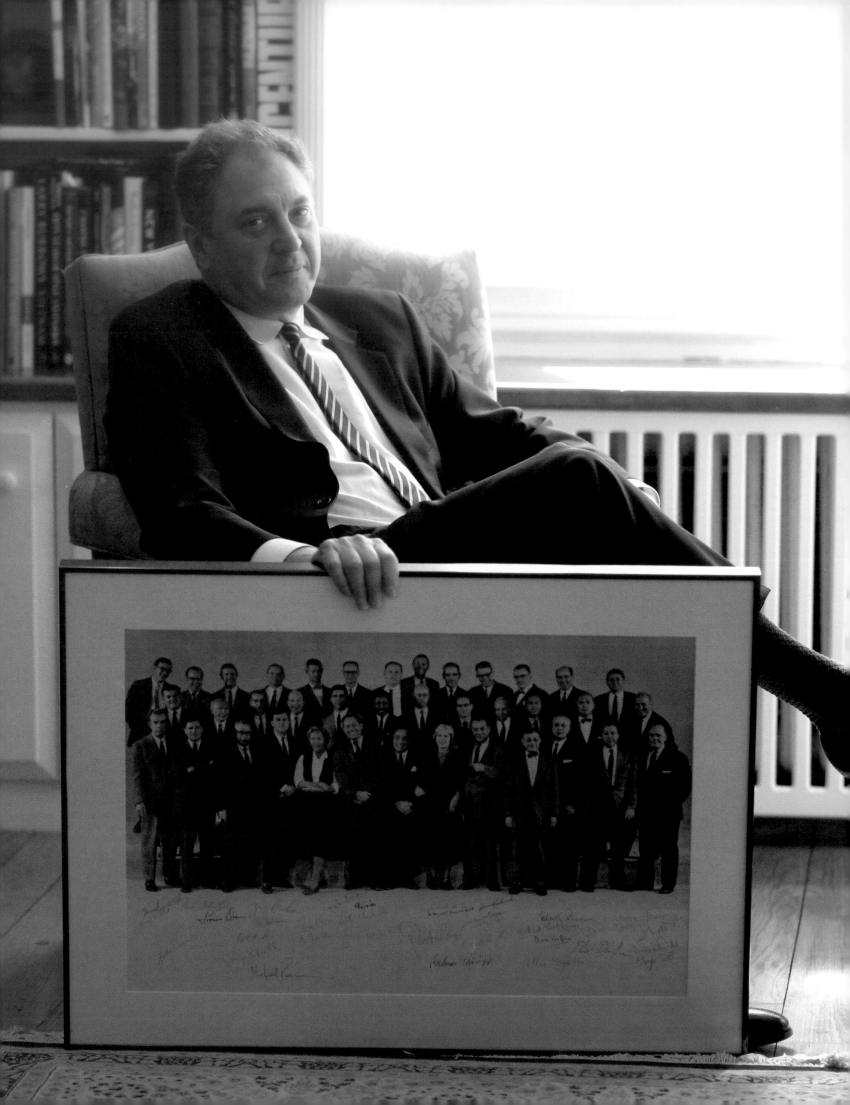

# DAVID
# Friend

**How did you come to own your possession?**

In 1992, shortly after being named *LIFE* magazine's director of photography, I received a phone call from Hanns Kohl, who oversaw the Time-Life Photo Lab. Hanns asked me to come down to his office, and when I arrived, he handed me a present. It was a very large print: a 1960 group photograph that included *LIFE*'s thirty-eight staff photographers. Remarkably, the picture was *signed* by every single one of them. For a generation, Hanns had squirreled it away (along with a couple of other similarly signed copies, so he told me). And he wanted me to have it. He knew that I had been a fan and champion of *LIFE*'s photographers (I was friends or acquaintances with some of those in the picture) and he understood that I had a deep respect for *LIFE*'s fifty-year photographic and journalistic legacy. I think he wanted me to keep it as a testament, a goad—and a visual reminder—that current photographers (and picture editors) owed a debt to those who had come before them. (Hanns also gave me a much smaller print, which I keep in my office. It was taken during that same photo session—and it shows *LIFE*'s managing editor, Ed Thompson, lying on the floor in front of them all.)

**How do you live with your heirloom?**

I store it in my attic and dust it off from time to time.

**Who in your life has most influenced your personal style and taste?**

As a kid: my uncle, Ben Aaronin; my maternal grandmother, Kay Rosenberg Simons; the Beatles; and a childhood friend, Scott Sklare (the coolest kid in the school). As a student: mentors such as Eunice Borman, Mary Kerner, Bob Boone, Armour Craig, Cullen Murphy, and novelist Robert Stone. As a young adult: authoritarian father figures, including my editors at *LIFE*, photographers Harry Benson and John Loengard, and *Vanity Fair* editor Graydon Carter.

**Fill in the blank: Whenever I look at _____ I can't help but smile.**

Nancy, Sam, or Molly

**What's the best part of your day?**

Any and every sunset.

**Describe your ideal day.**

Writing all day in a library or musty wood-paneled room, looking out on a lake. Followed by a bike ride or a long walk with Nancy. Followed by dinner with old friends and old wine. Followed by more Nancy.

**What is your favorite place to shop for antique/vintage pieces? Can be anywhere in the world.**

Any Middle Eastern bazaar. And the bookshops in Hay-on-Wye in Wales.

**What was the most memorable gift you've ever given or received?**

Giving my wife a surprise fiftieth birthday trip to Denmark. Giving my father, for his seventy-fifth birthday, the opportunity to throw out the first ball at a Chicago Cubs spring training game in Mesa, Arizona.

**What was your last purchase that you believe will mean something to you ten years from now?**

A Don McCullin photograph. And an early edition of James Joyce's *Finnegans Wake*.

# NINA
# Garcia

**How did you come to own your possession?**

I had been going to this chapel for many years—every time we visited Paris with my mother—and she would always purchase medallions for her family and friends. She thought of it as a form of protection because the miracle of the Virgin was near your heart. Even now, every time I visit Paris, I stop by the Chapelle Notre-Dame de la Médaille Miraculeuse. Throughout the years, I have collected many of these tokens of protection, and I, too, pass them along to friends and family. It makes me feel safe and is a reminder of my mother. They are a beautiful color blue, and in the summer I stack several together.

**How do you live with your heirloom?**

It "lives" in my drawer of faux and real bijouterie that I love to use and mix up.

**Fill in the blank: Whenever I look at _____ I can't help but smile.**

My two boys. I consider them my greatest accomplishment.

**What is the best part of your day?**

Seeing my boys before I go to work and putting them into bed at night. No matter what type of day I am having, they always put a smile on my face.

**What was the most memorable gift you've ever given or received?**

About eight years ago, my husband gave me a beautiful vintage art deco amethyst pendant with an incredible silk braided cord. I wear it often to events. Even though it is vintage, it feels very contemporary.

# TONY Goldwyn

**How did you come to own your possession?**

This Buddha head was in my mother's house when I was growing up. She had inherited it from her great aunt. My attachment to this Buddha is not really spiritual, although she is definitely part of my spirit. I suppose she is actually a "he," but I always thought of her as a feminine goddess.

She stood impassively in the dining room throughout my childhood and well into my adult years (until my mother passed away). The goddess was an almost sentient presence in our home. My brother and I used to play games with her, putting my mom's makeup on her and dressing her up in funny clothes. A Buddha in drag. I bet there are probably still lipstick traces on her.

**How do you live with your heirloom?**

The head is in our living room at home. It sits in the bay window overlooking our front yard.

**Who in your life has most influenced your personal style and taste?**

I would say that my mother most influenced my personal aesthetic. She was a painter and came from a literary family in New York. Her taste was very eclectic yet classic and elegant. Most of the art and furniture in our home growing up was very personal—not simply decorative. Things were functional, yet each item had a story, be it a chair or a drawing on the wall.

**Fill in the blank: Whenever I look at _____ I can't help but smile.**

My children. They just make me laugh.

**What's the best part of your day?**

This would be a toss-up between going to work (where I can't believe I get paid to do what I do) and coming home after (where I feel a deep sense of belonging).

**What was the most memorable gift you've ever given or received?**

When my wife and I had been dating for about a year, I bought her a necklace of freshwater black pearls. I was still in college and it seemed not only extravagant, but also a huge statement about our potential future together.

**What was your last purchase that you believe will mean something to you ten years from now?**

I bought my wife a painting for her birthday. This is how we buy art. Not for any estimated value but because we believe we will always want to look at it, particularly if it's associated with a specific point in our lives.

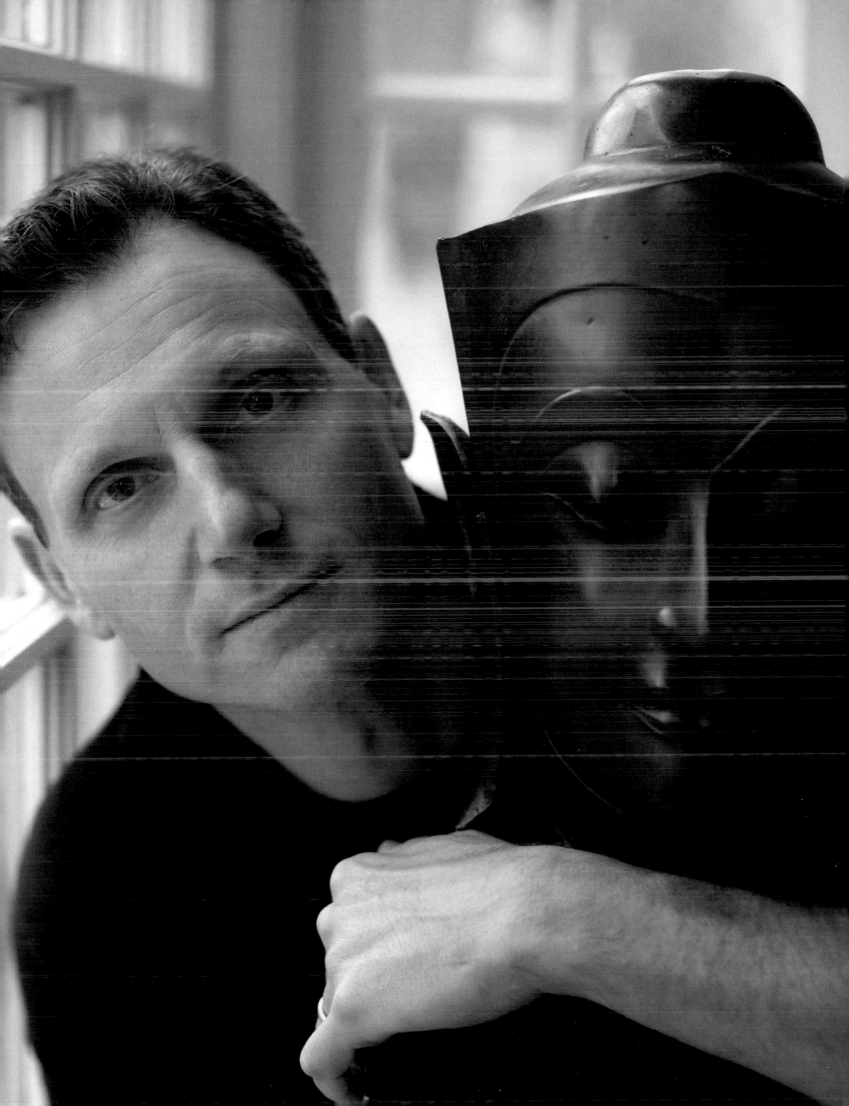

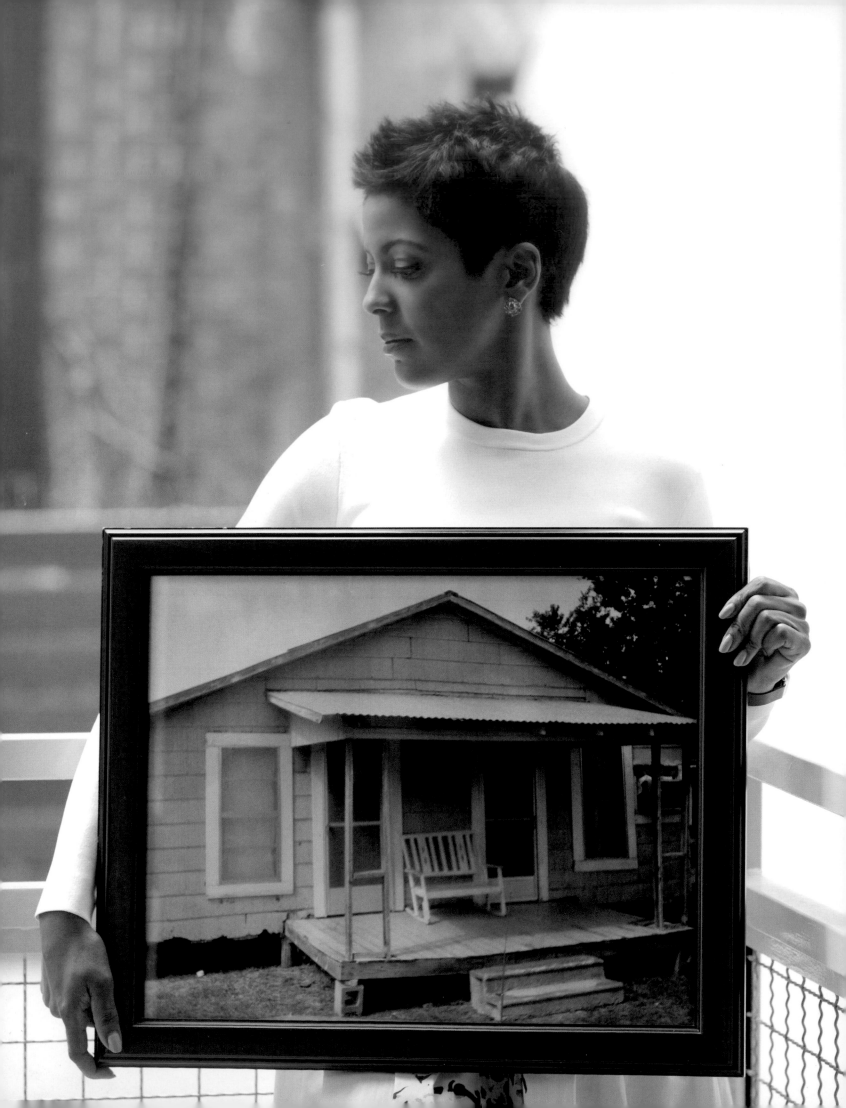

# TAMRON Hall

**How did you come to own your possession?**

I took the photo of my grandfather's home after my family gathered for the passing of my oldest uncle. I felt it was important to have a lasting image of the place that was the source of great happiness for me as a child.

**How do you live with your heirloom?**

I have a copy and my mother has one, too. We have it framed in our homes. As Dorothy Gale said, "There's no place like home." This tiny pink trimmed house is the original home for me.

**Who in your life has most influenced your personal style and taste?**

My mother, Southern churchwomen, and Kate Moss. You will never hear someone combine those three influences again!

**Fill in the blank: Whenever I look at _____ I can't help but smile.**

Whenever I look at my nephew and nieces I can't help but smile.

**What's the best part of your day?**

When I first touch my sheets at the end of a long day. It's like a cocoon securing me for the night. I reflect and recharge.

**Describe your ideal day.**

My ideal day is sleeping in and making breakfast for my friends and family. I love to ride my bike, and a nice nap at the beach would be the frosting on the cake.

**What is your favorite place to shop for antique/vintage pieces? Can be anywhere in the world.**

I'm an Internet shopping addict. 1stdibs is now an obsession for me. It places me anywhere in the world without moving.

**What was the most memorable gift you've ever given or received?**

Most memorable gift I've received is a long dramatic coat and sparkling bracelet owned by Lena Horne. It was sold at her estate auction in New York City. I am afraid to even bring them out of the closet. I need to loosen up and enjoy wearing them more often.

**What was your last purchase that you believe will mean something to you ten years from now?**

An art piece I bought as a birthday gift to myself. It's a mirrored piece by Tapp Francke that reads *Smile*. It's a message that never goes out of style.

*I felt it was important to have a lasting image of the place that was the source of great happiness for me as a child.*

# MUSA
# Jackson

**How did you come to own your possession?**

My favorite possession actually is Harlem. I don't own it, but I am possessed by it.

**How do you live with your heirloom?**

I live in Harlem. So I live with it every day.

**Who in your life has most influenced your personal style and taste?**

I would say icons like Sidney Poitier, Lena Horne, and the incredible stylist Freddie Leiba.

**Fill in the blank: Whenever I look at _____ I can't help but smile.**

Picture of my children (Jade and Elijah).

**What's the best part of your day?**

I love the evenings. Right after sunset, that transition is epic.

**Describe your ideal day.**

Waking up. Taking a walk from Harlem through Central Park. Having a coffee at an outdoor café. Some shopping. Dinner with a few friends and spending time with my children or my partner.

**What is your favorite place to shop for antique/vintage pieces? Can be anywhere in the world.**

Housing Works—any of their locations in New York City.

**What was the most memorable gift you've ever given or received?**

My mother gave me my father's wingtip shoes after he died. They are a size too small, so I've never walked in his shoes.

**What was your last purchase that you believe will mean something to you ten years from now?**

Ballet dance lessons from Dance Theatre of Harlem, for my nine-year-old daughter, Jade. She's already phenomenal. Ten years from now, she'll be epic.

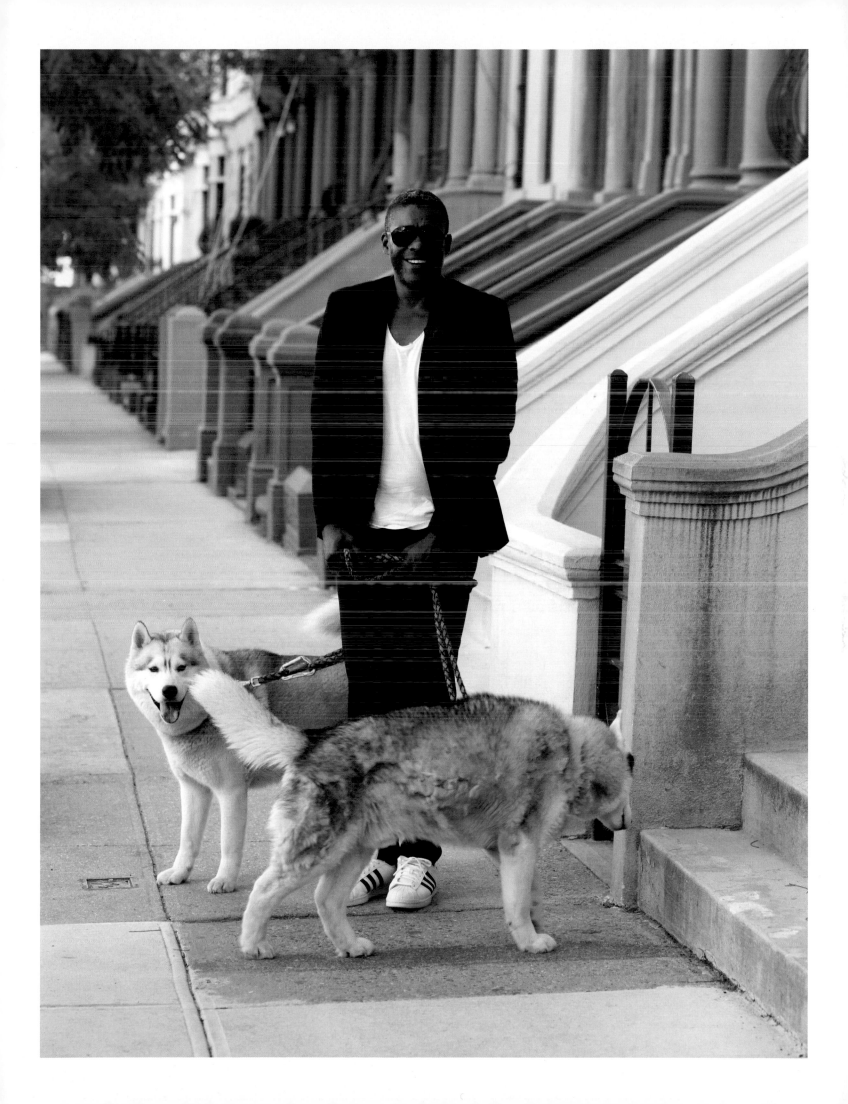

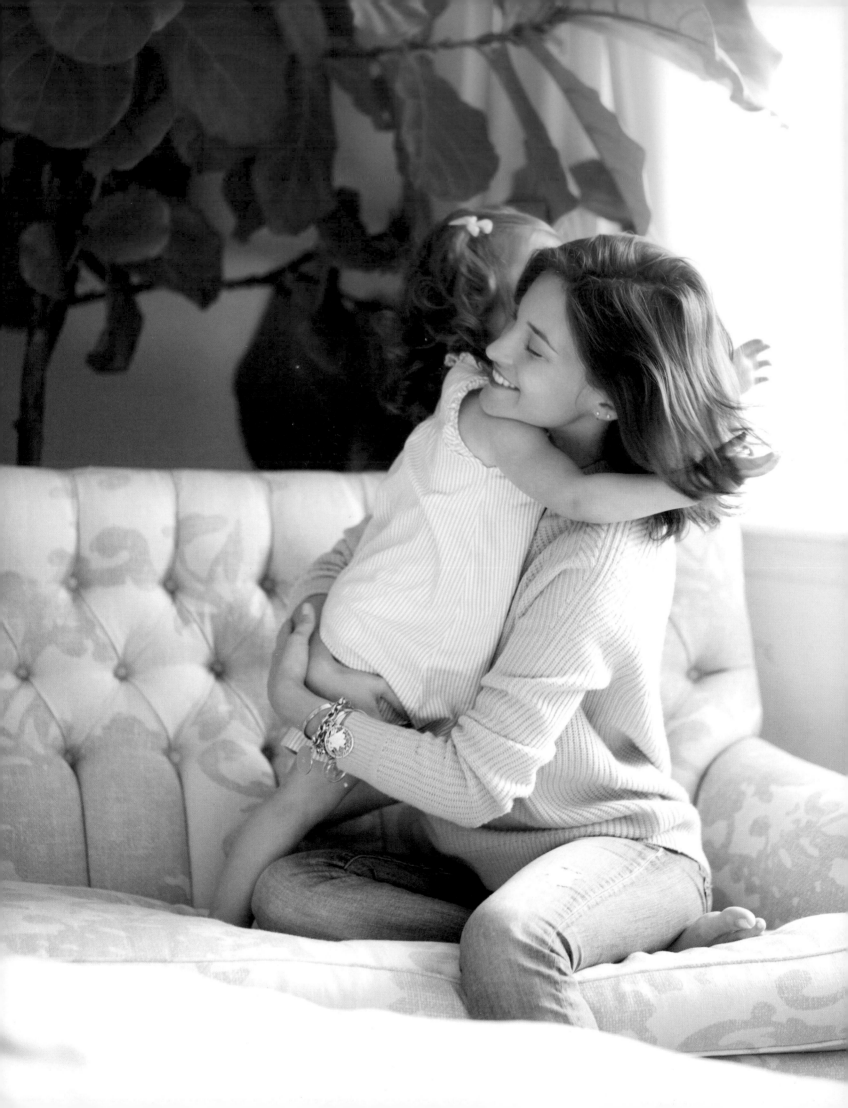

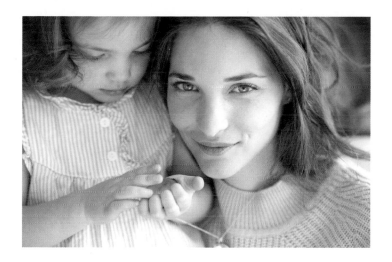

# MARIA DUEÑAS Jacobs

**How did you come to own your possession?**

My jewelry is an ongoing collection. It grows and grows, but my intention is to give it all away to my daughter and hopefully future children.

**How do you live with your heirloom?**

I am not too precious with my jewelry. I really enjoy wearing and getting good use of the pieces I own. I think that wearing your jewelry gives it a better life and attaches more memories to each piece.

**Who in your life has most influenced your personal style and taste?**

My work has definitely influenced my taste. My access to the accessories and jewelry industry has refined my eye and exposed me to a huge array of designers.

**Fill in the blank: Whenever I look at _____ I can't help but smile.**

My daughter's sweet smile.

**What's the best part of your day?**

Waking up in the morning and getting Luna out of bed. She is a morning person and is always excited and happy to start a new day. A hug and kiss from her is just about the best way to start any day.

**What is your favorite place to shop for antique/vintage pieces? Can be anywhere in the world.**

I love buying jewelry when I travel; I think it's very special to attach memories to specific pieces. Finding an antique/estate jeweler on a trip is an extra treat, but I also love so many in New York: Kentshire, Camilla Dietz Bergeron, Doyle & Doyle, Fred Leighton . . . and I also like to shop vintage online at Beladora.com and 1stdibs.

**What was the most memorable gift you've ever given or received?**

My husband and I have come up with a sweet plan for Luna's future birthdays. We buy her a piece of fine jewelry for every birthday, engrave each piece with the age she is turning (two, three, four) and write her a note to add to her growing jewelry box. While she grows up, I will keep them safe for her and add a bit of extra love with some wear. When she turns eighteen, we will start gifting them to her and give her the notes that we wrote when she was a baby and through the years.

**What was your last purchase that you believe will mean something to you ten years from now?**

My husband recently bought me a Claddagh ring from the 1820s. Its two hands symbolize trust and enduring love. I adore the sentiment and love trying to envision the women that previously owned this ring. It's lived many lives, and I feel grateful to have it as one of my possessions.

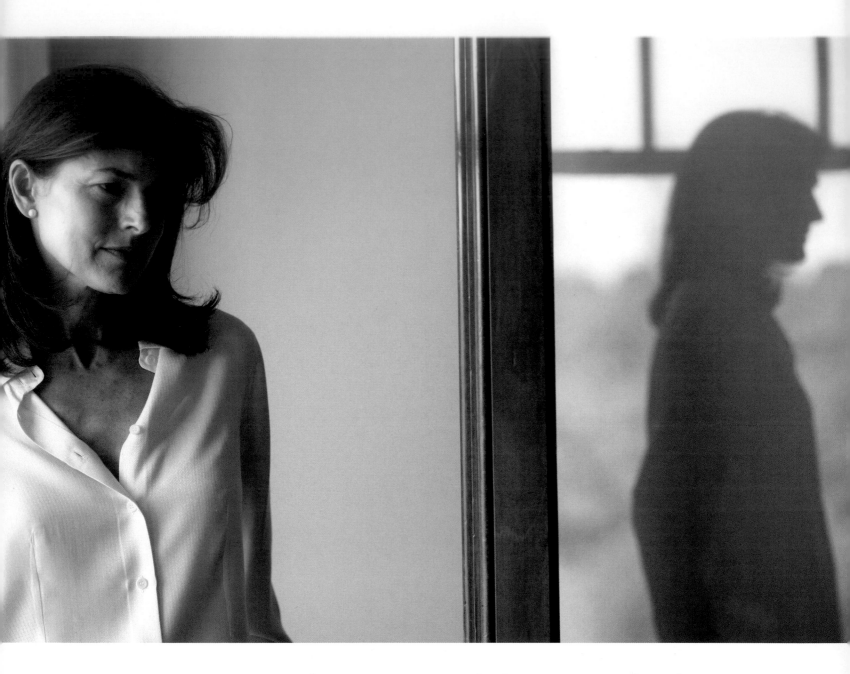

When I wear the earrings, I feel very connected to
my grandmother and her values,
which were as impeccable as her taste.

# KAYCE FREED
# Jennings

**How did you come to own your possession?**

The pearls belonged to my grandmother. She didn't have much money or many things, but she had impeccable taste, so those few things she had—several French antiques, two cashmere sweaters, her pearls—were just perfect. She was also frugal. So, instead of the usual two earrings, she had three. That way, if she lost one, she'd still have a matching pair. She never lost one. I did, but I still have a matching pair. When I wear the earrings, I feel very connected to my grandmother and her values, which were as impeccable as her taste.

**How do you live with your heirloom?**

The earrings are in a box with my other pearls: beautiful earrings from my sister and a necklace that my husband bought in Hong Kong when he was there reporting on the handover from Britain to China. I love them all, and they are all meaningful, but my grandmother's earrings mean the most.

**Who in your life has most influenced your personal style?**

I'm not sure I have as much personal style as I'd like. Well, I am sure, actually, that I don't. Both my grandmother and my mother had terrific style, though my grandmother was more conservative and traditional. She believed in the perfection of the French antique and, perhaps, she didn't feel she could afford to make mistakes. My mother is more creative, takes more risks. She believes in mixing styles, especially when it comes to interior design. She's always had great confidence in her own taste. As a child, I remember that she used to push my sister and me to be more daring—to shorten our skirts further. No matter how short, they were always too long for her! To wear more leather— or fake leather, anyway. To wear bolder and funkier jewelry. I'm still much more conservative in style than I, and my mother, would like me to be.

**Fill in the blank: Whenever I look at _____
I can't help but smile.**

My Airedale, Harper Lee. She's just so bloody adorable and com-forting, even if she is often infuriatingly diffident.

**What's the best part of your day?**

First thing in the morning, between six and seven, when I'm in Central Park with my dog. In the summertime, there's that gorgeous early morning glow; in the winter, the dawn bounces off the snow and there's a wonderful, enveloping hush. It's very, very peaceful. It's when I really notice the extraordinary beauty of the park.

**What was the most memorable gift you've ever given or received?**

It was a gift I was never given. But it was an ingenious idea: shares in a Russian chocolate factory. I'm a very serious chocoholic. It's a genetic condition and runs happily through my father's side of the family. My husband didn't really understand the addiction, but appreciated that it was real. So when the former Soviet Union started privatizing in earnest, and Peter heard that the State was selling off one of the big chocolate companies, he thought he'd found the perfect birthday present for me. He had, but he wasn't able to make it happen in time. I think he gave me a digital camera instead. A consolation prize, but a pretty good one—even if it wasn't chocolate!

**What was your last purchase that you believe will mean something to you ten years from now?**

A piece of Inuit art. I have a very modest collection of Inuit art, and I recently bought another sculpture by Barnabus, a carver whose work I particularly love. One of the reasons I love Inuit sculpture is that it is so tactile—you want to touch it and it's often meant to be touched. With the exception of some pieces that depict a shaman or transformation, which I avoid, I find it extraordinarily soothing. The very first piece of art I ever bought myself was an Inuit print I found on the way back from a trip to the Arctic. I still have it. When I met my husband, who was Canadian, he already had quite a bit of Inuit art, so it was great fun to continue to collect it together.

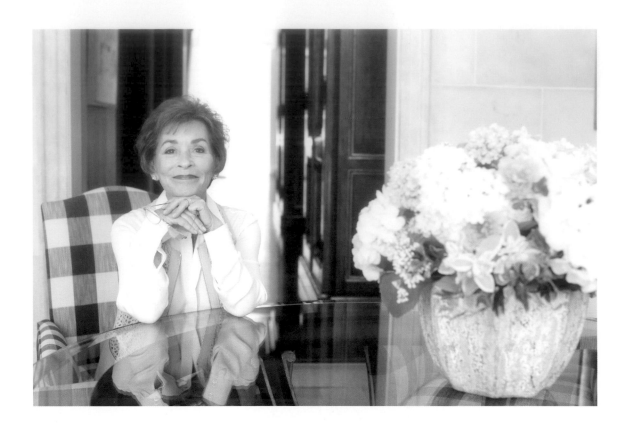

# JUDGE Judy

**How did you come to own your possession?**

I took possession of my father's glasses when he died twenty-five years ago.

**How do you live with your heirloom?**

I keep them in my office and often slip them on to read something he would like.

**Who in your life has most influenced your personal style and taste?**

My father.

**Fill in the blank: Whenever I look at _____ I can't help but smile.**

Puppy.

**What's the best part of your day?**

Every part!

**Describe your ideal day.**

A little work, a little play.

**What is your favorite place to shop for antique/vintage pieces? Can be anywhere in the world.**

New England.

**What was the most memorable gift you've ever given or received?**

I gave a dear friend a dog who was her companion for fifteen years.

**What was your last purchase that you believe will mean something to you ten years from now?**

A new puppy.

## (THE NEW POTATO)

# DANIELLE Kosann

**How did you come to own your possession?**

She was born and that was that!

**How do you live with your heirloom?**

She's my best friend and my business partner.

**Who in your life has most influenced your personal style and taste?**

My mother, who I inherited many things from, including my artistic eye. I feel very lucky for that.

**Fill in the blank: Whenever I look at _____ I can't help but smile.**

Puppy.

**What's the best part of your day?**

Waking up in the morning and having coffee. It's really quiet and peaceful and I can mentally prepare for the day.

**Describe your ideal day.**

It would be a typical weekend day with no plans, spent with my husband. I'd start the day by having him cook me his scrambled eggs, which are the best on the planet. We would take a walk through Central Park, go to a few museums, and have a long, leisurely dinner out in New York City.

**What is your favorite place to shop for antique/ vintage pieces? It can be anywhere in the world.**

I love Brimfield and Portobello Road. Atlantic Avenue in Brooklyn has amazing antique shops that I visit all the time. I also love to shop online on 1stdibs.

**What was the most memorable gift you've ever given or received?**

One of my favorite photographs is Arthur Elgort's *Stella Diving*, which I received from my parents as an engagement gift. It hangs above my desk and is one of the first and last things I look at every day.

**What was your last purchase that you believe will mean something to you ten years from now?**

A white marble Knoll table, which was definitely the biggest furniture purchase I've ever made!

# LAURA Kosann

**How did you come to own your possession?**

My older sister Danielle was born, and the rest, as they say, is Kosann history!

**How do you live with your heirloom?**

Danielle and I are lucky enough to both be best friends as well as work together. So my possession obsession isn't something I have to miss too often.

**Who in your life has most influenced your personal style and taste?**

I would say my parents. My mom is a photographer and designer, and therefore has an unbelievable eye; she's who I'd accredit my love of great fashion, design, and art, too. The same goes for my dad, who's always had a fashion background, and mainly he's also responsible for my weakness and appreciation for old Hollywood films.

**Fill in the blank: Whenever I look at _____ I can't help but smile.**

Dog.

**What's the best part of your day?**

Walking my dog, Scout, in the morning. We walk to the Le Pain Quotidien kiosk in Central Park, maybe play a little fetch, and I always give myself ten minutes to sit outside with him with my coffee. It's the only part of the day I somewhat succeed in unplugging.

**Describe your ideal day.**

Any day that happens in Paris.

**What is your favorite place to shop for antique/ vintage pieces? Can be anywhere in the world.**

I love the Porte de Clignancourt in Paris, Atlantic Avenue in Brooklyn, and certain parts of Portobello Road in London. I always loved also going with my parents when they'd stop at spots on the way to our grandparents' house in the Berkshires. Screaming Mimi's in NoHo is always fun, too.

**What was the most memorable gift you've ever given or received?**

The most memorable gift I've received was a gold necklace from my Italian childhood nanny, Rose. She gave it to me shortly before she passed away.

**What was your last purchase that you believe will mean something to you ten years from now?**

A vintage bar from the fifties on Atlantic Avenue.

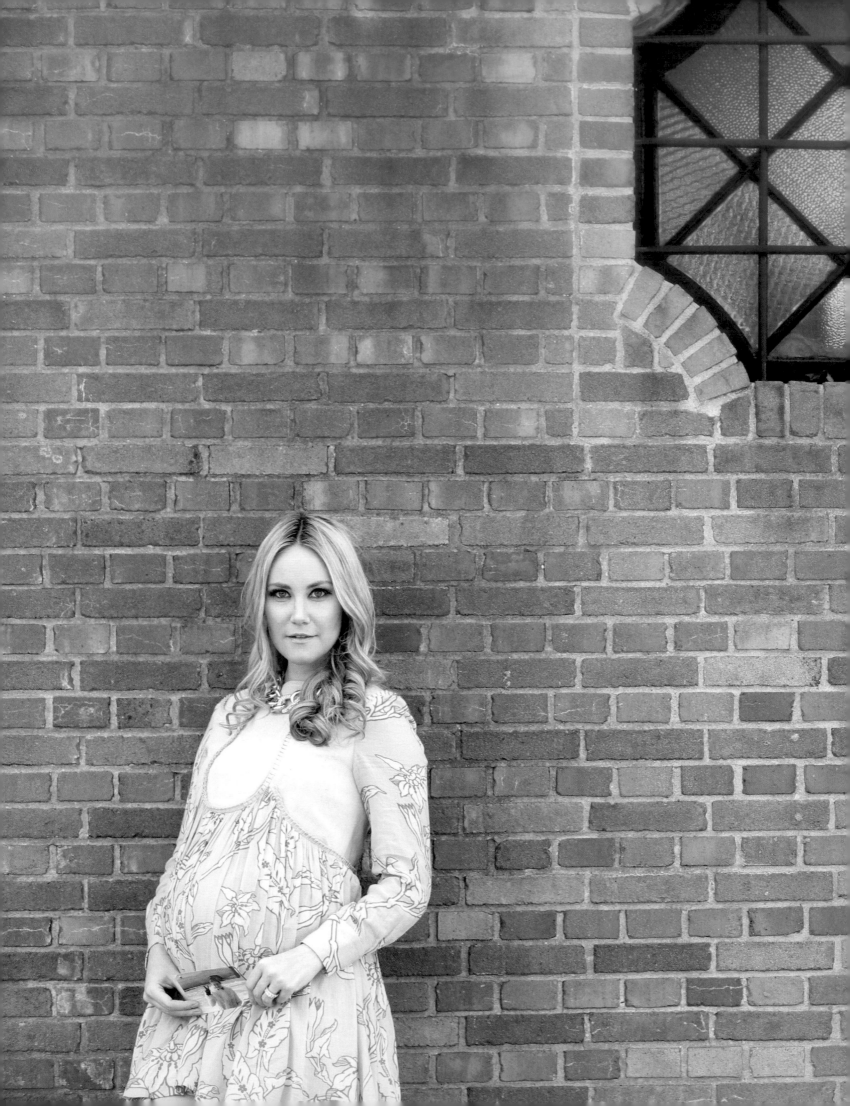

# ELIZABETH
# Kurpis

**How did you come to own your possession?**

I always loved certain photos of my mother and organically collected them from different family members over many years.

**How do you live with your heirloom?**

These pictures are kept safe in our master bedroom. They are never more than a few feet from me.

**Who in your life has most influenced your personal style and taste?**

My mother Joan has, and always will be, my biggest influence for all important aspects of my life. This is especially true for my personal style and taste.

**Fill in the blank: Whenever I look at _____ I can't help but smile.**

Whenever I look at a photo of my newborn daughter, Kingsley, I can't help but smile.

**What's the best part of your day?**

When I wake up and get to give my little girl a good morning kiss.

**Describe your ideal day.**

I don't have an ideal day per se, but the best days are an eclectic mix of family, friends, shopping, and adventure.

**What is your favorite place to shop for antique/**

vintage pieces?  Can be anywhere in the world.

My favorite place to shop for antique pieces is Europe. Probably a tie between France and Italy.

**What was the most memorable gift you've ever given or received?**

I would say the most memorable gift I ever received was my first car on the day I got my driver's license.

**What was your last purchase that you believe will mean something to you ten years from now?**

My little Maltese, Sammy.

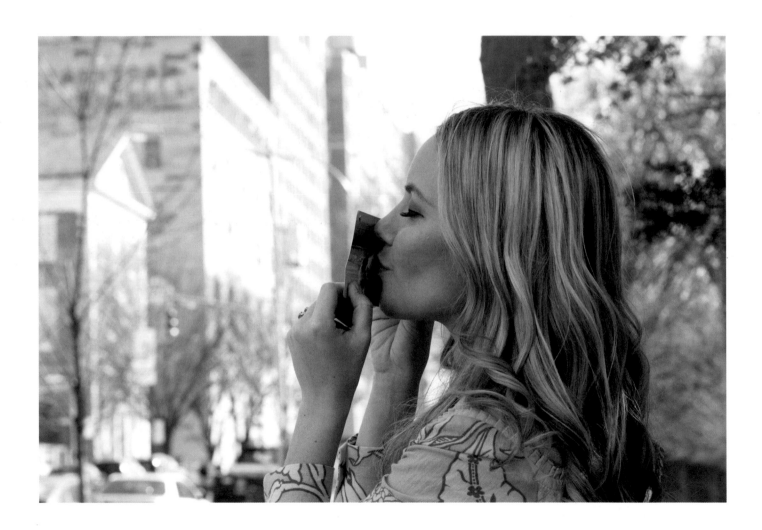

I always loved certain photos of my mother.

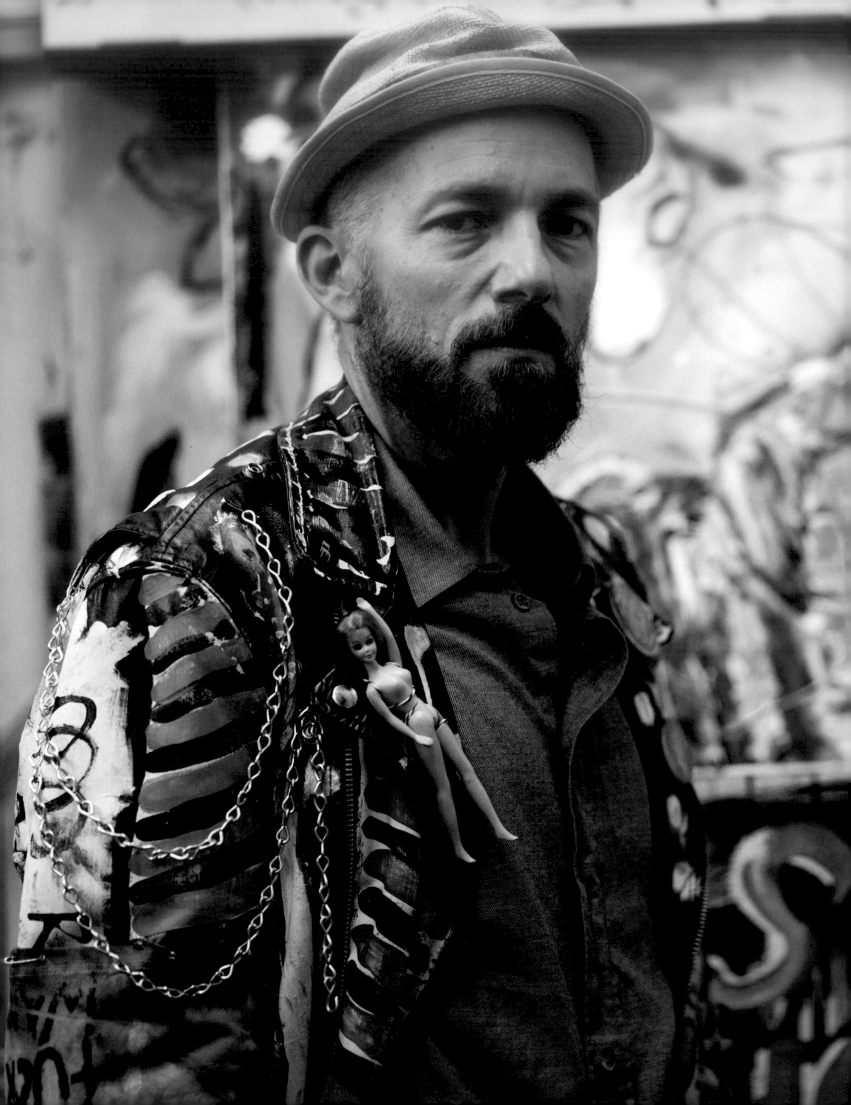

# SCOOTER LaForge

**How did you come to own your possession?**

I gave myself my possessions. They come from my brain and my creativity, which were given to me by my parents. Thank you, Anne and Camille LaForge.

**How do you live with your heirloom?**

I live with the paintings every day; they're all over my apartment and my studio.

**Who in your life has most influenced your personal style and taste?**

I love James Dean: jeans and a T-shirt and a vintage Porsche.

**Fill in the blank: Whenever I look at _____ I can't help but smile.**

Someone else's smile.

**What's the best part of your day?**

Waking up.

**Describe your ideal day.**

Getting up early, having Café Bustelo with my friend Johnny Rozsa, and going to work and surpassing my creative limits in my studio.

**What is your favorite place to shop for antique/vintage pieces? It can be anywhere in the world.**

At a flea market in Albuquerque, for instance, I bought beautiful Native American pottery, turquoise jewelry, and kachina dolls.

**What was the most memorable gift you've ever given or received?**

My mom gave me a beautiful Diné (Navajo) concho belt twenty years ago.

**What was your last purchase that you believe will mean something to you ten years from now?**

My Hermès Cape Cod watch. I'll never have to buy a watch again.

# LAUREN BUSH
# Lauren

**How did you come to own your possessions?**

When I was a teenager, my mom created this painting—a sweet scene of a bunny talking to a little snail—and gave it to me. It hung in my room growing up and still does to this day. Looking at it has always made me happy and reminded me of my mom's secret artistic talents, which I hope I've inherited in some capacity.

**How do you live with your heirloom?**

The painting hangs in my bedroom next to my mirror. I see it twice a day—when I go to bed and when I wake up.

**Who in your life has most influenced your personal style and taste?**

My personal style has been most influenced by my surroundings and experiences rather than one particular person. I always get so much inspiration from traveling, whether it is to Europe or somewhere exotic, and the artisanal work women are doing in developing countries around the world. Currently, I am working with female artisans in Guatemala, who are making FEED bags that will be sold at Lord & Taylor to help kids in Guatemala through UNICEF.

**Fill in the blank: Whenever I look at _____ I can't help but smile.**

Pugs. I find pugs incredibly cute and funny-looking! From the way they breathe to the way they strut down the street, I can't help but smile when one passes by.

**What's the best part of your day?**

It's hard to pinpoint one exact moment each day, but if I had to choose, I'd have to say dinnertime. First of all, I love a good meal. After a nice full day, there's nothing more fun than having dinner with my friends and family. Recently, I have been trying my hand at cooking more often, which makes the eating part all the more satisfying.

**What was the most memorable gift you've ever given or received?**

When I was five years old, my parents got me a puppy for Christmas. He was white and fluffy with a big red bow around his neck. I named him Junior. He was one of my favorite childhood playmates!

**What was your last purchase that you believe will mean something to you ten years from now?**

About nine months ago, I bought a gold ring with an engraving on the inside that reads: *This too will pass.* It is a simple reminder that no matter what happens, good or bad, it will not last. That means that we must soak in the good while we can, and be patient with the bad, as it naturally will pass. This helps me never lose perspective.

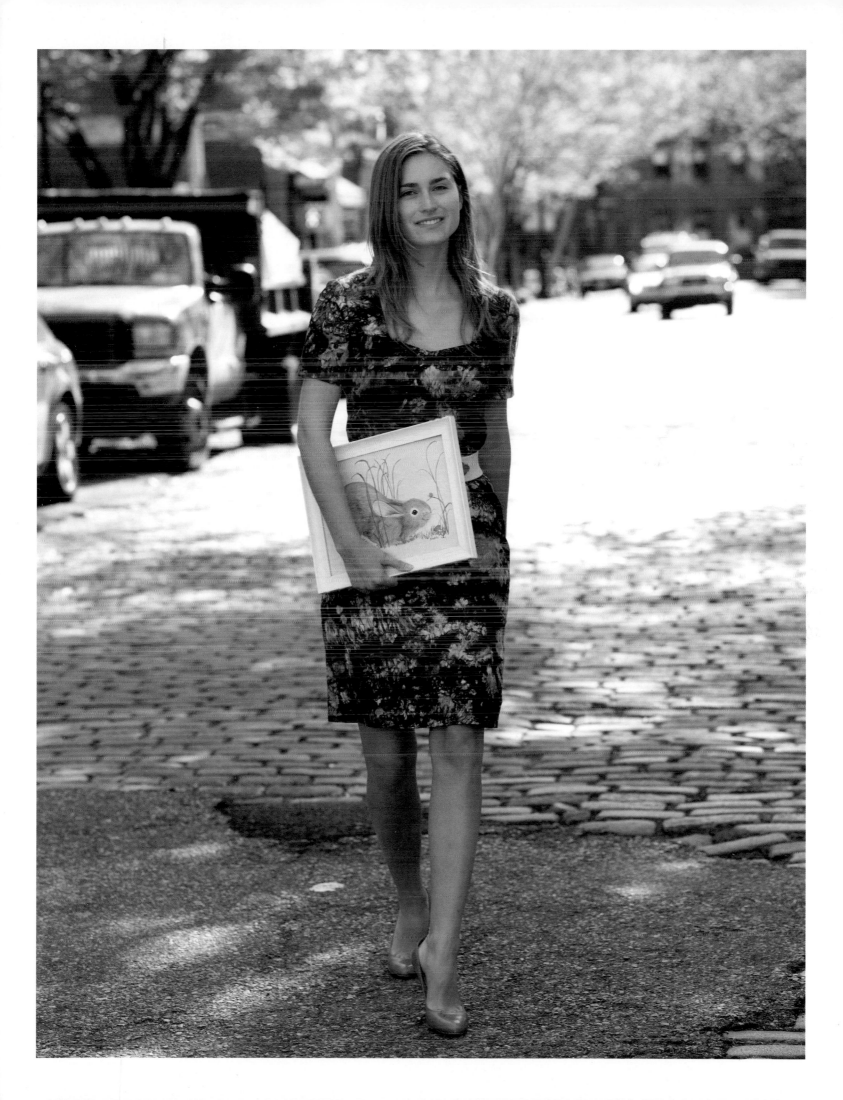

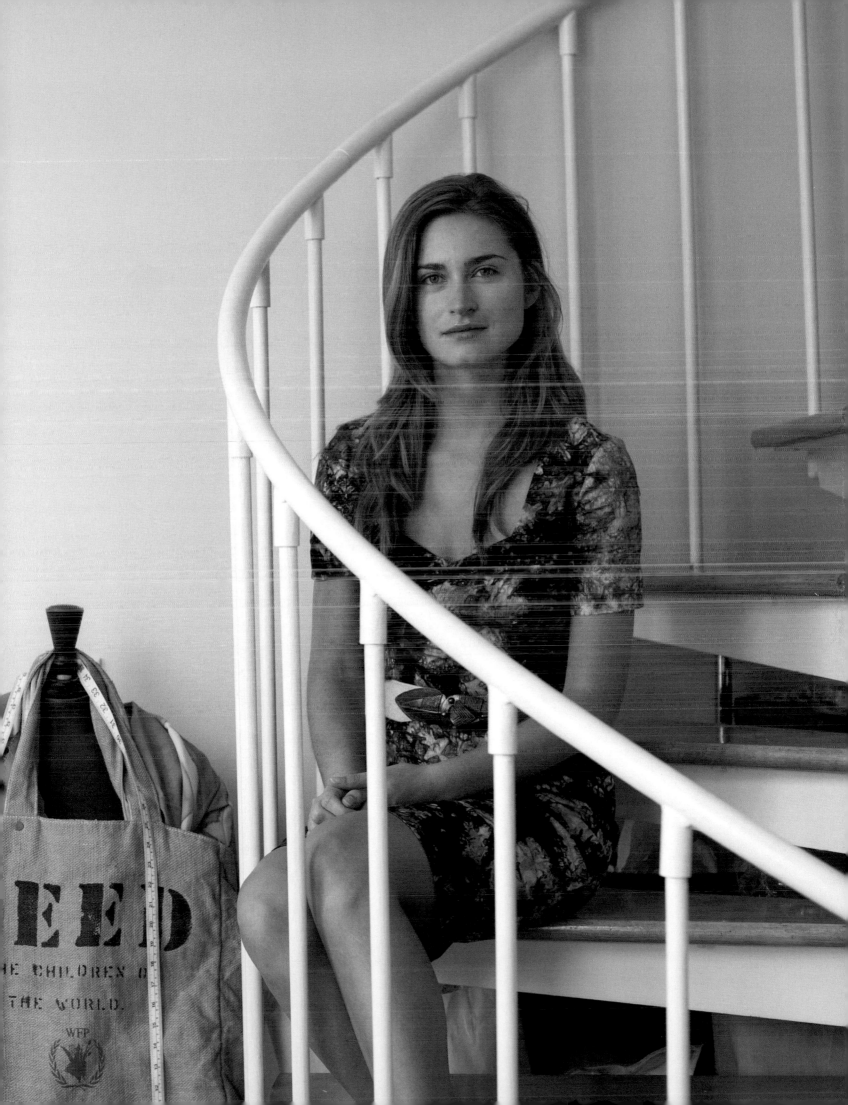

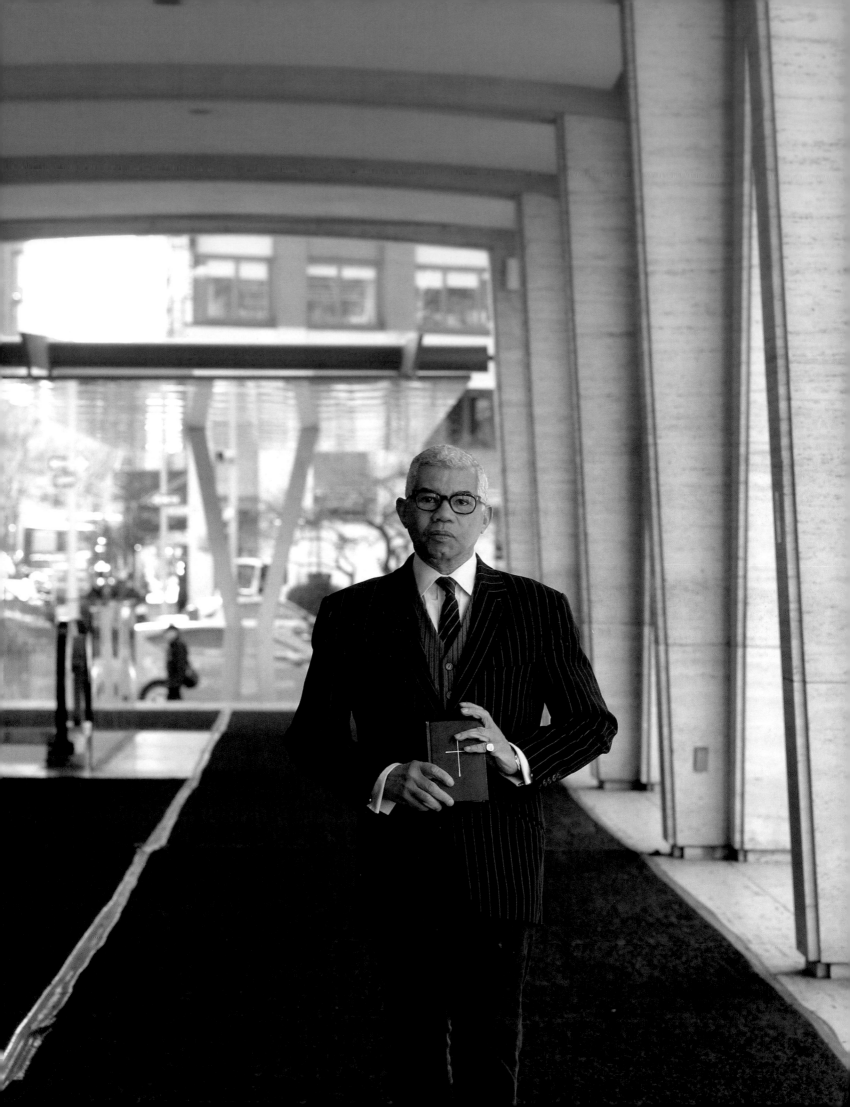

# FREDDIE
# Leiba

**How did you come to own your possession?**

Left to me by my mother.

**How do you live with it?**

Sitting on my bookshelf.

**Who in your life has most influenced your personal style and taste?**

My mother.

**Fill in the blank: Whenever I look at _____ I can't help but smile.**

Photo of my mother.

**What's the best part of your day?**

After a perfect workday, a glass of wine.

**Describe your ideal day.**

When my shoot is perfect.

**What is your favorite place to shop for antique/vintage pieces? Can be anywhere in the world.**

London.

**What was the most memorable gift you've ever given or received?**

A pair of art deco diamond cuff links.

**What was your last purchase that you believe will mean something to you ten years from now?**

Having my suits made in Savile Row.

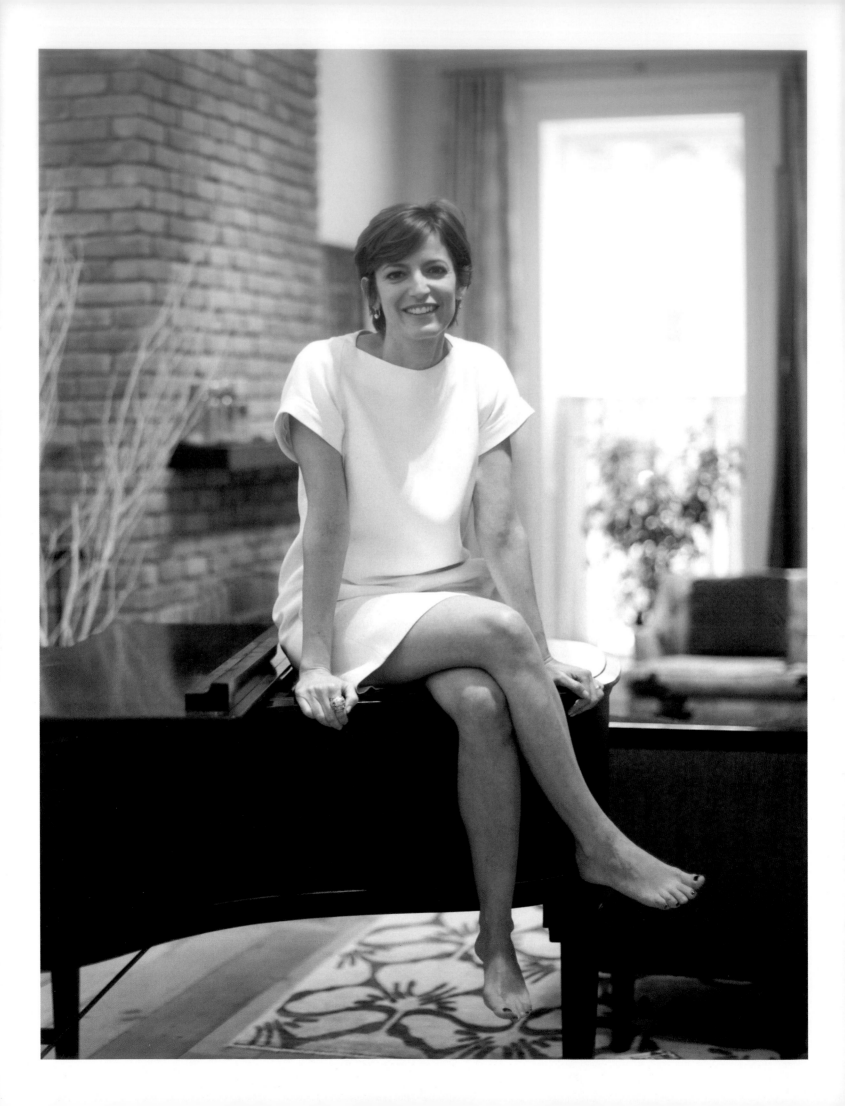

# CINDI
# Leive

**How did you come to own your possession?**

My heirloom is a Knabe piano—from Germany, probably made around the turn of the last century—that belonged to my grandmother, Clara Leive. It had been given to her by her husband, my grandfather, when they lived in the Bronx without a lot of room or money; I think it was one of their few luxuries.

I love it for lots of reasons. First, because Granny gave it to my father and mother, and after they divorced, it was one of the few objects from "my father's side" that stayed in my mom's house. I liked it because it, like me, had roots in both sides. Then, it was in storage for years while I lived in apartments too tiny to house it, and when I finally landed a place large enough for the piano, I felt like I was actually a grownup. Today it's the center-piece of our house, and my kids play it obsessively.

**How do you live with your heirloom?**

I live in a townhouse, and the piano sits in the middle of the parlor floor, which means it is smack in the epicenter of the house. It gets played every day by someone, though usually not by me!

**Who in your life has most influenced your personal style and taste?**

I could never pin it down to just one person. My mother influenced my style even though she didn't care about fashion in the least; she cultivated a kind of mad-scientist aesthetic (glasses, crazy curly hair) that I think taught me that loving how you look is more important than looking perfect.

As a kid and wannabe reporter, I cut out Brenda Starr comic strips and hung them on my wall; I thought her long wavy red hair, crisp shoulder-padded suits, and reporter's notebook were the most glamorous combination in the world.

**Fill in the blank: Whenever I look at _____ I can't help but smile.**

My two kids. Duh! Because I love them, but also because they're funny.

**What's the best part of your day?**

I like the moment in the morning when I've come back from a run and am having a cup of coffee with a kid on my lap. I don't love the actual exercising, but I really like it when it's over!

**What was the most memorable gift you've ever given or received?**

My uncle, father, and stepmother recently found an old record-ing of me goofing around, playing piano with my grandmother (the same one) when I was ten and made it into a CD. In the recording, we are cracking up, completely hysterical, singing a Gilbert and Sullivan song. I listened to it and felt like I was in the room again—amazing.

**What was your last purchase that you believe will mean something to you ten years from now?**

Well, much as I love my iPad, I'm pretty sure it won't be the latest, greatest thing in ten years! I'm going to go with my house. My husband and I moved our family to Brooklyn eight years ago and spent a lot of time thinking about what our dream house would look like. I still feel really happy when I walk through the door at night.

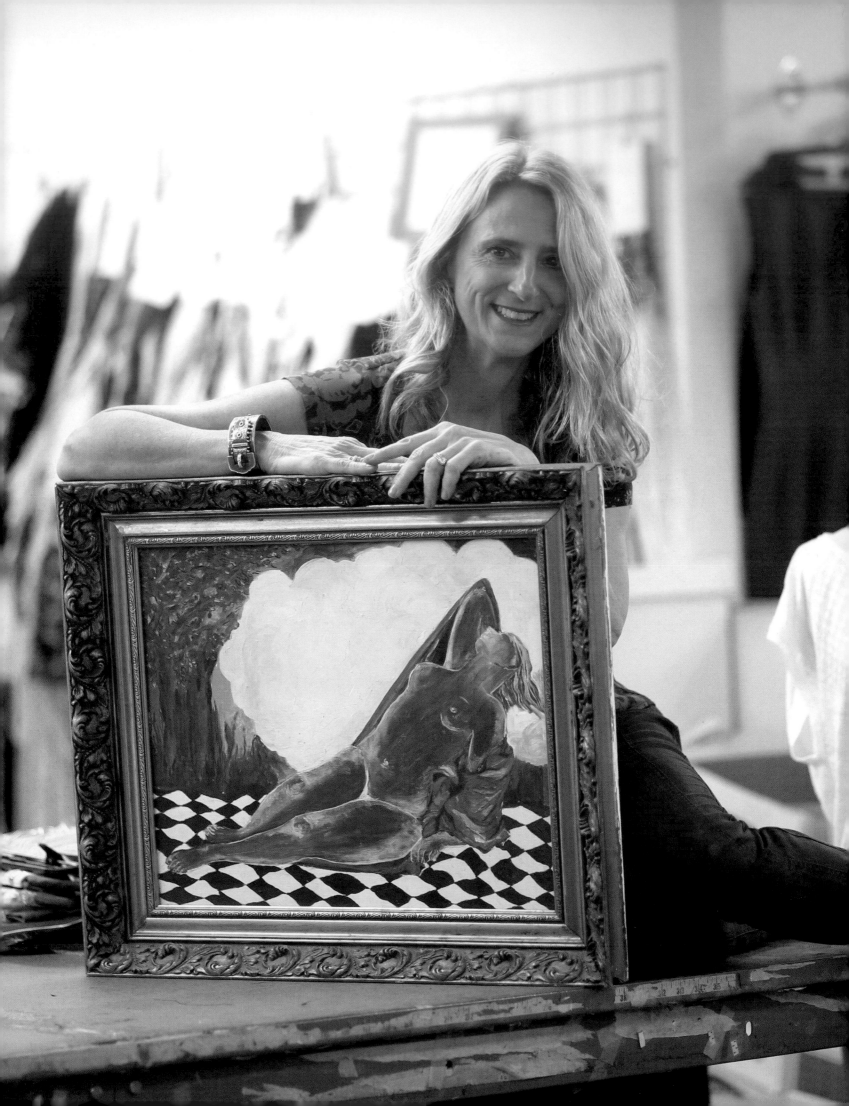

# NANETTE
# Lepore

**How did you come to own your possession?**
My husband painted it.

**How do you live with your heirloom?**
It's on a wall nearby.

**Who in your life has most influenced your personal style and taste?**
My mom.

**Fill in the blank: Whenever I look at _____ I can't help but smile.**
My daughter Violet's face.

**What's the best part of your day?**
A glass of wine at the kitchen table.

**Describe your ideal day.**
Sleeping in, and waking up to my Hamptons view.

**What is your favorite place to shop for antique/vintage pieces? It can be anywhere in the world.**
Clignancourt market in Paris.

**What was the most memorable gift you've ever given or received?**
A magnificent aquamarine bauble, which looks like the one from the movie *Titanic*.

**What was your last purchase that you believe will mean something to you ten years from now?**
An oversized Romeo Gigli striped velvet coat from the eighties.

# JAQUI
# Lividini

**How did you come to own your possession?**

My dad gave it to my mom for their tenth anniversary. I was fascinated by it as a child. It always sat next to my parents' bed on my mom's nightstand. When my parents moved to a smaller house, I asked my mother if I could have it.

**How do you live with your heirloom?**

It sits in my bedroom next to my bed. It reminds me every day of my wonderful childhood, my amazing parents, and how completely blessed I've been in life.

**Who in your life has most influenced your personal style and taste?**

My grandmother was an incredibly stylish woman. Although an Italian immigrant, she always dressed perfectly. Classic, tasteful, and elegant in an understated way. My mom loved to be surrounded by beautiful things, but never flashy things. They were always understated and simple in the most elegant way. My mother and grandmother both were/are meticulous in every way. Try as I may to achieve that aesthetic, there is still a bit of rebel in me.

**Fill in the blank: Whenever I look at _____ I can't help but smile.**

Fine jewelry.

**What's the best part of your day?**

Dawn, before anyone else wakes up. I adore the quiet and solitude.

**Describe your ideal day.**

Lying in bed with a stack of fashion and shelter magazines, with no cares, worries, or problems to solve—preferably in my beach house bedroom, with my kitty, Schnitzel, by my side. The day would end with a dinner party out on our porch (which overlooks the sound), with great friends, children, dogs, the works. And fireworks, of course.

**What is your favorite place to shop for antique/vintage pieces? It can be anywhere in the world.**

Online: eBay, One Kings Lane, 1stdibs.
Brick and mortar: Marston House in Maine, the Paris flea market, and Kentshire.

**What was the most memorable gift you've ever given or received?**

A pair of glass earrings made from shards that we found at the Olson Farmstead. John and I are both Andrew Wyeth fans. One afternoon, while driving the backroads of Maine, we happened upon Christina's World! It was amazing to come up over a ridge and see this iconic painting come to life. This was many years ago, before it was acquired by the Farnsworth Museum. The house looked abandoned, and in fact the second floor windows were shattered. The shards had fallen onto the front door landing. Unbeknownst to me, John picked up a few shards and had them made into earrings for me.

**What was your last purchase that you believe will mean something to you ten years from now?**

When my daughter, Calliope, was born, I started a charm bracelet for her. The bracelet has a sea life theme since John and I love the sea so much, and we knew she would, too. I found the original bracelet on eBay, a beautiful vintage Tiffany charm bracelet that had been discontinued years ago. Each year, I add a sea creature charm to the bracelet—all eighteen-karat gold, all gorgeous and completely unique. I plan to give it to Calliope on her twenty-first birthday (in ten years) with twenty-one charms!

*Try as I may to achieve that aesthetic, there is still a bit of rebel in me.*

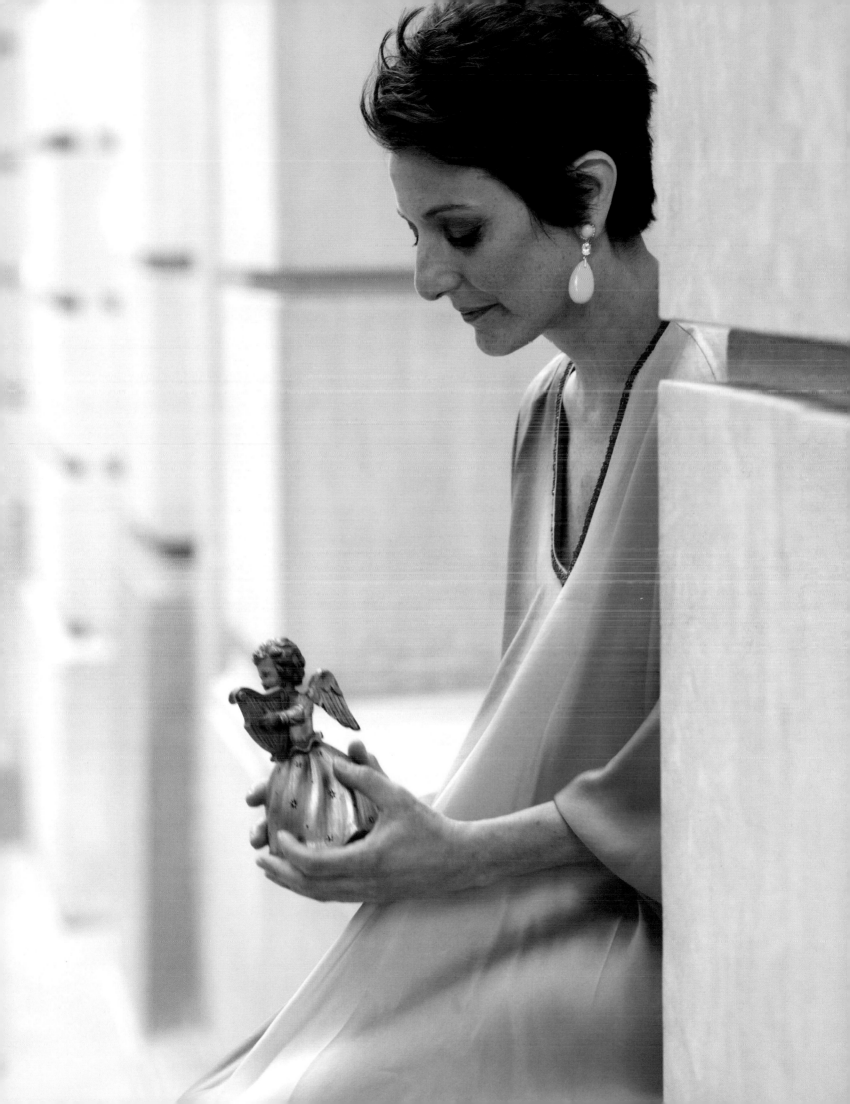

# REBECCA
# Minkoff

**How did you come to own your possession?**

My children are my greatest achievement; they're not a possession, they are my everything.

**How do you live with your heirloom?**

I live, eat, breathe, sleep—I do everything with them.

**Who in your life has most influenced your personal style and taste?**

My mom; when I was younger she encouraged me to make my own clothes and be creative.

**Fill in the blank: Whenever I look at _____ I can't help but smile.**

My children.

**What's the best part of your day?**

Coming home to my family.

**Describe your ideal day.**

Anything with my family; biking, going to the beach, swimming.

**What is your favorite place to shop for antique/vintage pieces? Can be anywhere in the world.**

Paris flea markets.

**What was the most memorable gift you've ever given or received?**

My engagement ring from my husband.

**What was your last purchase that you believe will mean something to you ten years from now?**

My apartment.

*My children are my greatest achievement.*

# ISAAC Mizrahi

**How did you come to own your possession?**

A psychic told me to start wearing diamonds on a Thursday. Any Thursday. So I had this ring made from an old Harry Winston setting, which I got from my friend.

**How do you live with your heirloom?**

I wear it every day. I take it off for bed. Also for the shower. Otherwise I'm always wearing it.

**Who in your life has most influenced your personal style?**

My mom.

**Fill in the blank: Whenever I look at _____ I can't help but smile.**

Dog.

**What's the best part of your day?**

Breakfast.

**Describe your ideal day.**

Breakfast out with my husband and the rest of the day spent at home with our dogs. Maybe a snowstorm.

**What is your favorite place to shop for antique/vintage pieces? Can be anywhere in the world.**

Any of the shops on Tenth Street. Karl Kemp, Maison Gerard, O'Sullivan Antiques.

**What was the most memorable gift you've ever given or received?**

My husband gave me the most beautiful gardenia plant.

**What was your last purchase that you believe will mean something ten years from now?**

My Hermès agenda, which is brown crocodile.

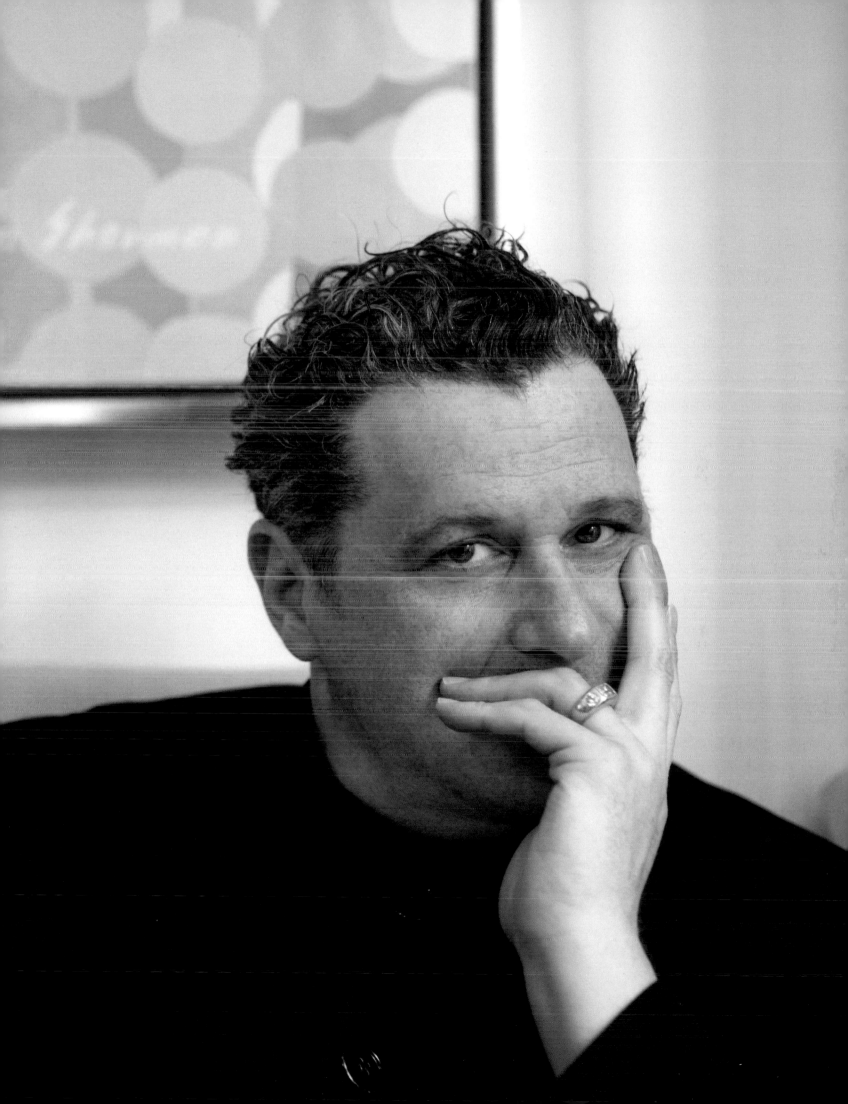

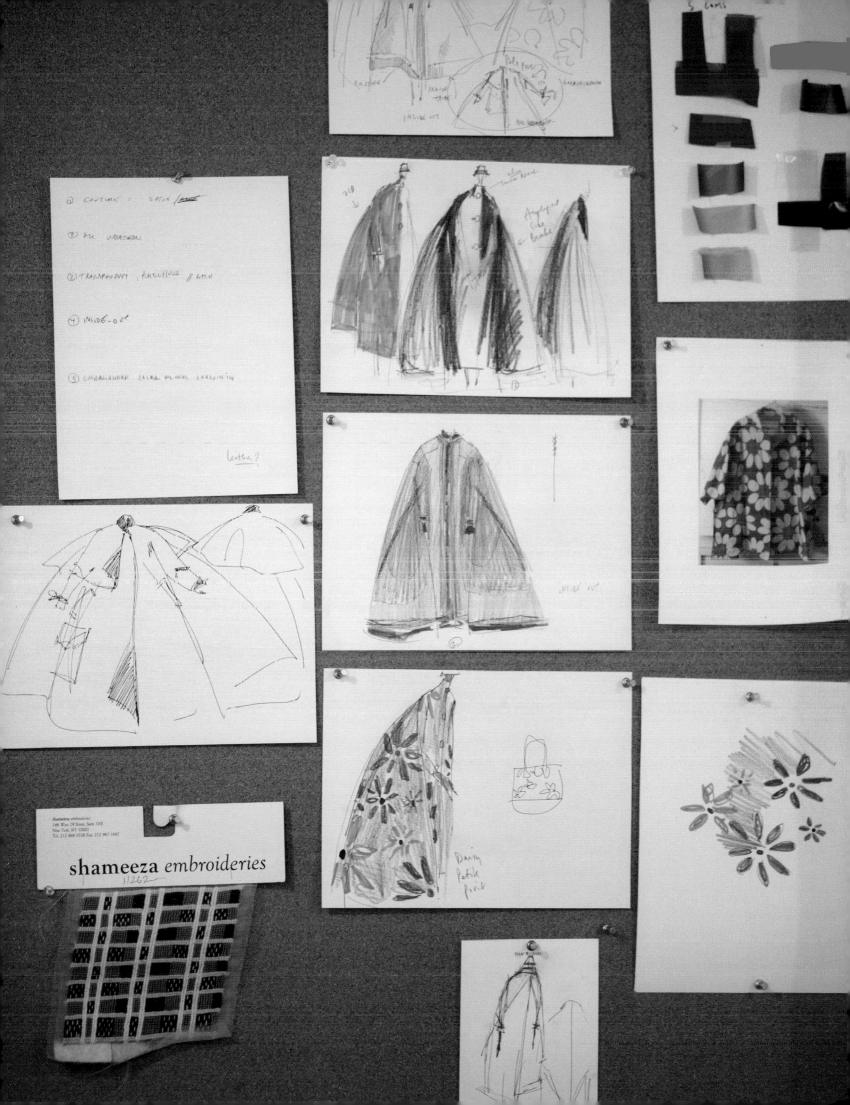

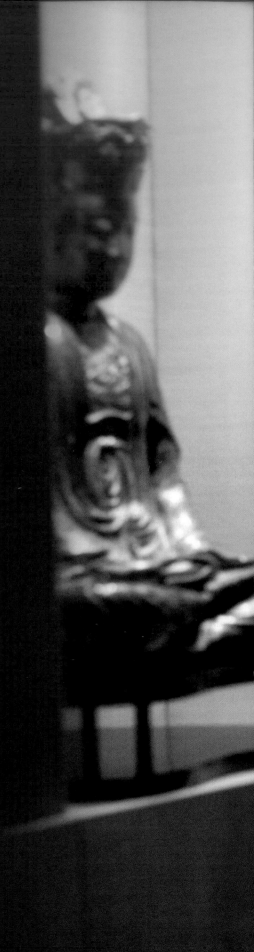

# JOSIE
# Natori

**How do you live with your heirloom?**

The Buddha is such a special piece that I keep it in one of my favorite rooms in my home, and one that I spend much of my time in, the piano room.

**Who in your life has most influenced your personal style and taste?**

My mother's style has most impacted my own. She always had a love for beautiful things and taught me to appreciate them from an early age. Lola, my grandmother, had that same love for art and beauty and passed it down to me as well.

**Fill in the blank: Whenever I look at _____ I can't help but smile.**

*One Thousand Buddhas.*

My favorite textile, *One Thousand Buddhas*, hangs framed in my dining room. It is unlike anything else I've ever seen. It's really a museum piece, and I was very lucky to encounter it. I feel it's so important to live amongst art. With this piece, not only do I appreciate its beauty, but it provides me with inspiration every day.

**What's the best part of your day?**

Winding down at the end of a hectic day is the best part. It's not only when I reflect back on the happenings of that day but also when I clear my mind for a new one as I get ready to go to sleep. I love my sleep!

**What was the most memorable gift you've ever given or received?**

The most memorable gift I've ever given was for both my parents and my husband on our twenty-fifth wedding anniversary. I played the piano in a concert with the Orchestra of St. Luke's at Carnegie Hall. It was a night we'll never forget! The best gift I've received is my grandson, Cruz Kai.

**What was your last purchase that you believe will mean something to you ten years from now?**

My Palm Beach apartment. It's the perfect place to get away and spend time with family and friends. In ten years, I'll still be vacationing there, enjoying some downtime with family, maybe even more grandchildren!

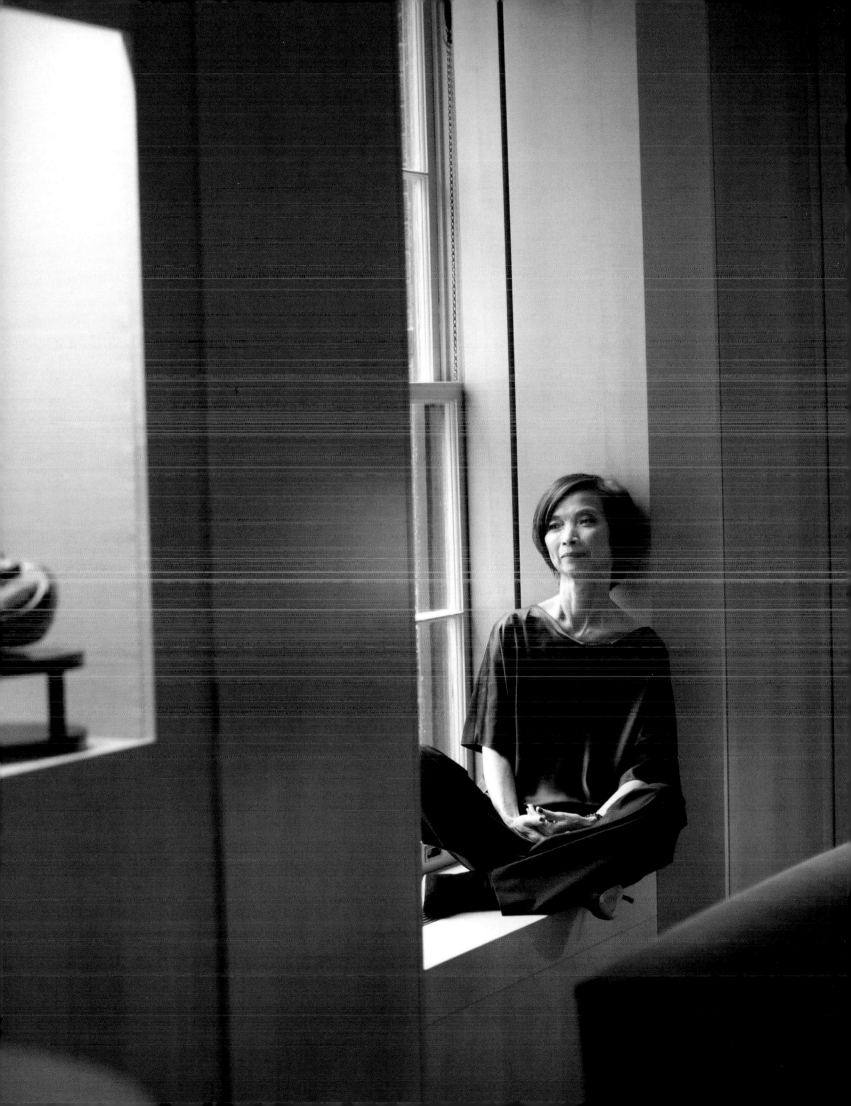

# BEATRIX Ost

**How did you come to own your possession?**
Seeing it by sheer luck.

**How do you live with your heirloom?**
Splendidly!

**Who in your life has most influenced your personal style and taste?**
My aunts, in my very early childhood. Read about it in *My Father's House*!

**Fill in the blank: Whenever I look at _____ I can't help but smile.**
A braggart.

**What's the best part of your day?**
Mornings.

**Describe your ideal day.**
Creating through the early afternoon, then cooking a meal and having friends over for the night.

**What is your favorite place to shop for antique/vintage pieces? Can be anywhere in the world.**
New York's vast possibilities.

**What was the most memorable gift you've ever given or received?**
Jewelry to my daughters-in-law when they gave birth.

**What was your last purchase that you believe will mean something to you ten years from now?**
Two crystal necklaces from a flea market in Paris.

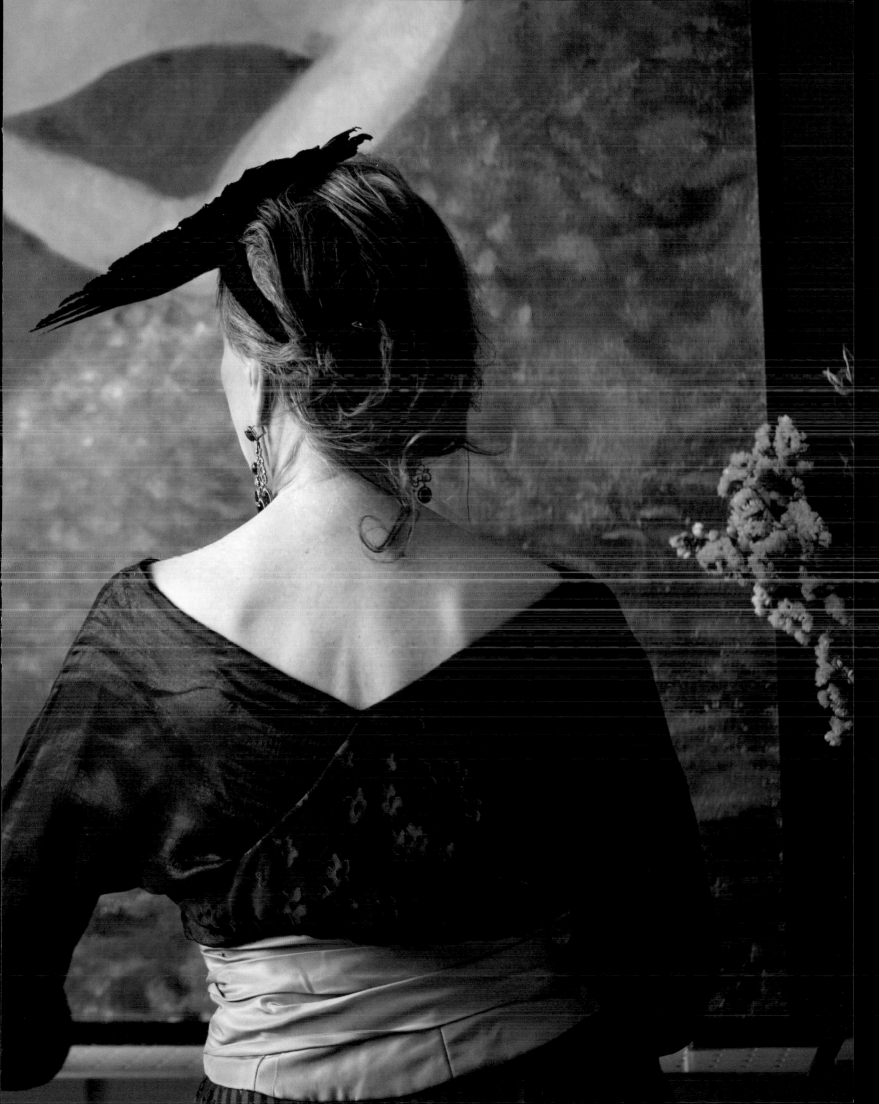

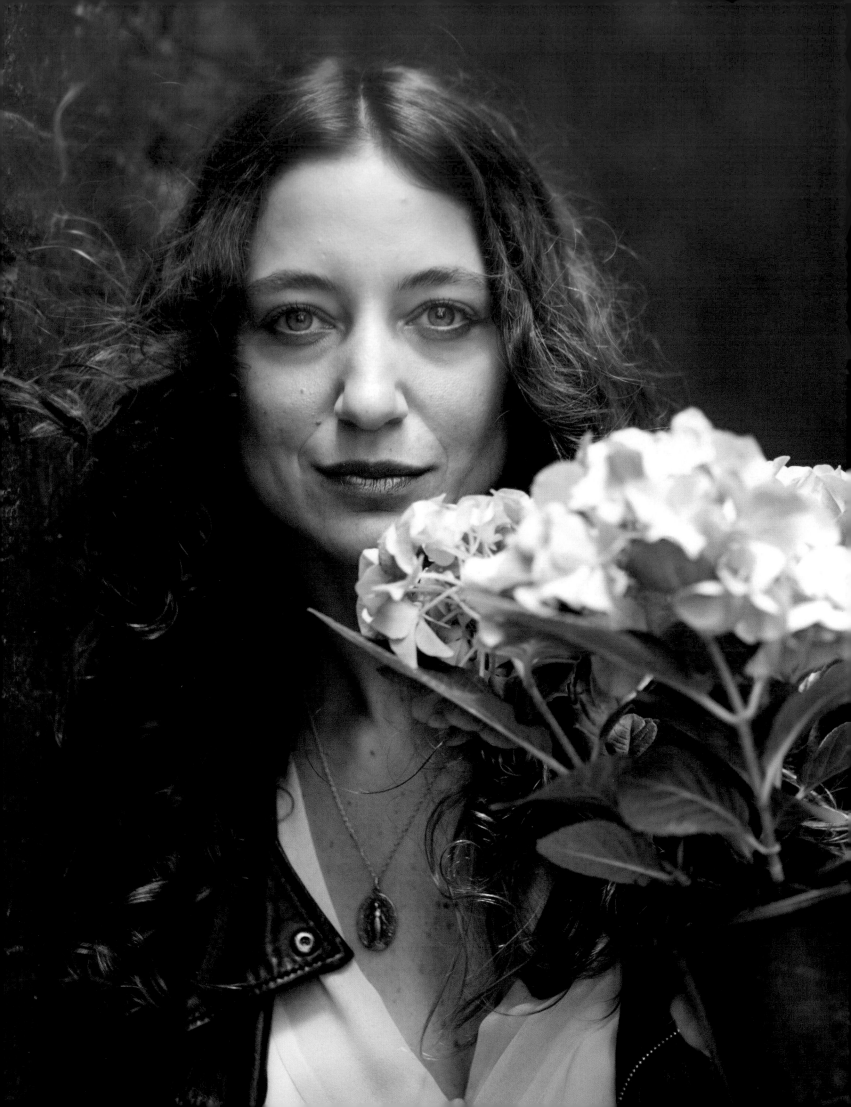

## (FLOWER GIRL NYC)

# DENISE
# Porcaro

**How did you come to own your possession?**

They belonged to close family members.

**How do you live with your heirloom?**

It's almost like the comfort of a memory, being that they are wearable.

**Who in your life has most influenced your personal style and taste?**

My mom.

**Fill in the blank: Whenever I look at _____ I can't help but smile.**

Puppy.

**What's the best part of your day?**

I like mornings.

**Describe your ideal day.**

It involves nature and being surrounded by those I get to love.

**What is your favorite place to shop for antique/vintage pieces? Can be anywhere in the world.**

Hudson, New York. You find the best when you are comfortable and the search isn't forced—that's half the battle.

**What was the most memorable gift you've ever given or received?**

A charm cluster, which my mom had made by a family friend for my twenty-fifth birthday. It explains me.

**What was your last purchase that you believe will mean something to you ten years from now?**

Vacations—you can't buy time, but the memories you make when on an amazing trip last a lifetime.

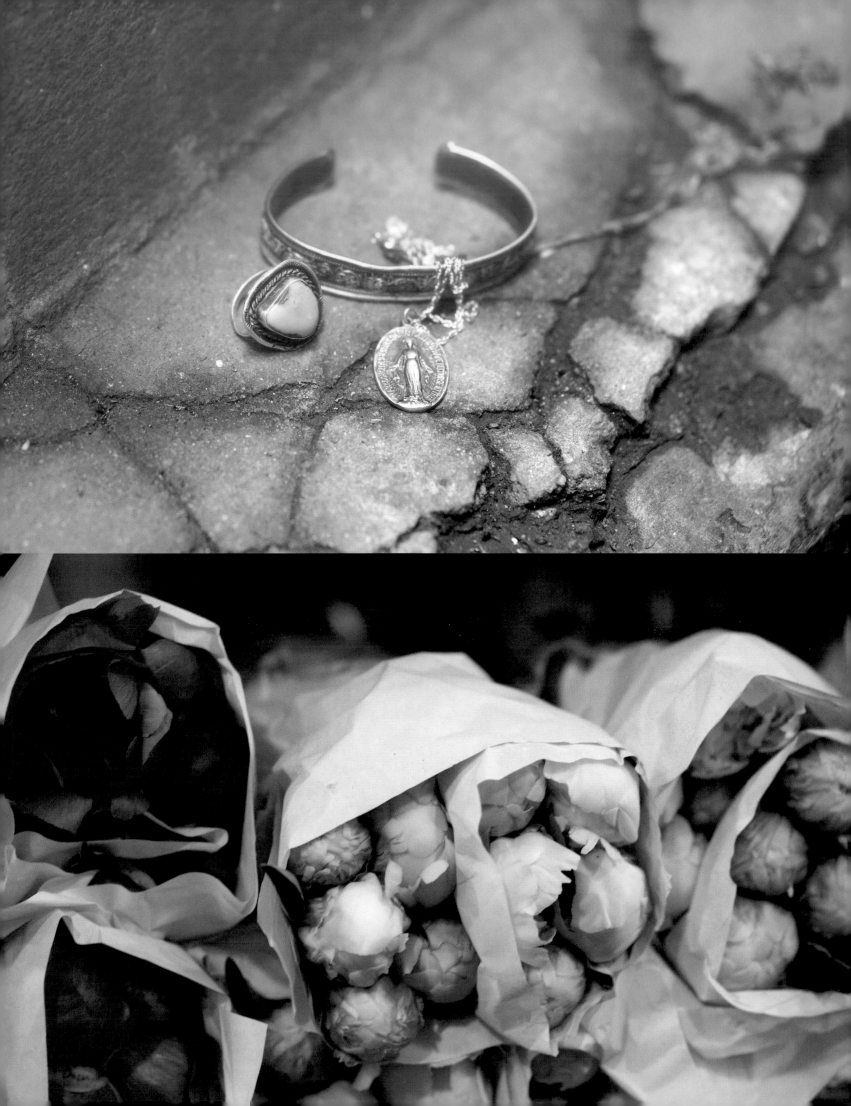

Believe or not, I do not shop.

# RALPH Pucci

**How did you come to own your possession?**

I represent numerous artists. Fabio Maria Micucci is our latest "find." The glass is produced in Murano.

**Who in your life has most influenced your personal style and taste?**

Professionally, Andrée Putman.

**Fill in the blank: Whenever I look at _____ I can't help but smile.**

Maira Kalman drawings.

**What's the best part of your day?**

Working with sculptor Michael Evert.

**Describe your ideal day.**

Working on new mannequin ideas in the morning and working with Patrick Naggar on furniture ideas in the afternoon.

**What is your favorite place to shop for antique/vintage pieces? Can be anywhere in the world.**

Believe or not, I do not shop.

**What was the most memorable gift you've ever given or received?**

My wife, Ann Pucci, replaced my thirty-year-old Cartier watch, which was stolen, with another Cartier watch.

**What was your last purchase that you believe will mean something to you ten years from now?**

A painting by Susan Rothenberg.

# ANNA
# Quindlen

**How did you come to own your possession?**

My mother loved little pretty porcelain things, perhaps because over the course of ten years she had five children and needed something tranquil in what was often a chaotic life. In 1971, I bought her this Royal Copenhagen bird for Christmas. It was her last Christmas; by mid-January she had died of ovarian cancer. So the little bird reverted to me, although I still think I'm just keeping it safe for my mother.

**How do you live with your heirloom?**

It sits on my desk every day, and has for many years. It's a kind of constant memory embodied in an object.

**Who in your life has most influenced your personal style and taste?**

I sound like a broken record, but probably my mother. Most of the time, she was in maternity smocks and shorts, but when she dressed to go out, she *really* dressed to go out. Black dress, black heels, red lipstick, jewelry. She taught me how to put on makeup and what to wear and not wear. Brunettes don't wear blue. It's as simple as that.

**Fill in the blank: Whenever I look at _____ I can't help but smile.**

Labrador retriever.

**What's the best part of your day?**

If I've had a good run of writing, I can knock off at about 4:00 p.m. and watch an hour or so of television before my husband gets home for dinner. I think the person who invented the DVD and On Demand cable should win the Nobel. I can curl up with my needlepoint and watch *Homeland* or *The Good Wife*. I hate people who trash television; there's so much good stuff on these days.

**Describe your ideal day.**

Read the papers, power-walk for an hour, talk to my best friend Janet on the phone, go out to Cafe Luxembourg for breakfast with one of my kids, read a Scandinavian mystery novel, putter around the neighborhood, buy something at Babette, and maybe have everyone over for takeout from Shun Lee. Or, alternatively, go to London and just walk around from morning till night and finish at the theater in the West End. I appreciate either very ordinary or very out of the ordinary.

**What is your favorite place to shop for antique/ vintage pieces? It can be anywhere in the world.**

I collect Victorian mourning jewelry, and there really is no better place than the stalls and small shops of London.

**What was the most memorable gift you've ever given or received?**

For his fiftieth birthday, I told my husband we were going to brunch. We got in a cab and after a while he realized that we were on our way to Kennedy Airport. When we got on a flight to Montego Bay, he figured out that I was taking him to the elegant house called The Hermitage on Bluefields Bay in Jamaica that we had rented for years when the kids were small. When the kids got on the plane just before they closed the doors, he started to cry.

**What was your last purchase that you believe will mean something to you ten years from now?**

I built a writing porch on a knoll overlooking our country house. It seemed like a ridiculous indulgence at the time, but now I think that if it only had a bathroom, I would move into it full time.

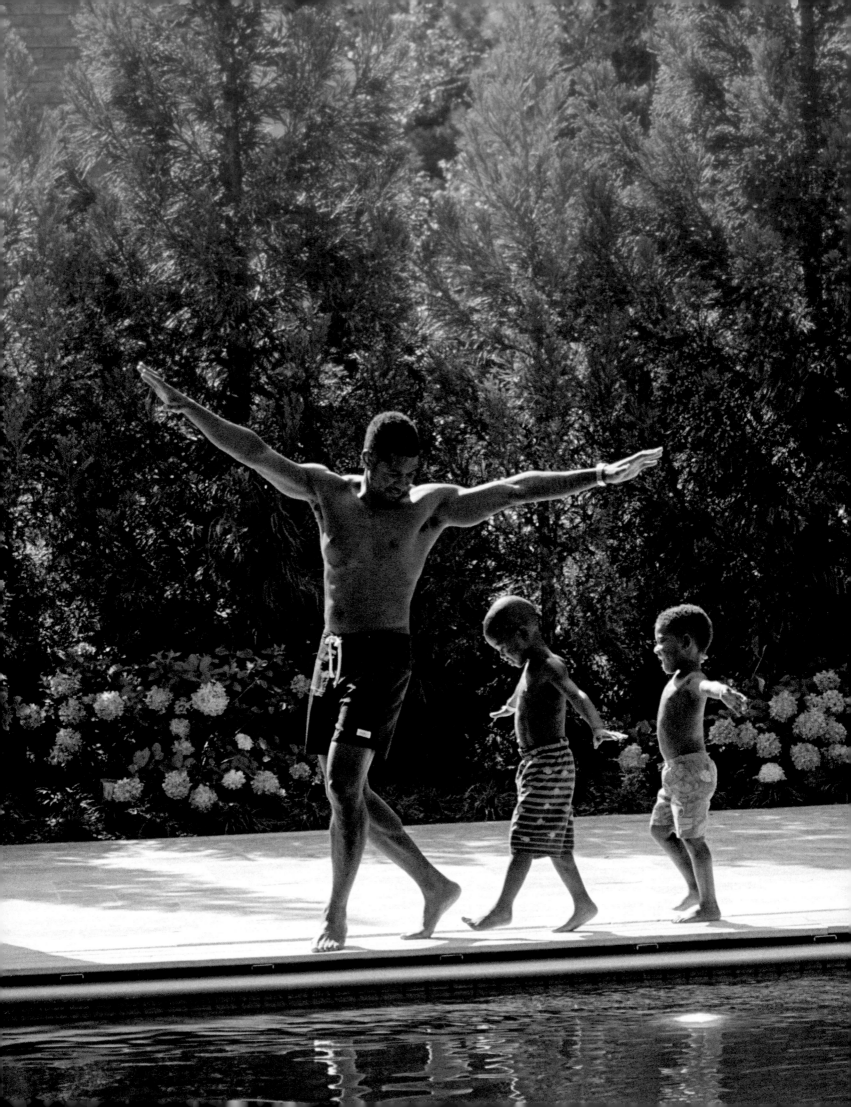

# Usher
## RAYMOND IV

### How did you come to own your possession?

My possession is home. Home is where I am so often, and the greatest part of home is the people who are there, the people who make me feel comfortable: my kids and wife, friends, and family.

### Who in your life has most influenced your personal style and taste?

An eclectic mixture has influenced me over time. I established my style based on all of the places I have gone, the things I have seen, and the broadly different taste levels of those I have met. In that sense, my style is a melting pot of the greatness and quality of my experiences. And the breadth of these influences ultimately also allows me to create my own history, since each of our histories is formed by how we incorporate our personal style into our life and work.

# DAVID Rockwell

**How did you come to own your possession?**

I've been collecting kaleidoscopes for more than twenty years. I've amassed my collection from a variety of places, and some were given to me as gifts. Kaleidoscopes are an interesting analogy to look at the world. At their core, they take objects that we're familiar with and jumble them to create surprising new ideas. It's kind of like the Busby Berkeley of toys.

**How do you live with your heirloom?**

I keep many of my kaleidoscopes in my office. They're a great source of inspiration for my work. Rockwell Group is a mashup of some 150 designers from a diversity of disciplines, so my studio is quite kaleidoscopic!

Two of my favorites are the Slow Yo-Yo and the Tilt-a-Whirl kaleidoscopes. The Slow Yo-Yo's body is covered in red leather with a wood trim. As you look into it, you reel a crank that sends colored ribbons up, and the ribbons spin out like a yo-yo to create a kaleidoscopic image.

I recently purchased the Tilt-a-Whirl, a kaleidoscope made from African bubinga wood with a large glass object chamber over seven inches long and three inches wide, filled with silicone beads, dichroic glass, and other objects. The chamber is filled with glycerin so the objects float at different rates and in different directions.

I love the fact that both the Slow Yo-Yo and the Tilt-a-Whirl are made by Tom and Carol Paretti, two master woodcrafters that have been creating imaginative, handcrafted kaleidoscopes for years.

**Who in your life has most influenced your personal style and taste?**

My mother Joanne probably influenced me the most. She ran a community theater in Deal, New Jersey. Those productions opened my eyes to the power of design to create compelling narratives and emotional connections between people and their environments. They also made me realize that something temporary could have as much impact and power as something permanent.

**Fill in the blank: Whenever I look at _____ I can't help but smile.**

A "pocket park." New York City has a number of these mini parks. These urban public spaces have the quality of an oasis—they interrupt the pulse of the city, providing people with places for repose or play. Paley Park in midtown Manhattan is one of the best examples. Designed in 1967 by Zion & Breen Associates, its dramatic waterfall drowns out the din of the city.

**Describe your ideal day.**

Taking my kids to school, going to the gym, and walking across Union Square Park to my office. The rest of the day is a series of in-house design meetings with my staff about a range of current projects, including Andaz Maui, Nobu Doha, the National Center for Civil and Human Rights in Atlanta, and a new rug collection for The Rug Company. Then I go home in time to have dinner with my wife and our kids, have a glass of wine, do some sketching, and go to bed around midnight.

**What is your favorite place to shop for antique/ vintage pieces? It can be anywhere in the world.**

Joanne Hendricks Cookbooks at 488 Greenwich Street in Manhattan is a one-of-a-kind shop. During my free time, I cook for family and friends, so I love to explore their eccentric collection of antique cookbooks and cookware from around the world.

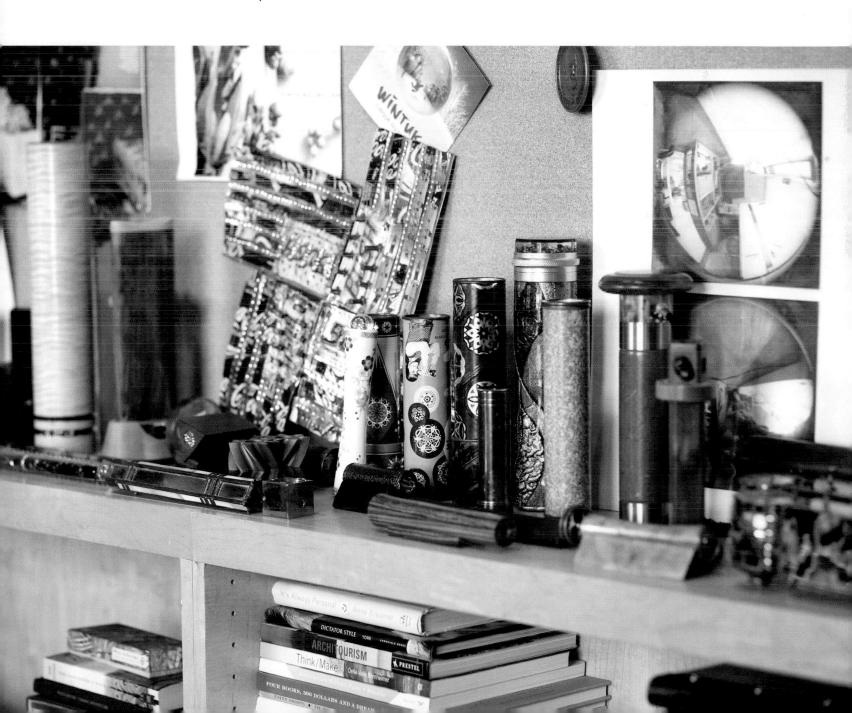

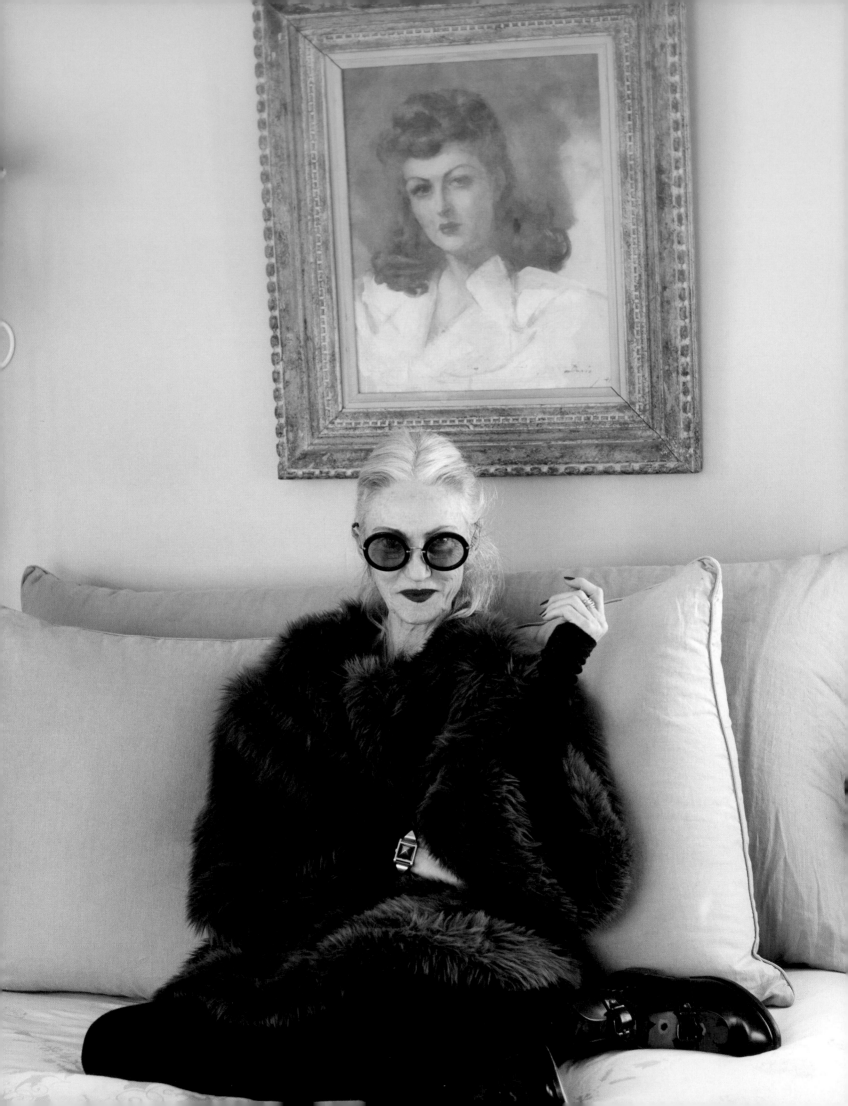

# LINDA
# Rodin

**How did you come to own your possession?**

I inherited it from my mother.

**How do you live with your heirloom?**

It hangs above my bed.

**Who in your life has most influenced your personal style and taste?**

My mother and my aunt.

**Fill in the blank: Whenever I look at _____ I can't help but smile.**

Winky, my doggie.

**What's the best part of your day?**

Getting home after work and relaxing and not looking at my iPhone.

**Describe your ideal day.**

Waking up around 11:00 a.m. Having a delicious cappuccino, walking around town with Winky, antiquing and taking it easy.

**What is your favorite place to shop for antique/vintage pieces? It can be anywhere in the world.**

Anywhere and everywhere. A treasure is beckoning me from all sorts of places.

**What was the most memorable gift you've ever given or received?**

My basset hound, Billy.

**What was your last purchase that you believe will mean something to you ten years from now?**

A gold necklace I bought that says *Winky* in script.

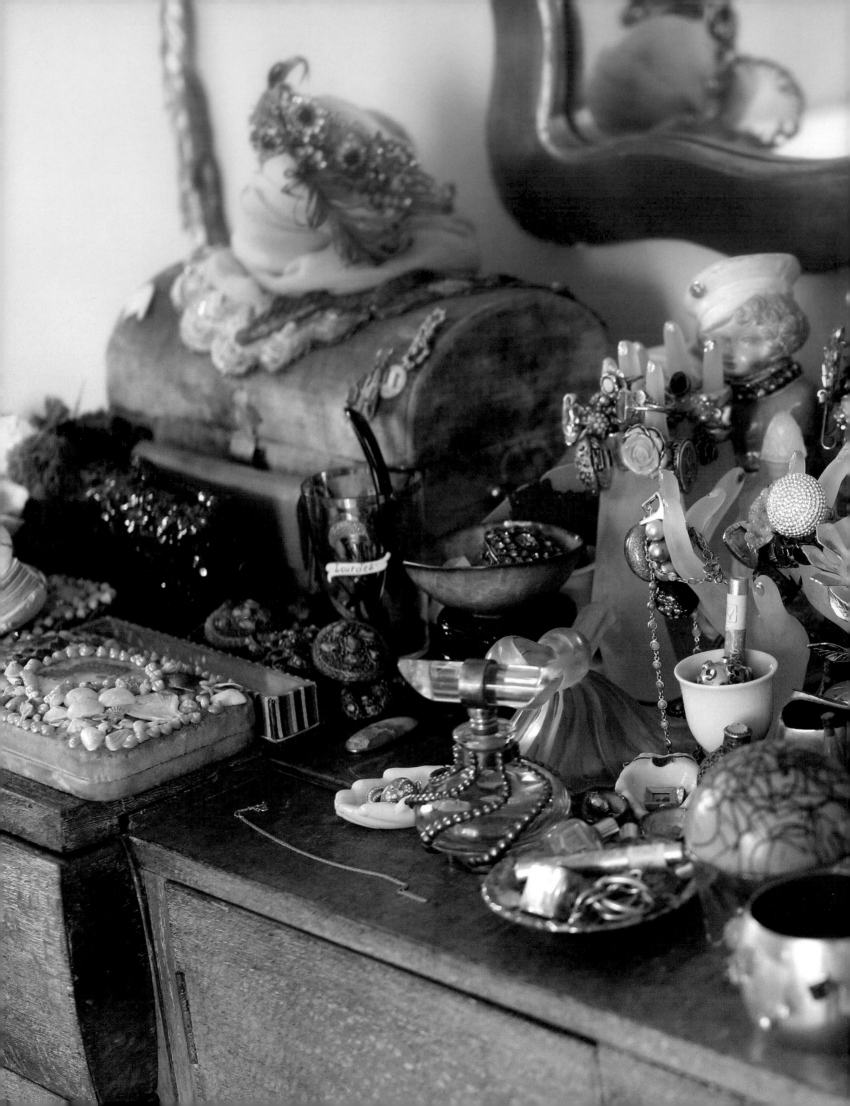

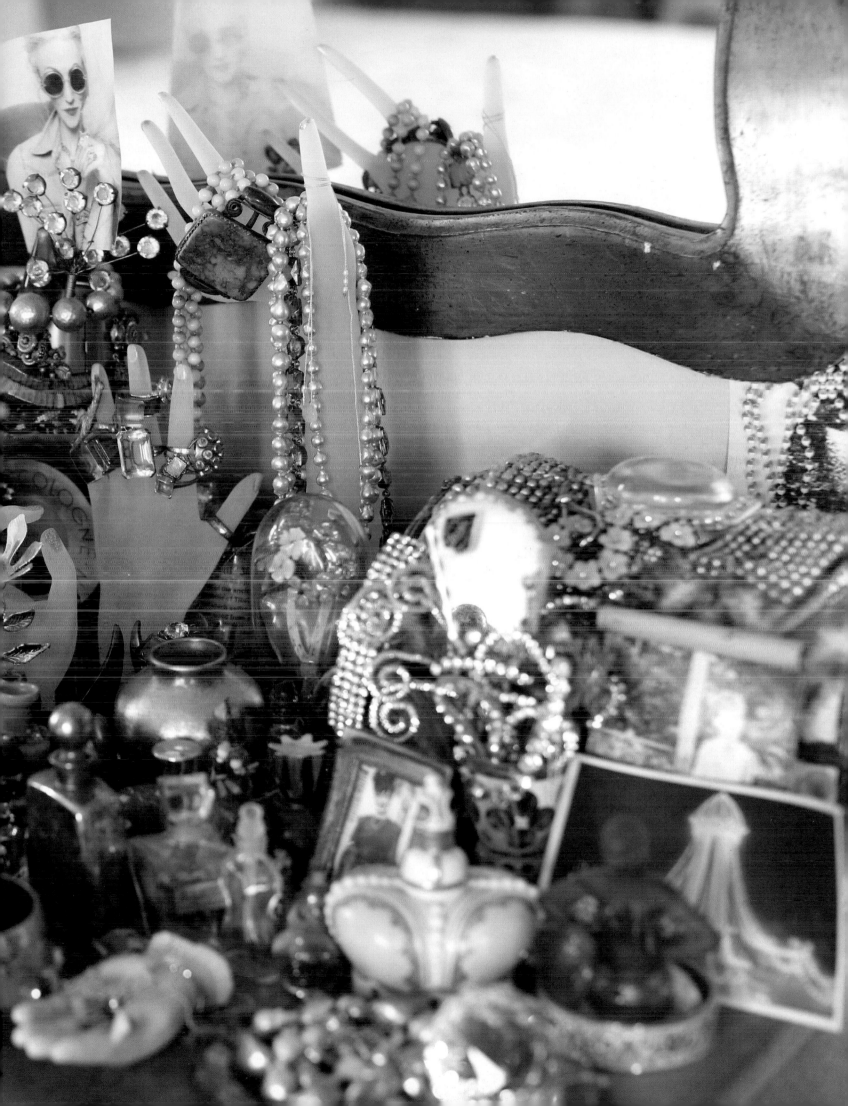

# LELA
# Rose

**How did you come to own your possession?**

My mother gave me these chairs and she got them from her mother. I love that they have been in all of our homes and have looked completely different in each one.

**How do you live with your heirloom?**

They serve as a glamorous focal point of my living area. I have the chairs covered in a fabric that was hand-embroidered with thread and paillettes. It's fun to have something with a little sparkle to sit on!

**Who in your life has most influenced your personal style and taste?**

Hands down—my mother. She will always be an inspiration, and I find I have to have her approval, even still.

**Fill in the blank: Whenever I look at _____ I can't help but smile.**

My adorable dog.

**What's the best part of your day?**

Coming home to my kids at the end of the day and getting hugs.

**What's the most memorable gift you've ever given or received?**

A Christmas gift from when I was a little girl. My mother would do a "string" gift every year, where I would unwrap a little box and inside would be a string. I would have to follow the string winding around the house to my actual gift. My favorite year was when she had hidden fifteen Steiff animals in a tree. I still own all of these Steiff animals and use them to decorate my own Christmas tree.

**What was your last purchase that you believe will mean something to you ten years from now?**

My husband just bought me a work of art by Pae White. It stops me in my tracks every time I see it and hope it will continue to do so for many years to come.

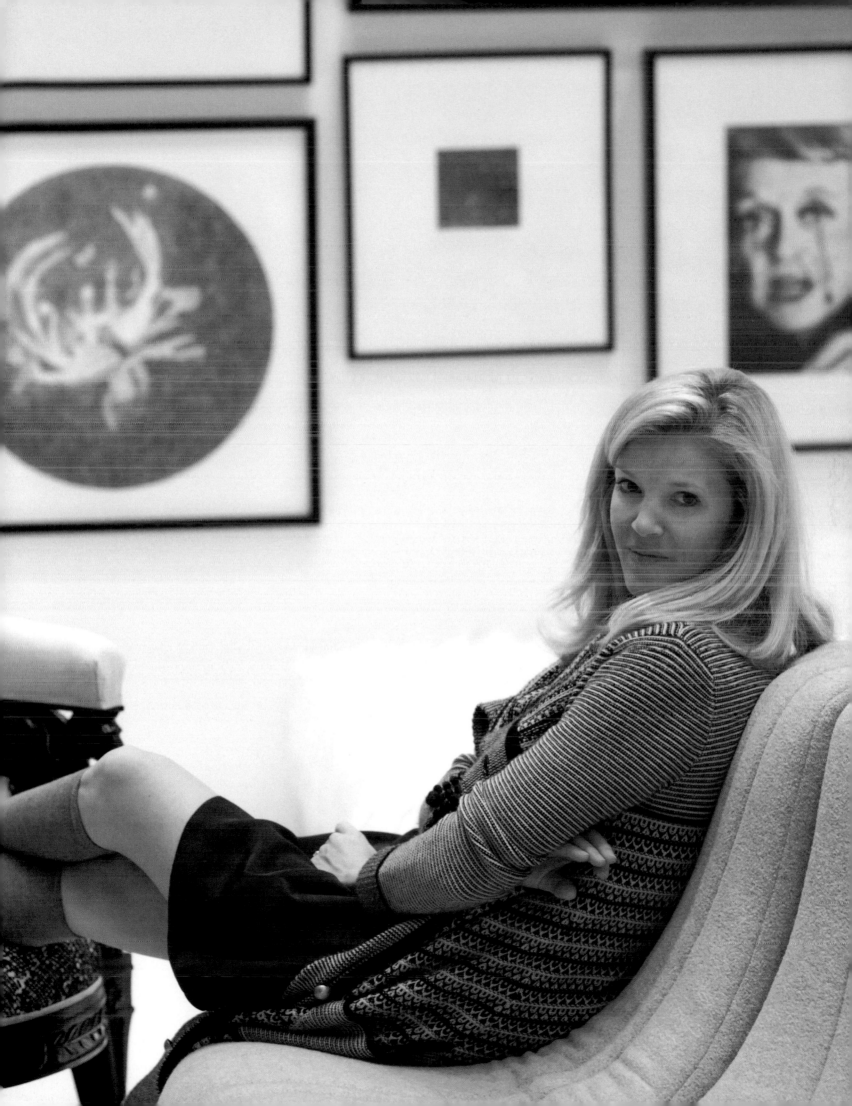

# JOHNNY
# Rozsa

**How did you come to own your possession?**

I collect stuff on my travels. Turquoise from Albuquerque, seed beads from Bahia, glass beads from East Africa, and a stone necklace from a New York thrift store!

**How do you live with your heirlooms?**

In baskets at home.

**Who in your life has most influenced your personal style and taste?**

Nancy Cunard and Diana Vreeland.

**Fill in the blank: Whenever I look at _____ I can't help but smile.**

Mirella Ricciardi photograph.

**What's the best part of your day?**

Horizontal—in bed.

**What is your favorite place to shop for antique/vintage pieces? It can be anywhere in the world.**

Tangier.

**What was the most memorable gift you've ever given or received?**

A first-class return ticket to Tokyo.

**What was your last purchase that you believe will mean something to you ten years from now?**

A handwoven Moroccan marriage blanket.

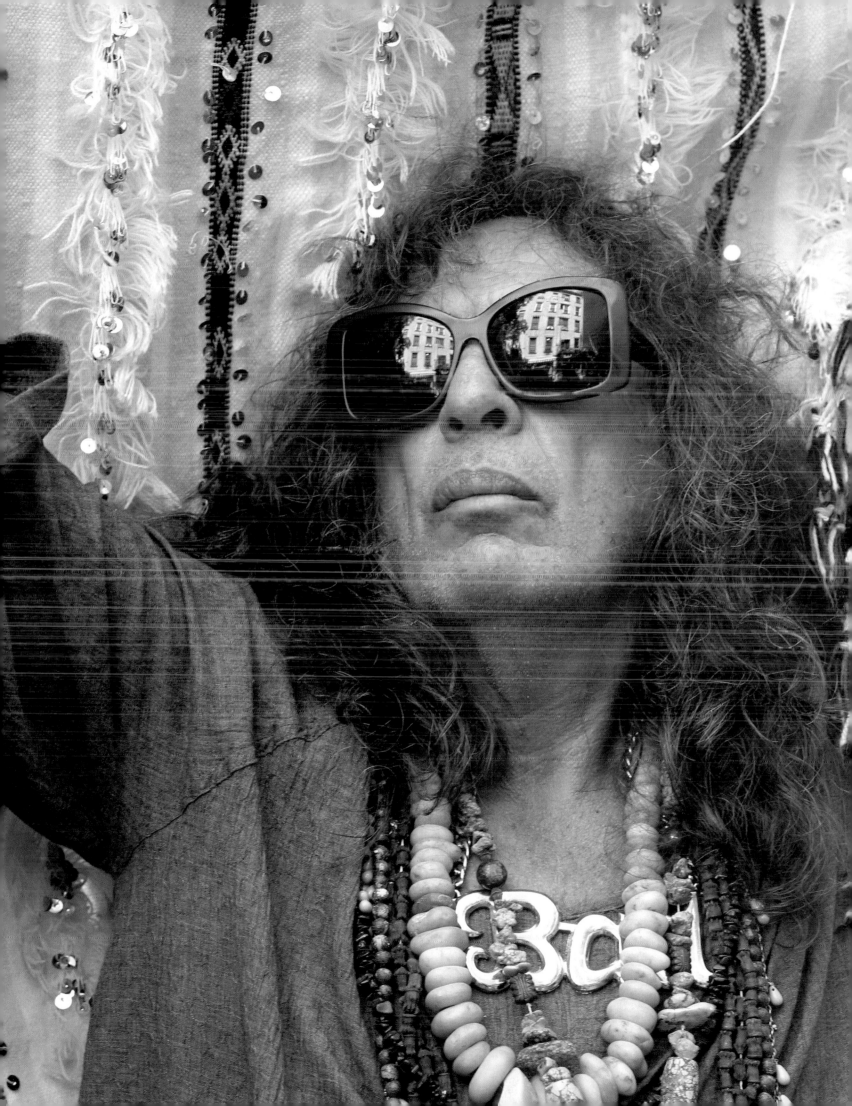

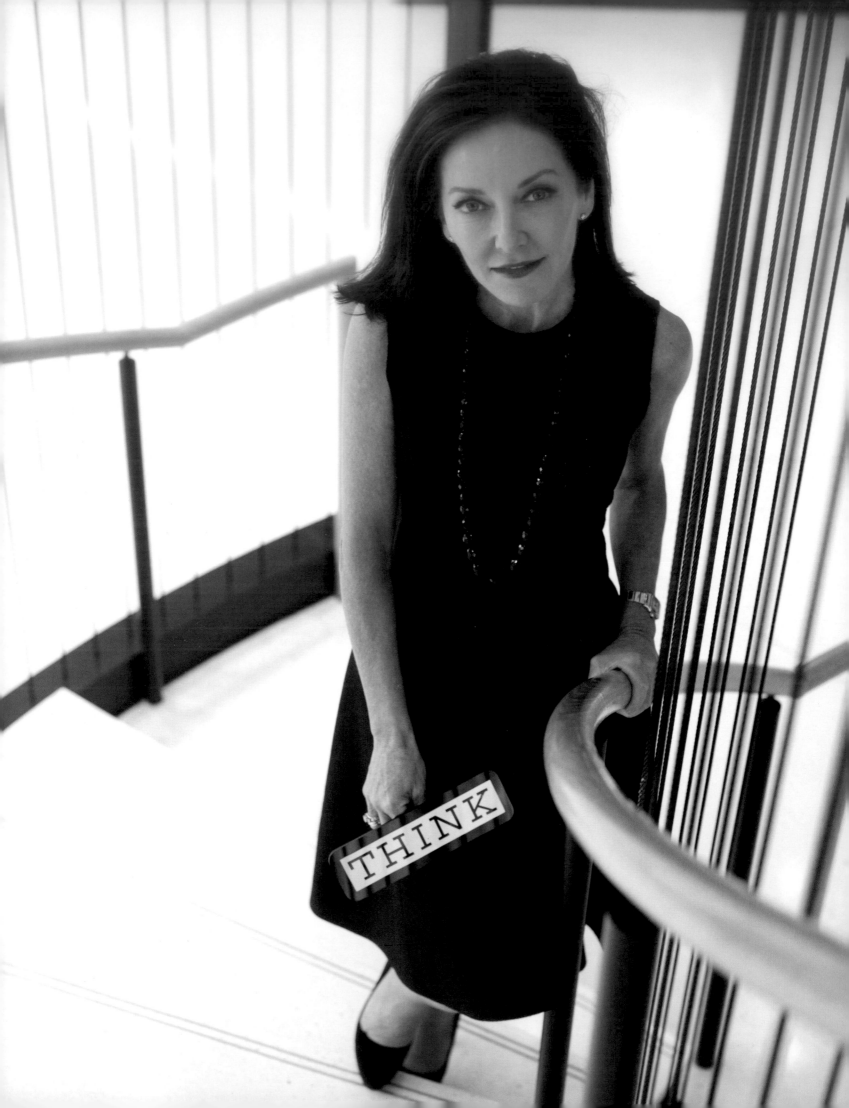

# MARGARET Russell

### How did you come to own your possession?

One of the things I treasure most is actually quite humble. It's a small vintage sign from IBM that says *think*. It's a daily reminder of my father, who passed away when I was a teenager. He was assistant general counsel of IBM in the 1970s, and I recall that nearly every object at the company during that time was emblazoned with this mantra—pens, pencils, notepads, etc.

In truth, my father was an extraordinary man—very inspiring and deeply kind—but he wasn't particularly patient. He taught my sister, brother, and me to be fearless and strong and to rise above challenges; he expected us to excel.

### How do you live with your heirloom?

The sign sits next to my desk at work, and it makes me stay focused. It keeps me on track. One simple yet powerful word: *think*.

## CHRIS "MAD DOG"
# Russo

**How did you come to own your possession?**

My grandfather's watch. It was given to my grandfather in 1963.

**How do you live with your heirloom?**

I wear it.

**Who in your life has most influenced your personal style and taste?**

My wife, Jeanne.

**Fill in the blank: Whenever I look at _____ I can't help but smile.**

My watch. It makes me think of my grandfather. He was born in 1898 and died in 1975.

**What's the best part of your day?**

Sitting on the 6:16 train heading to Darien, Connecticut.

**Describe your ideal day.**

Sitting in a high school gym watching my sixteen-year-old playing an AAU basketball tournament.

**What is your favorite place to shop for antique/ vintage pieces?  It can be anywhere in the world.**

I am not an antique/vintage shopper.

**What was the most memorable gift you've ever given or received?**

I received a backstage pass for a Bruce Springsteen concert as a birthday present a few years ago.

**What was your last purchase that you believe will mean something to you ten years from now?**

A book by Rennie Airth, *The Reckoning*.

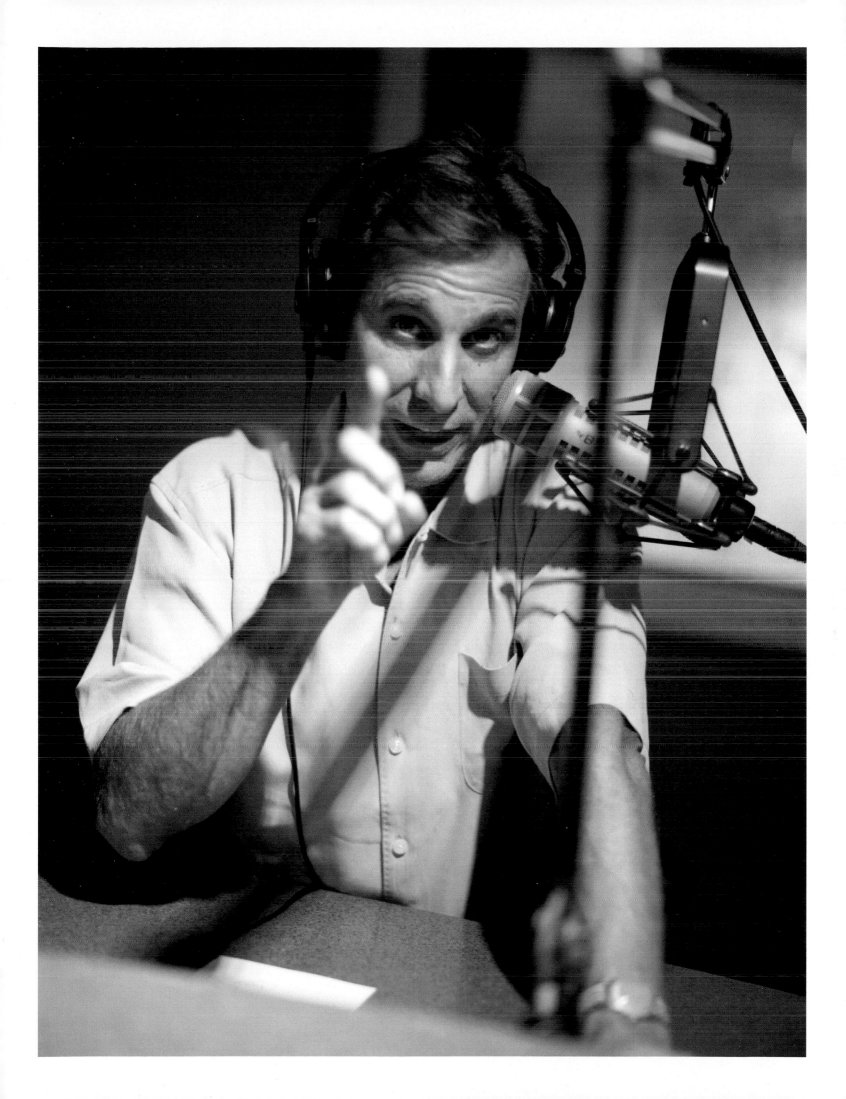

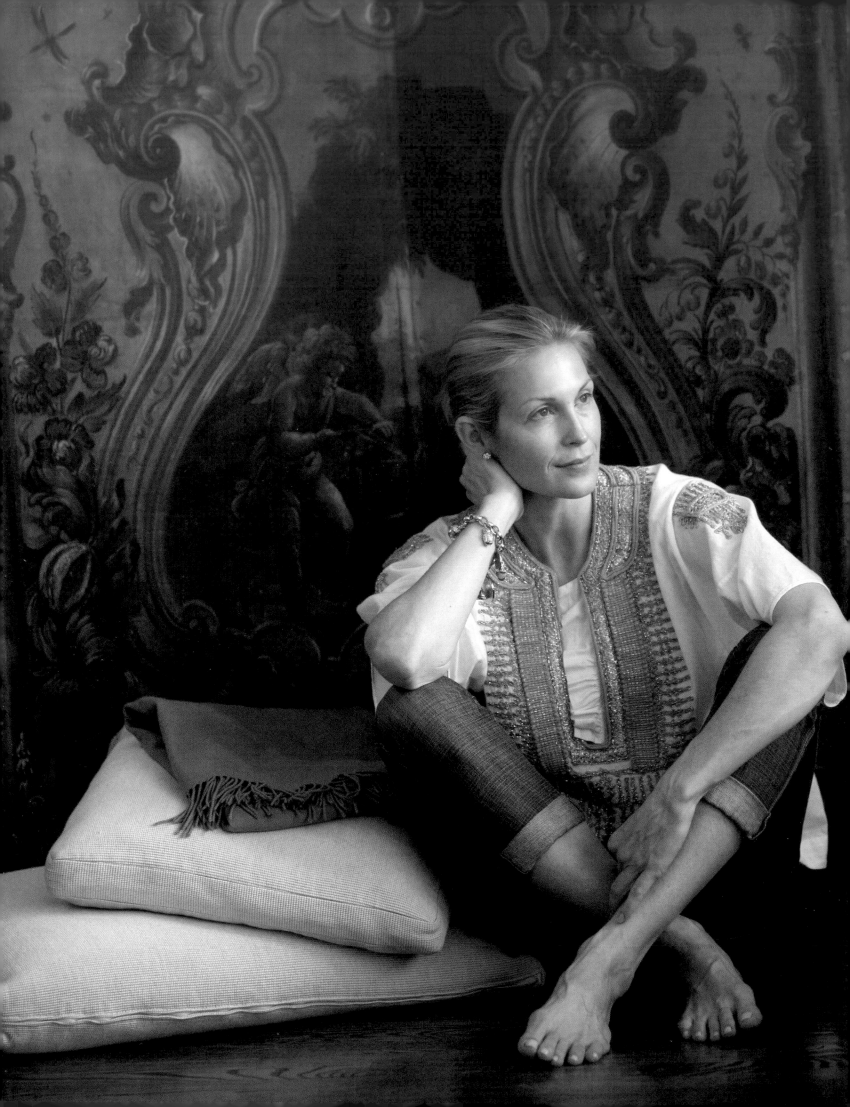

# KELLY
# Rutherford

**How did you come to own your possession?**

I went to a Marlene Dietrich auction at Sotheby's years ago. Everyone wanted the clothes, of course. I stayed and bid on the screen and a triangle-shaped side table—a gift from Dietrich's friend, Ernest Hemingway. I've had the pieces ever since.

**How do you live with your heirloom?**

The screen is used behind the B&B Italia sofa, so we look at it every day. I've been too busy to hang it on the wall!

**Who in your life has most influenced your personal style and taste?**

Actresses like Catherine Deneuve and Grace Kelly. Vogue magazine in all its foreign edition languages. Oh, and my mother!

**Fill in the blank: Whenever I look at _____ I can't help but smile.**

My children, Hermes and Helena.

**What's the best part of your day?**

Cuddling with my children wherever we are. Hearing their voices. Hearing the word *mama*.

**What's the most memorable gift you've ever received?**

My children's artwork. In fact, I'm making a whole wall of it.

**What was your last purchase that you hope will mean something to you ten years from now?**

My Hermès bags. Not only are they a great investment, but my daughter will love them.

# NAUSHEEN Shah

**How did you come to own your possession?**

I have always been a fan of vintage trunks. When I moved into my new apartment in the West Village, which is notorious for shoebox living, each piece of furniture had to have a purpose—usually multiple purposes—to conserve space. As luck would have it, I discovered this gorgeous 1890s Damier Louis Vuitton trunk with Japan and Singapore stamps on it while on my hunt for new furniture.

**How do you live with your heirloom?**

It now acts as my coffee table/miscellaneous storage/art piece.

**Who in your life has most influenced your personal style and taste?**

It's tough to pinpoint one person, as it has been more a combination of events in my life. From growing up with three sisters, to running Zac Posen's collections, to becoming a travel writer . . . these would be three pivotal points in my life that have evolved my style.

**Fill in the blank: Whenever I look at _____ I can't help but smile.**

Body of water.

**What's the best part of your day?**

The best part of my day is when the most unexpected moments happen. In New York City, we all have a routine, but it is often broken by the most wonderful surprises. It's one of the main reasons I live here: anything is possible.

**Describe your ideal day.**

Well, I am a travel/fashion writer who travels fifty percent of the year. So ideally I would be spending the day in some exotic location on the other side of the world, scoping out new restaurants, shops, exhibits, and beaches, of course!

**What is your favorite place to shop for antique/vintage pieces?  It can be anywhere in the world.**

I love the antique shops in Hudson Valley and Marguerite de Valois in Paris.

**What was the most memorable gift you've ever given or received?**

I gave a dear friend of mine a necklace with an antiqued metal envelope pendant. In addition, I gave her five mini metal plates with a special word engraved on each one. That way, she could slip one of the plates into the envelope whenever she needed that particular word the most and hold it close to her heart.  I am a strong believer in energies and manifestation.

**What was your last purchase that you believe will mean something to you ten years from now?**

Well, my vintage Louis Vuitton trunk, of course!

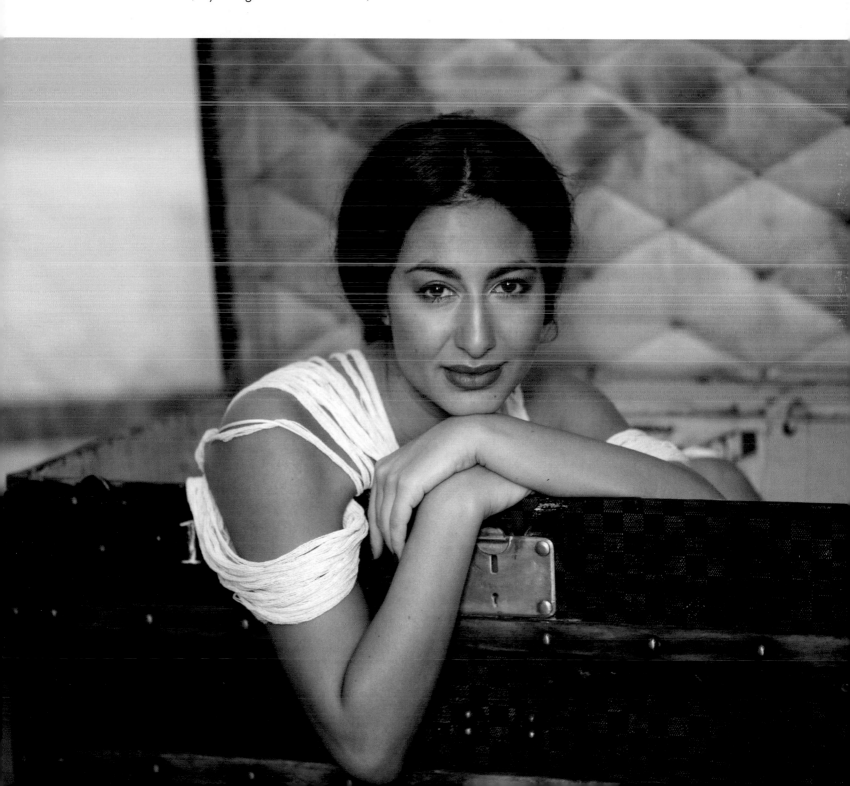

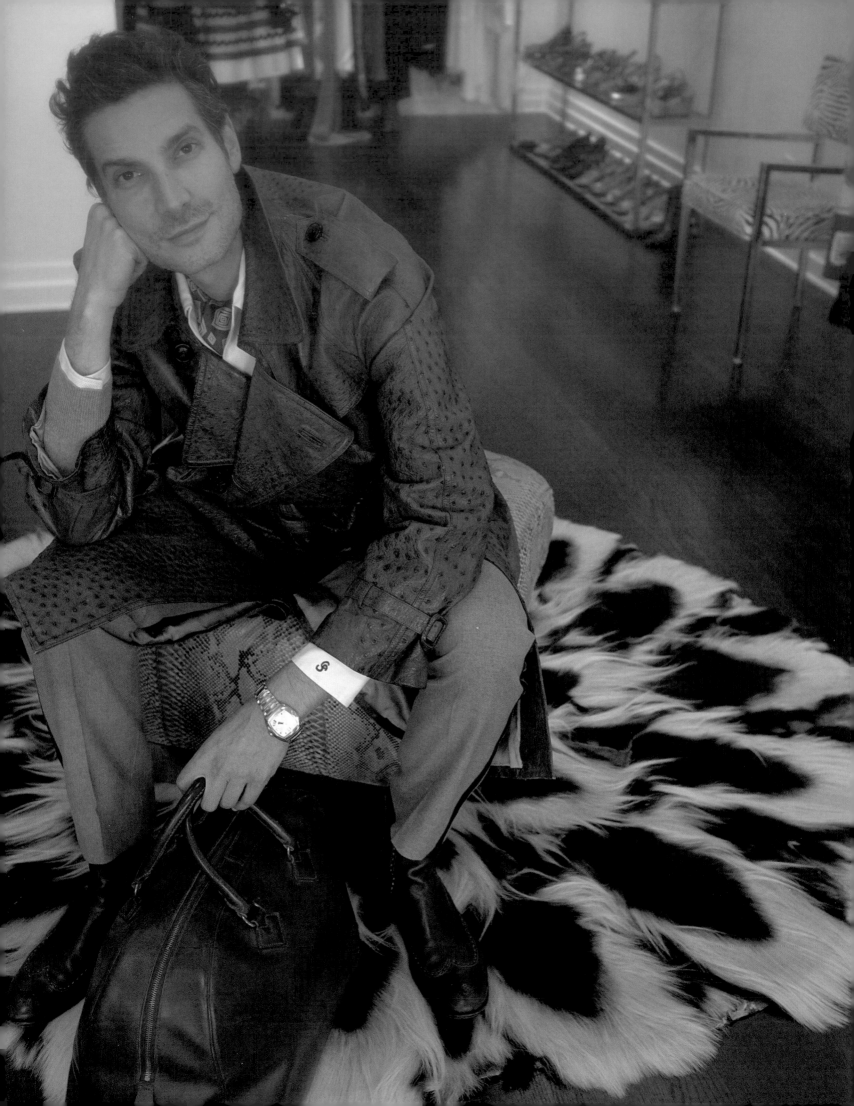

# CAMERON Silver

**Who in your life has most influenced your personal style and taste?**
Everyone influences me daily.

**Fill in the blank: Whenever I look at _____ I can't help but smile.**
Gary, my dog.

**What's the best part of your day?**
Waking up, drinking coffee, and enjoying the morning.

**Describe your ideal day.**
A morning hike, followed by yoga, then a casual alfresco brunch at home with friends.
Finally, a nap and then a Lebanese dinner with my family.

**What is your favorite place to shop for antique/vintage pieces? It can be anywhere in the world.**
Marché Serpette and Paul Bert in Paris.

**What was the most memorable gift you've ever given or received?**
A one-of-a-kind Boucheron platinum and diamond watch.

**What was your last purchase that you believe will mean something to you ten years from now?**
My house, and that was fifteen years ago!

*Everyone influences me daily.*

# SALLY
# Singer

**How did you come to own your possession?**

My heirloom is a forty-square-inch brass table by Philip and Kelvin LaVerne, a father-and-son team who made unique metal furniture in the 1960s. This is a strange piece for the craftsmen, who were best known for much more elaborate, often historical scenes on tables. Etched into the face of this particular table are figures from the Sistine Chapel that appear unfinished by these designers' standards.

I found the table seven years ago in a storage space that belonged to a copy editor who worked at *House Beautiful.* I was looking to buy some furniture when I saw the table under a pile of things. I immediately thought, *That is what I need in my life.* I paid $800 for it, which seemed like a fortune at the time. But actually, when I later looked up the LaVernes, I realized their pieces start at around $10,000 at most auction houses.

I bought the table when my three boys were small (they're now ten, nine, and seven). I think children remember things like faces and have an appreciation for representational art. My sons always sit in the same places, next to the same figures. They know who has got which guy. There's not a lot of etching, but the faces are specific and important to my kids.

**How do you live with your heirloom?**

As you enter our house and go down a hallway, you're immediately in our kitchen, which opens into our living room. The table is one of the first things you see. It sort of defines the center of how we live because we're always at that table. We eat on it every single day. Anyone who comes in and sits at it looks down and smiles because they see a funny little face staring up at them. I've really come to appreciate it.

**Who in your life has most influenced your personal style and taste?**

My maternal grandmother influenced me, but not in a direct way. She was a bourgeois, Midwestern Jewish woman from Minneapolis. She had very precise ideas of what looked, as she would say, "smart." She bought expensive things and wore them often. She had one Valentino sweater (not ten) that she kept in pristine condition. She also had a Calvin Klein and Chanel jacket and three St. John's knits. She wore these pieces repeatedly to every event and party.

That kind of rigor and precision in how you pick the things that define you (there was no promiscuity in her wardrobe or life) was everything I rebelled against for an enormous part of my life. I was a punk kid with little respect for things like that.

I probably started appreciating her style when I began working in fashion and thinking about clothes professionally. It was right around the time she passed away. I had to go through all her stuff with my sister. There wasn't much, but what she had was really good and in impeccable shape. I think this is very much the way I live now. Our look isn't the same, but our approach to our look is.

**Fill in the blank: Whenever I look at _____ I can't help but smile.**

My sons sleeping. When I go to wake them up in the morning, they look so adorable and peaceful. It's the moment right before the chaos begins.

**What's the best part of your day?**

When I take a bath every night, it signifies the day is done. It's really nice. I like to add Japanese yuzu bath salts, which I buy from Tortoise in Los Angeles. It has this pretty, citrusy scent.

**What was the most memorable gift you've ever given or received?**

When I went to *British Vogue* from the *London Review of Books*, which was a huge change in my professional life (I basically exited one world and entered another), I decided to reward myself with an Hermès date book. I organize my whole life in this little thing, which is now falling apart—literally, the inner side flap is hanging on by four stitches.

It's the one thing I bought myself that I have never wanted to replace. I have so many memories around it. I save all the little date books, so I can always go back and know where I was at any given time. The last few years are lined up (in order) in the back of a desk so I can go through them to remember where I was or to find a phone number.

**What was your last purchase that you believe will mean something to you ten years from now?**

Two days before Christmas last year, I bought a ring from Fred Leighton that I had been eyeing on my screensaver for seven years. It's from the turn of the nineteenth century and has a little enamel of a child's face surrounded by extremely tiny diamonds. I decided to finally buy it specifically to get me through the New Year (it was an emotional time for me for family reasons). Something about this little enamel face that has survived for centuries just charmed me. I knew I could look at it every day and be happy.

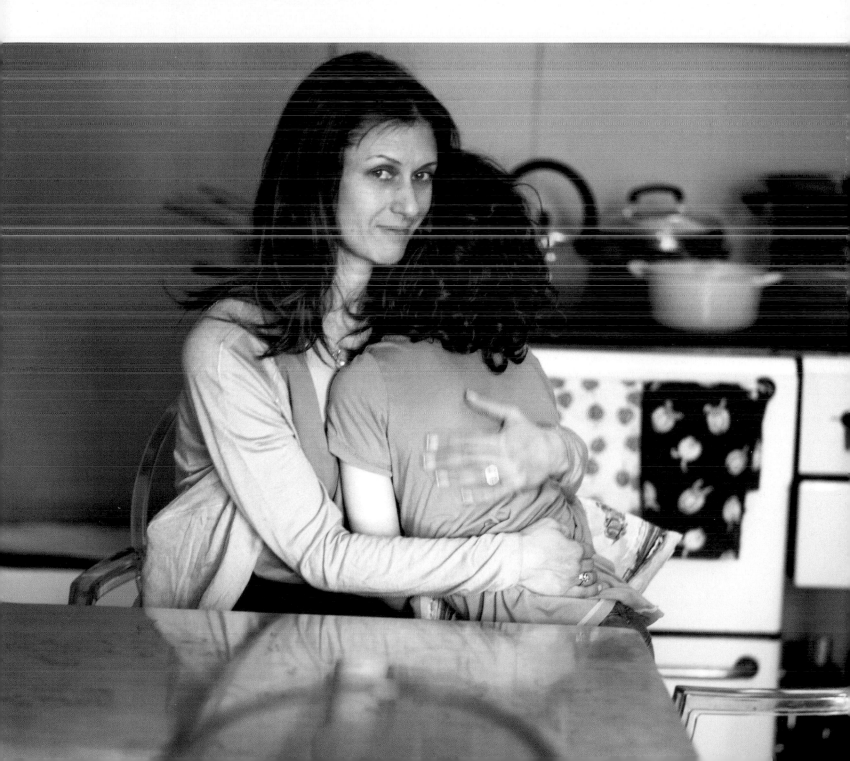

# CHRISTIAN Siriano

**How did you come to own your possession?**

My mother gave me this piece of art when I moved into my first apartment in New York back in 2008.

**How do you live with your heirloom?**

It has an old frame that fits perfectly within my large gallery wall full of treasures.

**Who in your life has most influenced your personal style and taste?**

As a designer, so many women influence the way I approach style. All my customers and my mother and sister were really my first muses. They always had taste, which I believe is something you are born with; it can't be taught.

**Fill in the blank: Whenever I look at _____ I can't help but smile.**

Photo of my puppies.

**What's the best part of your day?**

The best part of my day usually is when my design team and I get to see a final garment finished and ready for the show. Clothes spend so much time flat on the table and in pieces. It's so magical to see them come to life in three-dimensional form.

**Describe your ideal day.**

I love to be in my office just creating. Sometimes the best days are when I don't have to make any business decisions that are stressful and I can just play with fabric, drape, and create something new. Oh, and I must have a perfect lunch at my desk. That is important.

**What is your favorite place to shop for antique/vintage pieces? It can be anywhere in the world.**

I shop for antiques everywhere I go. I love shopping upstate and in Connecticut. There are so many wonderful finds for the best prices. Also the Paris flea market Marché aux Puces—I always find something amazing that I try to fit into my suitcase.

**What was the most memorable gift you've ever given or received?**

It's so hard to choose. My partner gave me a beautiful sketch of our dogs by an artist friend, and I love it very much.

**What was your last purchase that you believe will mean something to you ten years from now?**

I never really know, because some things that I have purchased become special and bring back memories only over time. I did recently buy my first home, and it will always have a perfect place in my heart.

I also have a beautiful pair of eighteenth-century chairs that were my first furniture purchase ever. I can't bring myself to recover them, even though they need it! They really will always mean something to me.

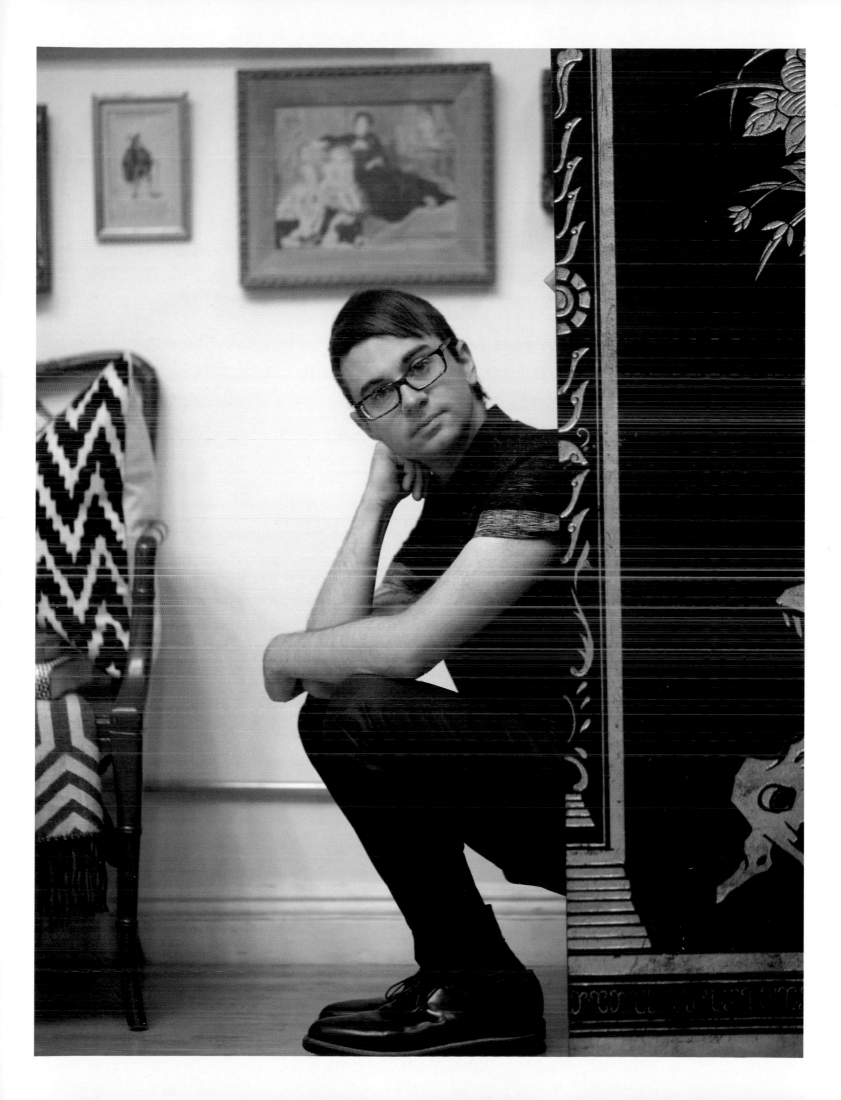

# ANNA
# *Sui*

**How did you come to own your possession?**

I've always collected papier-mâché millenary display heads and pincushions I found in the flea markets (particularly the charming ones from the 1960s, produced by Gemma Taccogna in Mexico).

**How do you live with your heirloom?**

When decorating my first store, my friends and I got together as a rainy afternoon craft project and made our own papier-mâché "Dolly Heads" to use as display pieces. These original heads still happily reside in my New York boutique and office and have become my mascots.

**Who in your life has most influenced your personal style and taste?**

I remember watching my mother getting ready to go out for the evening. I was totally fascinated by the whole ritual of it; the beautiful dresses, the jewelry, the makeup. She is still such an elegant woman, so polished. I learned a great deal from her.

Also, I used to go fabric shopping with my mom. I loved watching her sew, and I would take the scraps and make doll clothes. She was also a painter, so I inherited from her that passion for color.

**Fill in the blank: Whenever I look at _____ I can't help but smile.**

*Codognato* snake bracelet (I got from the Elizabeth Taylor auction). I can't help but smile.

**What's the best part of your day?**

I usually get to the office around 8:15 a.m. Arriving early gives me a moment to breathe and collect my thoughts in preparation for the day.

**Describe your ideal day.**

On the weekends, I enjoy seeing friends, going to the movies, shopping, visiting museums, and trying new restaurants.

**What is your favorite place to shop for antique/ vintage pieces? It can be anywhere in the world.**

I want to visit a flea market in every city I visit! I guess my favorite is the Portobello Road in London, but I also love the Ghost Market in Beijing.

In New York, I love the Antiques Showplace, and Shirley Mariaschin's shop, Jewelry Just for You. I collect her ethnic Berber necklaces, arts and crafts peacock-eye earrings, and Egyptian revival pieces from the 1920s.

**What was the most memorable gift you've ever given or received?**

My dad got me a subscription to *Seventeen* magazine when I was a kid. I was constantly hounding him about it, and he finally gave in. I saved most of those issues and still refer to them all the time. My dad had to admit that it was a good investment!

**What was your last purchase that you believe will mean something to you ten years from now?**

Black pearls from my trip to Tahiti.

# JONATHAN Waxman

**How do you live with your heirloom?**
It is in our living room.

**Who in your life has most influenced your personal style and taste?**
My parents.

**Fill in the blank: Whenever I look at _____ I can't help but smile.**
A Serapi.

**What's the best part of your day?**
Sitting in bed with my nine-year-old, Foster, and tickling him in the morning to wake him.

**Describe your ideal day.**
Tea in bed with my wife, the Sunday *New York Times*, a cup of Earl Grey tea, and the cats on the bed. Then make breakfast for the kids, walk in the park, go to a great movie, make dinner for the family at home—with vegetables from the farmers' market and a glass of rosé champagne—and then watch Masterpiece Theater on PBS with my wife and daughter.

**What is your favorite place to shop for antique/vintage pieces?**
Online: eBay, Bonhams, Sotheby's, and Christie's.

**What was the most memorable gift you've ever given or received?**
I gave a 1929 reconstructed Mason & Hamlin piano to my kids for Christmas.

**What was your last purchase that you believe will mean something to you ten years from now?**
A Patek Philippe rose gold watch I bought to remind me of my late mother.

# MARISSA Webb

**How did you come to own your possession?**

I wanted something that was always with me. Something that was a part of me that was a constant reminder to focus on the important stuff. My tattoo means "inner peace" in Korean.

**How do you live with your heirloom?**

Organically, it has become a permanent part of me and who I am.

**Who in your life has most influenced your personal style and taste?**

This is one of the hardest questions for me to answer. I am not easily influenced and certainly never by just one person. My inspiration comes from a melting pot of many. I can be inspired by a gentleman that I pass on the street whom I'll never see again.

**Fill in the blank: Whenever I look at _____ I can't help but smile.**

My dogs.

**What's the best part of your day?**

The sheer fact that it can change in an instant, which is what keeps life so interesting.

**Describe your ideal day.**

I want to feel as if I have accomplished something and contributed something positive to someone else's life. I want to wake up energized and go to bed eager for the next morning.

**What is your favorite place to shop for antique/vintage pieces? It can be anywhere in the world.**

I have so many! One of my many go-to places in New York is Stock Vintage.

**What was the most memorable gift you've ever given or received?**

I know I should say it was the ring from my fiancé and my vintage Rolex. Honestly, even though I work in the fashion industry, the most memorable gifts are not objects. It is friendship and trust that I hold the most dear.

**What was your last purchase that you believe will mean something to you ten years from now?**

Probably the addition to my home. Adding another bedroom means so many things. . . .

# CONSTANCE White

**How did you come to own your possession?**

I grew up with the bowls. They were part of a set that was brought out to use on special occasions. They were a wedding gift to my parents.

**How do you live with your heirloom?**

My heirloom is locked away in the highest reaches of my kitchen cabinets so no one can reach and break them.

**Who in your life has most influenced your personal style and taste?**

My mother was a big influence. Diana Ross, Angela Davis, and women on the street are an inspiration to me.

**Fill in the blank: Whenever I look at _____ I can't help but smile.**

My kids. They are a miracle of life right in front of my eyes. And sometimes they're funny.

**What's the best part of your day?**

When I finish the day, I feel a sense of accomplishment. And it's sometimes a period of peace and reflection.

**What was the most memorable gift you've ever given or received?**

My wedding ring, but also experiences with my mom or my kids. I think you remember time together doing something forever.

**What was your last purchase that you believe will mean something to you ten years from now?**

It's a carved wooden head. I bought two—one man and one woman—and gave one to my dad and the other to my then-boyfriend (now husband). My husband still has his and, whenever I look at it, it reminds me of our love and of my late dad.

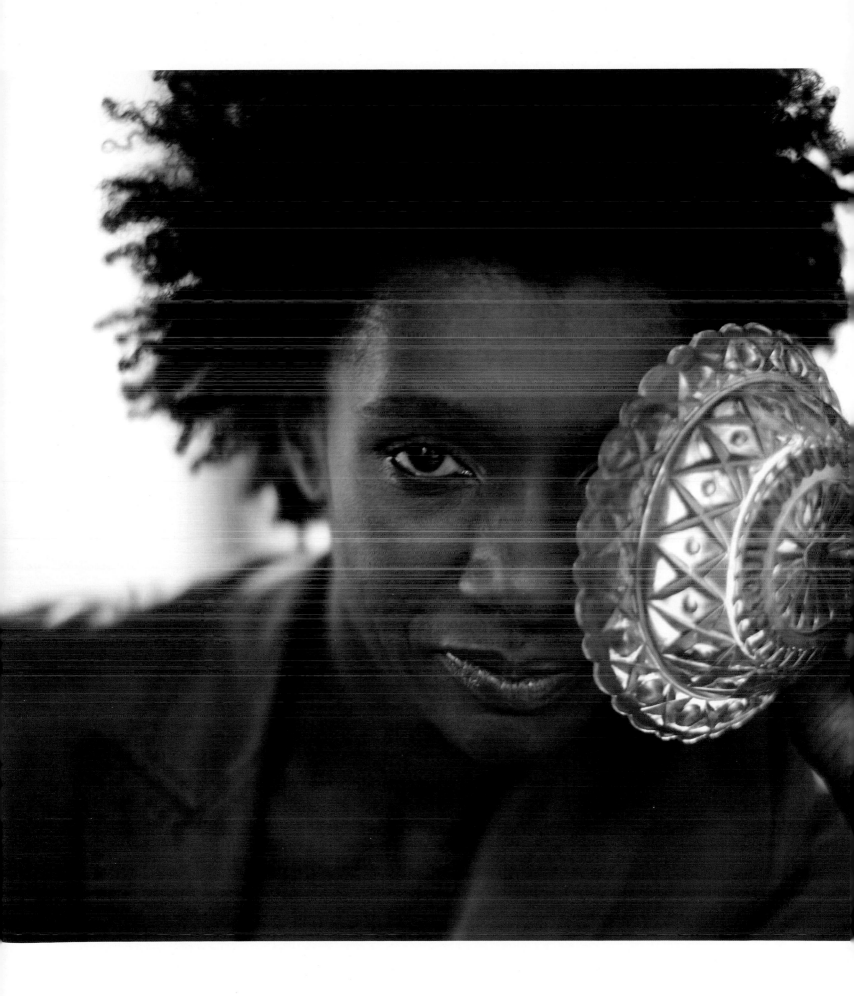

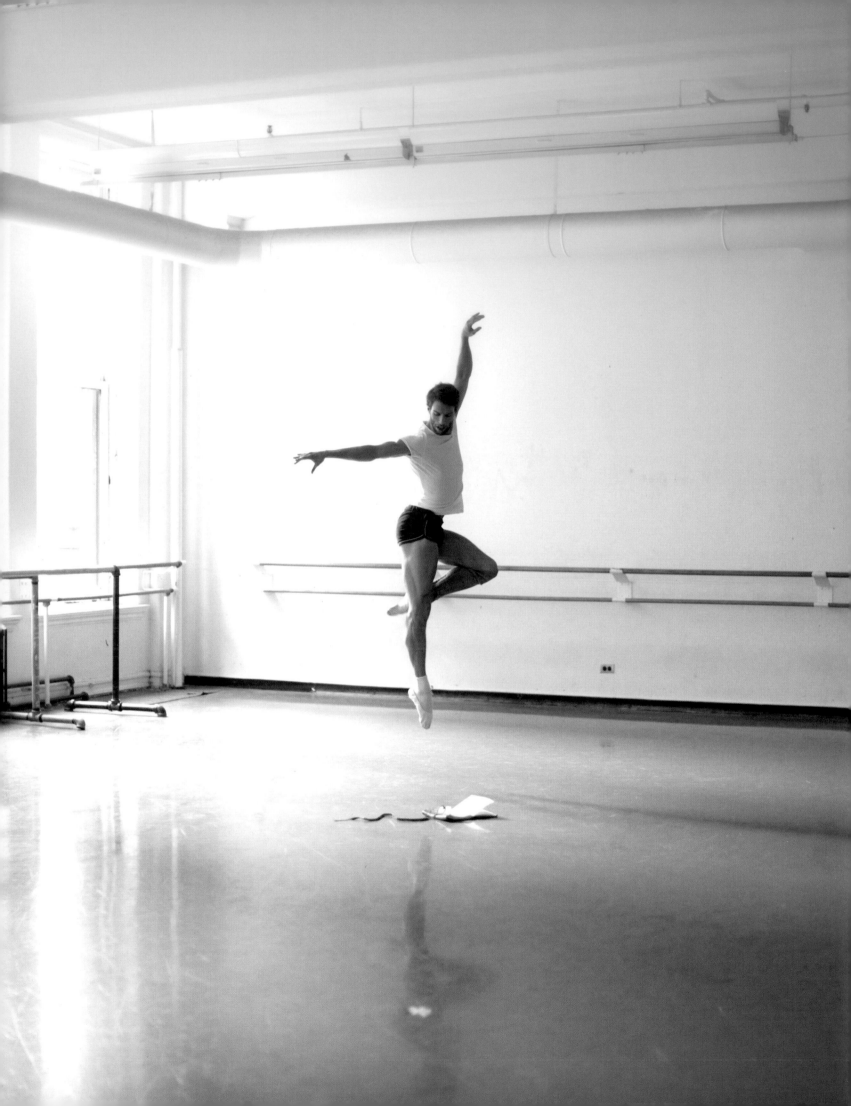

# JAMES Whiteside

**How did you come to own your possession?**

My notebook was given to me by my friend and manager, Ryan. I believe the card he gave it to me with said something like, "For your plots of world domination."

**How do you live with your heirloom?**

I write everything from choreography ideas, to original lyrics, to plumbing job quotes in my notebook. It's multipurpose!

**Who in your life has most influenced your personal style and taste?**

Aging has really influenced my style and taste. I think it's important to evolve. Could you imagine if I wore the same clothes that I wore in high school? Tragic! Or amazing? The beautiful thing about style and taste is that it's all subject to opinion. In my book, no one opinion is right.

**Fill in the blank: Whenever I look at _____ I can't help but smile.**

Cute animal. I'm a sucker for an adorable dog or cat.

**What's the best part of your day?**

Coffee time is my most productive time of day. It's relaxing and motivating all at once.

**Describe your ideal day.**

An ideal day is feeling inspired to create, regardless of what art form I'm in the mood for. Vacations are alright, too! I love the ocean!

**What is your favorite place to shop for antique/ vintage pieces? It can be anywhere in the world.**

I love going to rural American towns and rummaging through their thrift/vintage shops. My job sometimes takes me to very random places, and even though I can't buy and take things on the plane with me, I love to look.

**What was the most memorable gift you've ever given or received?**

My mom gave me a painting when I was a kid that reads: *Follow your dreams, for they hold endless possibilities.* It's a good mantra.

**What was your last purchase that you believe will mean something to you ten years from now?**

I recently bought a new laptop. My old one lasted for eight years. I love to write and create media, so I know it will be very good to me in the creation department. The computer itself may not mean something to me, but what it can facilitate will.

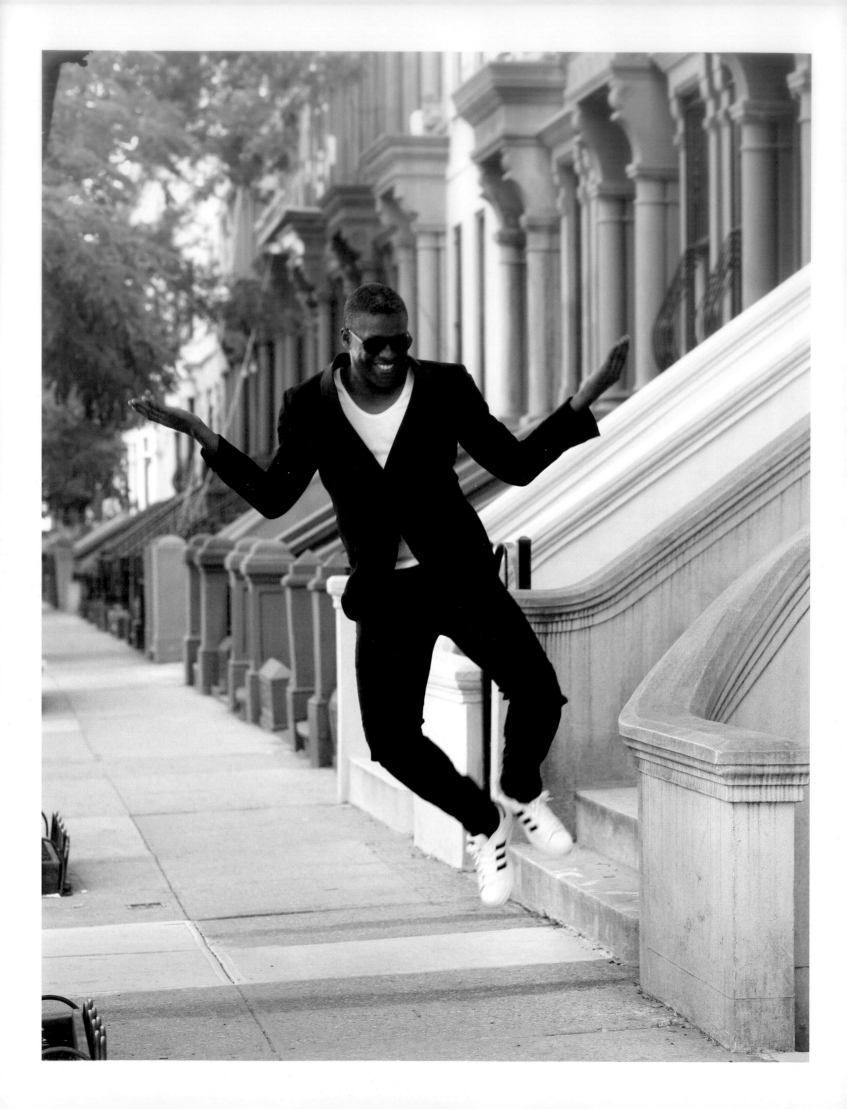

# biographies

**CHRISTENE BARBERICH** is a giant in the world of fashion and design. In 2005, she served as a founding partner of Refinery29, where she is presently editor-in-chief. Prior to the launch, she'd written for a variety of publications, including *The New York Times*, *New York Magazine*, *Elle Decoration*, and *Dwell*. She also contributed as founding editor of *CITY* magazine, where she earned an ASME nomination for General Excellence. She is co-author of *Style Stalking*, a *New York Times* bestseller celebrating creative street style.

Fashion designer **JOHN BARTLETT** exploded onto the menswear scene in 1992 and quickly earned kudos from his peers, including the prestigious Perry Ellis Award for Best Newcomer in 1993 and CFDA's Menswear Designer of the Year in 1997. In 2003, he opened his namesake boutique in New York's West Village. The Cincinnati native has shifted his devotion from high-end menswear to animal activism. In memory of his beloved three-legged pit bull rescue, the designer created the Tiny Tim Rescue Fund, which helps save the lives of dogs and cats by removing them from high-kill shelters and providing proper care.

**MARIA BARTIROMO** is a pioneer in broadcasting and a thirty-plus-year veteran in financial news. A two-time Emmy Award–winning journalist, she was the first reporter allowed to broadcast on the floor of the New York Stock Exchange in 1994. She spent twenty years at CNBC, where she was the face of the network, and is currently at Fox Business Network anchoring *Mornings with Maria*, as well as Sunday morning features on the Fox News Channel.

An influencer, media personality, motivational speaker, and entrepreneur, **TAI BEAUCHAMP** is on a mission to inspire women to live the beautiful lives they deserve. Her expertise in media, fashion, and beauty was solidified through her background at *Harper's Bazaar*, *Good Housekeeping*, *O, The Oprah Magazine*, and *Seventeen*. Her website, TheTaiLife.com, and her media company, Tai Life Media, connect style with a holistic lifestyle.

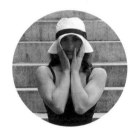

After her success as a Tumblr sensation with her account From Me To You, photographer **JAMIE BECK** created AnnStreetStudio .com with her visual graphics artist husband, Kevin Burg. Here, she shares her eye for glamour, beauty, and fantasy in the signature GIF-like moving images she calls "Cinemagraphs." The aesthetic appeal of these magical moving pictures has captured the attention of brands like Ralph Lauren and Oscar de la Renta.

Tony Award–winner **LAURA BENANTI** is a major screen and stage actress. She joined the season three cast of ABC's hit series *Nashville*, and last year Benanti appeared in reoccurring roles on CBS's *The Good Wife* and Showtime's *Nurse Jackie*. In addition, she appeared in her critically acclaimed performance as Elsa Schraeder in NBC's *The Sound of Music Live!* starring Carrie Underwood. Benanti is a highly celebrated, four-time Tony Award–nominated stage actress who took Broadway by storm at the age of eighteen.

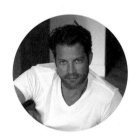

Since **NATE BERKUS** established his award-winning interior design firm at the age of twenty-four, his approachable and elevated philosophy has transformed countless homes. He has helped people around the world through his design work, home collections, books, television shows, and media appearances.

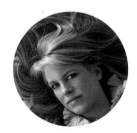

After eight years as fashion news director at *Vogue*, **KATE BETTS** became the youngest fashion editor in history when she took on the position of editor-in-chief of *Harper's Bazaar*. She has since also put the title bestselling author under her belt with *My Paris Dream: An Education in Style, Slang, and Seduction in the Great City on the Seine*, which chronicles her life as a fashion journalist in Paris after graduating from Princeton. She contributes writing to *Time* and the *Daily Beast*.

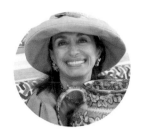

As CEO of Burberry from 1997 to 2005, **ROSE MARIE BRAVO** is revered as the driving force in expanding the classic British brand on the US market. Before that, she was president of Saks Fifth Avenue. In recognition of her efforts to promote British fashion, the Queen of England named her a Commander of the British Empire in 2006. She serves on the boards of Tiffany & Co., the Estée Lauder Companies, Williams-Sonoma, and the nonprofit organization Phoenix House.

Before her company became synonymous with fresh, clean, and modern beauty, **BOBBI BROWN** built a cult following in New York City as the go-to makeup artist for the natural makeup look. Frustrated by the lack of flattering makeup options on the market, Brown set out to create her own—a collection of ten brown-based lipsticks. Twenty-five years after the debut of her brand, Brown continues to empower women with her unique "be who you are" approach to beauty.

Executive director of *Harper's Bazaar*, Aussie **LAURA BROWN**'s style and charisma have earned her a slew of television appearances, not to mention her very own web series on *Harper's Bazaar*'s YouTube channel. She was a featured judge alongside Iman and Isaac Mizrahi on Bravo's *The Fashion Show* and appears regularly on television.

**JANIE BRYANT** is an Emmy Award–winning costume designer well known for her designs on AMC's *Mad Men* and HBO's *Deadwood*. Her work has been credited as influential by major designers. Bryant released a book called *The Fashion File*, which speaks to her career as a costume designer and her fashion inspiration.

Cuban–Haitian rap artist **FARRAH BURNS** dazzles audiences with her unique sound, which fuses Afro-Caribbean beats with French folk and futuristic melodies. In 2013, Burns blew away fans worldwide with the release of a groundbreaking single and video entitled "New York State Of Mind."

Formerly the host of CNN's *Fashion: Backstage Pass*, journalist **ALINA CHO** currently serves as editor-at-large at Penguin Random House's Ballantine Bantam Dell division. While at CNN, she covered President Barack Obama's first election, the aftermath of Hurricane Katrina, and twice reported from inside communist North Korea. Prior to her work at CNN, Cho worked for CNBC and ABC News.

**MICHAEL CLINTON** is the President, Marketing and Publishing Director of Hearst Magazines. He is the author of nine books and has traveled to over 120 countries.

At age nineteen, identical twin sisters **COCO** and **BREEZY DOTSON** formed NYC-based sunglass brand Coco & Breezy, which has since been featured in a multitude of titles from *Teen Vogue* to *New York Magazine*. Their eclectic pieces have been spotted on the likes of Lady Gaga and Serena Williams.

**AMY FINE COLLINS**, a former art historian and author of the memoir *The God of Driving*, has been a special correspondent for *Vanity Fair* since 1993, covering topics in fashion, design, and society.

**JOHN DEMSEY** holds the post of executive group president at the Estée Lauder Companies, where his creative vision and strategic thinking has contributed to the growth of brands like MAC Cosmetics and La Mer.

With more than thirty-five years of experience in the fashion industry, Barneys' creative ambassador-at-large, **SIMON DOONAN**, is also a columnist at online magazine *Slate,* and his vivacious personality has merited a number of television appearances.

Famed residential and commercial designer **JAMIE DRAKE** is the creative force behind notable interiors, including an LA showplace for Madonna and a number of projects for twenty-year client Michael Bloomberg. The Parsons graduate mixes the traditional and contemporary, playing with color to create distinctive, inviting environments.

Power stylist **MICAELA ERLANGER** reliably designs dazzling red carpet looks for Hollywood's leading ladies, turning up-and-coming stars like Lupita Nyong'o into style icons overnight. Her fresh taste and attention to detail have attracted clients such as Michelle Dockery, Olivia Munn, and Winona Ryder.

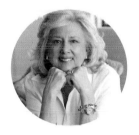

As head of the sex crimes prosecution unit of the Manhattan District Attorney's office for over twenty-five years, **LINDA FAIRSTEIN** made a name for herself supervising every case of sexual assault and domestic violence, as well as homicides related to those crimes. Her experience inspired successful titles, including eighteen bestselling crime novels and *Sexual Violence: Our War Against Rape*, detailing the history of sexual assault–related legislative reform.

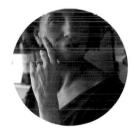

Style and lifestyle guru **PAMELA FIORI** was editor of *Travel + Leisure* for fourteen years, where she was credited with the title's rise to success. Then, as editor-in-chief of *Town & Country*, she solidified her reputation as one of the foremost authorities on lifestyle and luxury travel. Fiori has written six books and has received many honors, among them the Audrey Hepburn Humanitarian Award from UNICEF.

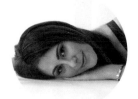

**JODIE FOX** integrated her advertising and law background with her penchant for fashion when she founded ShoesOfPrey.com. Based in Sydney but available worldwide, the multimillion-dollar web-based enterprise gives women the freedom to design their own shoes.

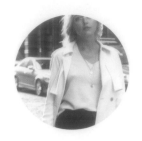

**KELLY FRAMEL** is a creative director based in downtown New York City, responsible for designing innovative print and digital initiatives for luxury brands like Tiffany & Co. and Chanel Haute Couture. She is publisher of The Glamourai, a leading webzine; a partner in Kizmet, an agency... in entertainment, retail, and hospitality; and is the fashion curator for Faena District Miami Beach.

After filling the role of director of photography at *LIFE* magazine in the 1990s, **DAVID FRIEND** joined the team at *Vanity Fair*, where he has been editor of creative development since 1998. He has covered conflicts throughout the Middle East and won accolades for his work examining the subject of 9/11, such as his book *Watching the World Change: The Stories Behind the Images of 9/11.*

Best known for her prestigious role as a judge on award-winning hit show *Project Runway*, Colombian native **NINA GARCIA** is creative director of *Marie Claire* magazine and also the *New York Times* bestselling author of four books.

These days, viewers of ABC's hit drama *Scandal* know him as President Fitzgerald, but **TONY GOLDWYN**'s impressive career as an actor and director has included films such as *Ghost, The Last Samurai*, and voicing the title character in Disney's *Tarzan*.  He has directed such movies as *A Walk on the Moon* and *Conviction*, including episodes of *Dexter* and *Scandal*.

**TAMRON HALL** is an award-winning journalist and a co-host of NBC News's *TODAY*, as well as the anchor of *MSNBC Live* with Tamron Hall. She is also the host of *Deadline: Crime with Tamron Hall* on Investigation Discovery. Hall is a native of Luling, Texas, and she holds a Bachelor of Arts degree in broadcast journalism from Temple University.

A top model during the eighties, **MUSA JACKSON** is an award-winning screenwriter, event producer, social columnist, magazine editor, community activist, leader, and philanthropist—aka Harlem's Ambassador.

*ELLE* Accessories Director **MARIA DUEÑAS JACOBS** began her career as a freelance stylist in college. After years working at Proenza Schouler and *Vogue*, she became accessories editor at *Glamour* before taking on her current role at *ELLE*.

**KAYCE FREED JENNINGS**'s career in television journalism began at ABC News in London. After studying at Brown University and the London School of Economics, she spent twenty years at ABC News. She is co-founder of The Documentary Group; senior producer of Girl Rising, a girls' education campaign; and on the boards of Win, which serves homeless families, and School of Leadership Afghanistan.

Since 1996, family court judge **JUDY SHEINDLIN** has starred as herself in the daytime television sensation *Judge Judy*. Before holding court on the Emmy Award–winning program, she had a career as presiding judge in New York's Family Court, during which she heard more than 20,000 cases.

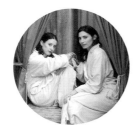

With their food, fashion, and lifestyle destination, The New Potato, sister duo **LAURA AND DANIELLE KOSANN** present the world through the lens of food, covering all things culture and interviewing a host of characters across many industries, from restaurateurs to designers to celebrities. They also script, produce, and act in their videos, which include celebrity cameos and cover a range of comical, on-the-pulse topics from über ratings to Brooklyn versus Manhattan to dating apps.

**ELIZABETH KURPIS** gracefully balances her job as a high-profile lawyer with involvement in the New York scene as an art connoisseur, philanthropist, and fashionista. When she is not busy with her career, family, or travel, the attorney contributes to institutions like the American Museum of Natural History, the Frick Collection, and Memorial Sloan Kettering Associates Committee.

New Mexico native **SCOOTER LaFORGE** built quite a reputation in the art scene in San Francisco before moving to Manhattan, where his work has been shown at galleries like Exit Art, Wooster Projects, and White Columns. A graduate of Cooper Union, he paints in a style reminiscent of pop art, abstract expressionism, and classicism.

**LAUREN BUSH LAUREN**, former model, is the founder and CEO of FEED, a social business whose mission is to "create good products that help FEED the world." Every product sold has a measurable donation attached to it and, to date, the social business has been able to provide over 87 million school meals globally through the WFP and Feeding America.

Iconic celebrity stylist **FREDDIE LEIBA**'s influence dates back to working with Andy Warhol to launch *Interview* magazine. He's dressed top style icons, worked with every notable fashion photographer, and collaborated with a variety of reputable brands on their ad campaigns.

The elegant editor-in-chief of *Glamour* magazine, **CINDI LEIVE** was named Most Powerful US Fashion Magazine Editor by *Forbes*. In addition to discussing new fashion trends, she is a champion of women's issues, celebrating female leaders annually at *Glamour*'s Women of the Year Awards.

**NANETTE LEPORE** is a renowned fashion designer from Youngstown, Ohio, who currently resides in New York. Her items are featured worldwide and sold at her own namesake boutiques.

**JAQUI LIVIDINI** is founder and CEO of Lividini & Co., a brand strategy company that specializes in positioning and driving marketplace success for iconic fashion, retail, and lifestyle brands. Jaqui began her career at Saks Fifth Avenue, where she rose through the executive ranks, culminating in the position of SVP Fashion Merchandising and Communications. She is highly regarded for her legacy of service and philanthropy.

**REBECCA MINKOFF** has developed into a global lifestyle brand with a wide range of accessories, footwear, apparel, handbags, jewelry, and wearable tech. Her playful and edgy designs can be spotted around the world on young women and celebrities alike. Her lifestyle brand is distributed in over nine hundred stores worldwide.

Four-time CFDA award-winner **ISAAC MIZRAHI** is a fashion designer, TV presenter, and creative director of Xcel Brands whose stylish designs have outfitted prominent women like Audrey Hepburn and Hillary Clinton, and pop culture icons like Julia Roberts and Rihanna. In December 2009, Mizrahi launched his lifestyle collection, *Isaac Mizrahi Live!*, on QVC.

Born and raised in the Philippines, **JOSIE NATORI** began her career as the first female vice president at Merrill Lynch. She then transitioned from Wall Street to the fashion business, where she is now CEO and founder of The Natori Company, a high-end women's brand. She also served as commissioner on the White House Conference on Small Business.

German-born style legend **BEATRIX OST** exudes effortless elegance, expressing herself creatively as a writer, artist, designer, and theatrical producer—truly exemplifying the modern-day Renaissance woman.

Known as "Flower Girl," owner and head florist in downtown NYC **DENISE PORCARO** has been crafting enchanting seasonal flower arrangements with a distinct edge for her clients since 2004. Her fashionable clients include *Vogue*, Chanel, and Marc Jacobs.

**RALPH PUCCI** is the force behind Ralph Pucci International, located in West Hollywood, Fort Lauderdale, and New York City. He is the author of *Show*, and his work was recently celebrated in the Museum of Arts and Design's exhibition *Ralph Pucci: The Art of the Mannequin.*

Novelist and social critic **ANNA QUINDLEN** has appeared on fiction, nonfiction, and self-help bestseller lists. Her column for *The New York Times*, "Public and Private," won the Pulitzer Prize.

Innovative architect and designer **DAVID ROCKWELL** leads New York–based Rockwell Group. The award-winning firm crafts a unique narrative for each project through the intersection of theater and architecture. Credits include projects like Nobu restaurants, hotels worldwide, and set design for major Broadway productions.

First appearing on the scene as a model in Italy at age eighteen, and later working as fashion editor at *Harper's Bazaar*, stylist **LINDA RODIN** has had a lengthy career in fashion. She translates her industry smarts and fantastic personal style to the skincare arena with her collection Rodin Olio Lusso.

Fashion designer **LELA ROSE** grew up in Dallas, Texas. Five years after graduating from Parson's School of Design, she debuted her eponymous collection, which has made her a trusted supplier of sophisticated ready-to-wear and bridal, sold nationwide.

Born and raised in Nairobi, photographer **JOHNNY ROZSA** began his career in London and is now based in New York, specializing in fashion, portrait, and celebrity photography. His portraits have been exhibited worldwide, from Sydney to Vienna.

**MARGARET RUSSELL** is the editor-in-chief of *Architectural Digest*, a position she has held since August 2010. She has spearheaded a highly regarded redesign of the magazine and the relaunch of archdigest.com. Prior to joining *Architectural Digest*, Margaret served as vice president and editor-in-chief of *Elle Decor*, a publication that she helped found in 1989. Margaret was appointed by President Obama to serve on the Board of Trustees of the John F. Kennedy Center for the Performing Arts, and she sits on the Advisory Council of the Philip Johnson Glass House.

Known as Mad Dog to his listeners, **CHRIS RUSSO** began his career in sports radio as a cohost of *Mike and the Mad Dog* with Mike Francesa. Now he runs Mad Dog Radio, his own channel on Sirius XM Radio.

Kentucky-born television and film star **KELLY RUTHERFORD** shared on-screen DNA with Blake Lively in her role as Lily Humphrey (van der Woodsen) on the hit show *Gossip Girl*. In addition to her sensational performance on-screen, the gorgeous, lithe blonde has earned a reputation for her impeccable personal style.

**NAUSHEEN SHAH**'s impressive portfolio includes fashion, editorial, personal, and celebrity styling, print advertising, fashion shows, and music videos. Her artistic approach to creating attention-grabbing looks makes her a valuable asset for clients like Bergdorf Goodman, *Travel + Leisure*, *L'Officiel*, and the *New York Post*.

In 1997, fashion philanthropist **CAMERON SILVER** opened celebrated consignment shop Decades on Melrose Avenue in Los Angeles, and since then his playful vintage style has been a source of inspiration for fashion houses from New York to Milan. He has served as a creative consultant for Azzaro and Samsonite and currently stars in Bravo's *The Dukes of Melrose*.

*Vogue* Creative Digital Director **SALLY SINGER** took the roundabout way to her permanent front-row seat at fashion shows in New York and Paris. Her career path detours include a brief stint as a San Francisco beautician and editor at the *London Review of Books*, which she eventually left for a job at *British Vogue,* followed by *ELLE*. Then, after eleven years at *Vogue* as fashion news director, Singer left the magazine for two years to serve as editor-in-chief of *The New York Times Style Magazine*, making her triumphant return in 2012 to run Vogue.com.

*Project Runway* winner **CHRISTIAN SIRIANO** was inducted as a member of the CFDA in 2013. His eponymous collection has a regular slot at New York Fashion Week, and *ELLE*'s "new king of old-school glamour" has partnered with brands like Payless ShoeSource and Victoria's Secret, in addition to dressing the world's leading ladies.

One of the top five fashion icons of the decade, **ANNA SUI** hails from Detroit and has made a name for herself by infusing her original aesthetic with her devotion to rock and roll. Her fashion empire includes clothing, shoes, cosmetics, eyewear, accessories, and a line of fragrances. In 2009 she earned the Geoffrey Beene Lifetime Achievement Award from the CFDA.

Chef and owner of West Village favorite Barbuto, California native **JONATHAN WAXMAN** has published two cookbooks and participated in two seasons of Bravo's *Top Chef Masters,* where he was known as Obi-Wan Kenobi. The *Los Angeles Times* once dubbed him "the Eric Clapton of chefs."

Korean-born designer **MARISSA WEBB** exemplifies her elegant personal style in her eponymous fashion label while simultaneously working as adviser for design at Banana Republic.

**CONSTANCE WHITE** is an arbiter of culture and style, an award-winning journalist, and a champion of female empowerment. Her wealth of experience has made her an esteemed source of editorial expertise for companies such as *The New York Times, ELLE, Essence,* and eBay.

Dancer **JAMES WHITESIDE**, formerly with Boston Ballet, has been a soloist with the American Ballet Theatre since 2012. He was named a principal dancer in 2013. He has since graced the stage as Romeo in *Romeo and Juliet,* the Nutcracker Prince in Alexei Ratmansky's *The Nutcracker,* and Prince Désiré in *The Sleeping Beauty,* to name a few.

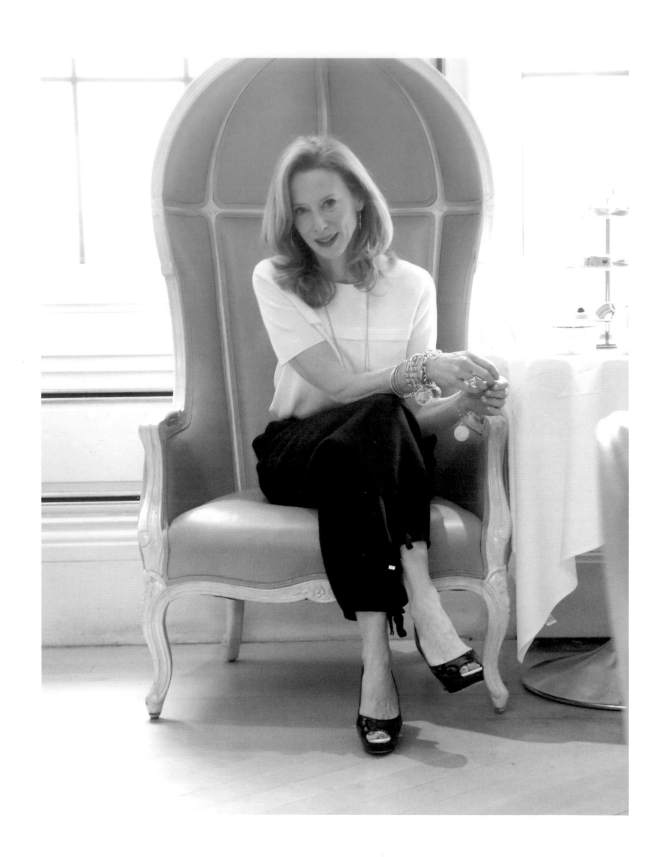

**MONICA RICH KOSANN** is the creative director and founder of Monica Rich Kosann, a fine jewelry and home accessory brand. Monica's lifelong love of art, design, and photography led her to begin her career as a fine art black-and-white portrait photographer. The personal nature and heirloom quality of her portraits were an ever-present inspiration for her as she scoured the world's most unique antique shows and flea markets for vintage cigarette cases, powder compacts, and lockets that she repurposed to hold her photography clients' most intimate family portraits.

As demand for these vintage pieces grew, Monica designed a fine jewelry collection to hold these special photographs and personal messages, integrating her clients' most cherished stories and possessions into their daily lives.

Today, Monica's brand-name fine jewelry collection includes a wide range of styles such as lockets, poesy rings, charm bracelets and charm necklaces, one-of-a-kind items, and a broad collection of other covetable and collectable fine jewelry pieces in eighteen-karat gold and sterling silver.

For Monica, the jewelry design process is driven by one question she always asks herself: "Would a woman want to pass along this piece of jewelry to her daughter in twenty years?" She says, "My collection offers my customers heirlooms while maintaining an enduring sense of fashion and timeless style. Living and celebrating the memories created in our daily lives is universal to all of us, and my jewelry is the focus of that universal idea. A locket captures a moment unique to each of us, a charm bracelet tells and celebrates the story of each woman's life—in that way, it is like a fingerprint, totally unique to that woman."

What began as an idea for bringing enduring fashion and style to a locket has expanded to a collection of fine jewelry that gives a woman countless reasons to return to Monica's brand. The collection is sold on her website, MonicaRichKosann.com, and in more than one hundred fine jewelry stores throughout the United States, including Neiman Marcus and a shop at Bergdorf Goodman in New York City.

Monica is a member of the CFDA (Council of Fashion Designers of America) and has published two photography and lifestyle books, *The Fine Art of Family* and *Living With What You Love*.

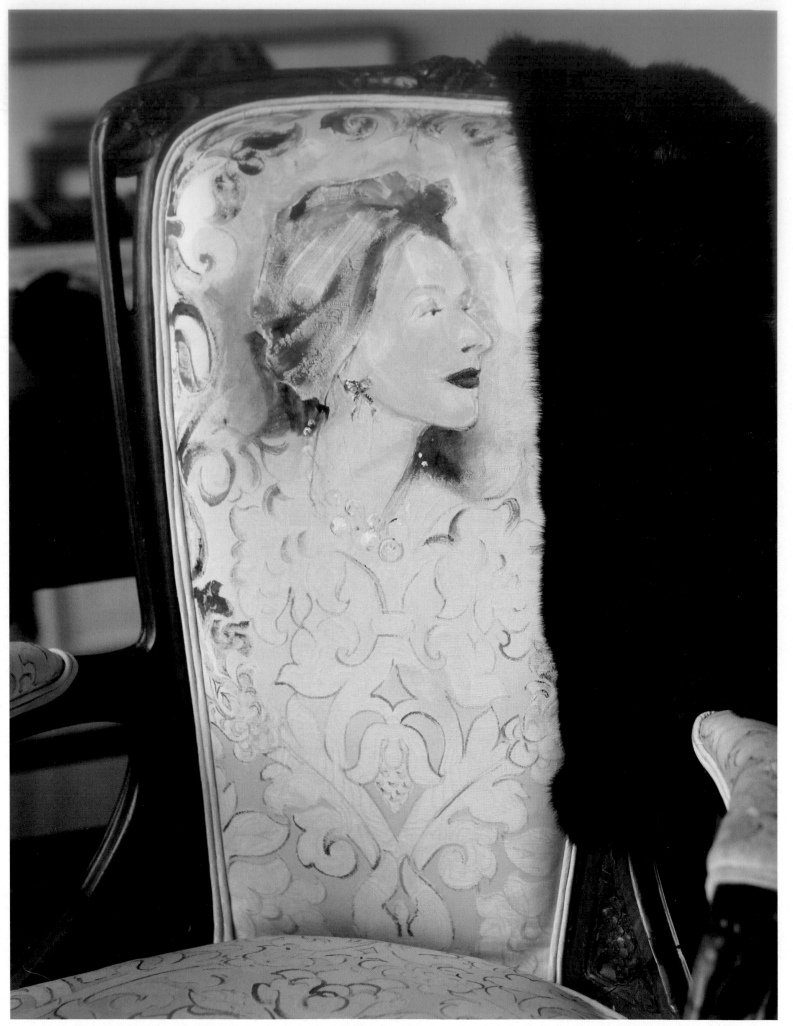